# Northern Ireland
# 30 Years of Photography

Published by Belfast Exposed
in partnership with the MAC

Northern Ireland: 30 Years of Photography
Colin Graham
First edition 2013

Published by Belfast Exposed in partnership with the MAC
on the occasion of the exhibition **Northern Ireland: 30
Years of Photography** at Belfast Exposed and the MAC
(10 May to 7 July 2013) curated by Karen Downey.

Author: Colin Graham
Production Editor: Karen Downey
Copy Editor: Simon Coury
Book Design: Tonic Design
Production Assistants: Ciara Hickey and Laura McMorrow

Belfast Exposed
23 Donegall Street
Belfast
BT1 2FF
Northern Ireland

T. +44 (0)28 9023 0965
www.belfastexposed.org

The MAC
10 Exchange Street West
Belfast
BT1 2NJ
Northern Ireland

+44(0)28 9023 5053
www.themaclive.com

Printing: Zrinski, Croatia

ISBN: 978-0-9561766-1-5

Funded by Arts Council of Northern Ireland

LOTTERY FUNDED

# Northern Ireland
# 30 Years of Photography

Colin Graham

# Contents

# Foreword
# Northern Ireland: 30 Years of Photography

Belfast Exposed is delighted to have the opportunity to publish this book on the occasion of its 30th anniversary. Through its community photography and new work commissioning programmes, Belfast Exposed has been actively promoting and supporting the development of photography in Northern Ireland for 30 years. Its work, and the work of the many photographers associated with it, form a small but significant part of the wider history of photography that is charted in the book.

Belfast Exposed is also very pleased to publish this book in partnership with the MAC, Belfast's newly launched arts venue. The exhibition which accompanies the book features photographs by more than 30 photographers produced over 30 years and has been staged across the Belfast Exposed and MAC gallery spaces, allowing the full scale and ambition of the project to be realised.

*Northern Ireland: 30 Years of Photography* brings together significant works by some of the most influential photographers of the last three decades to examine the phenomenon of new photographic practices in Northern Ireland. The book is not a comprehensive survey of photography from the region, but focuses mainly on the shift in photographic practice from the press and media context of the 1980s to the gallery and photo-book publishing contexts of the 1990s and 2000s.

Taking a historical and thematic approach, the publication begins with the media imagery of the Troubles that compelled photographers and artists to intervene in the flow of press photography that dominated a global, visual portrayal of Northern Ireland in the 1970s. From this response, and in response to wider, international trends in contemporary photography, an engaged and often polemic aesthetic emerged, individual to each photographer but also shared across diverse photographic practices.

With the Peace Process in the 1990s a new dynamic entered the scene which required photographers to think about the social and political past and future of Northern Ireland. The author examines how photographers have used the archive as a device to explore the role of memory and the legacy of conflict in post-Agreement Northern Ireland. He also pays detailed attention to how the changing topography of Northern Ireland's cities and border regions have been documented and interpreted by contemporary photographers.

Through the inclusion of work by photographers with a keen sense of trends and debates in the wider contexts of contemporary photography and art, *Northern Ireland: 30 Years of Photography* presents photography in and from Northern Ireland as a reflection of place in the broadest possible sense.

Belfast Exposed would like to thank the author Colin Graham, not only for his work on this book, but for the substantial contribution he has made over the years as a critical voice in Northern Irish photography. Extended thanks are due to the many local and international photographers whose work is represented here. We would like to thank Keith Connolly of Tonic Design for his thoughtful and beautiful book design. Belfast Exposed would also like to acknowledge the contribution made by its dedicated team of staff and volunteers, including its voluntary Board. We express our gratitude to the funding bodies that have contributed to building and sustaining our project and to those who continue to support the development of new work. Finally, Belfast Exposed would like to thank the many individuals, organizations, audiences, activists and communities who have been part of our story for their continuing interest and support.

*Pauline Hadaway*
Director, Belfast Exposed

*Karen Downey*
Senior Curator, Belfast Exposed

# Introduction: 'an invitation to observe'

*'To see something in the form of an image is an invitation to observe, to learn, to attend to. Photographs can't do the moral or the intellectual work for us. But they can start us on the way.'*
Susan Sontag[1]

One of the most influential books on Northern Ireland during the years of the Troubles was John Whyte's *Interpreting Northern Ireland* (1990). Whyte surveyed the way in which political science had tried to work out what was going on in the North. He bemoaned the fact that in 1968 there was, for example, little in the way of 'attitude surveys', from which political scientists could get a sense of the social temperature in Northern Ireland. By the time he was writing the book, Whyte suggested, things had moved on. Because of the Troubles, 'Northern Ireland may be one of the most heavily researched places in the world', he wrote.[2] It is tempting to think of the book you are reading, and the accompanying exhibition, as telling something of a similar story – moving from a dearth of fine-art documentary photography at the beginning of the Troubles to an extraordinary fruitfulness of photography in the twenty-first century, just as Whyte's Northern Ireland went from being of little interest to political scientists to becoming a place swarming with statisticians and judgers of the force and direction of political winds.

Photography is everywhere in the world, and now everyone is a photographer. Photography has also fully entered the art gallery, and it is primarily photography that is seen in an art context which this book discusses. Photography does not 'study' Northern Ireland in quite the same way as do the political scientists whom Whyte considered. But photography, even in what might be thought of as the rarefied form of 'art photography', does report on Northern Ireland. Just as political science has a journalistic mode to it, reportage is one of the origins of art-documentary photography in Northern Ireland. It is the kind of photography that looks hard and looks long. It wonders and, through our own consideration of its images, it makes us think. It 'can start us on the way'.

It is often said that a photograph is the enclosure of a moment, 'a way of arresting time in order to contemplate it'.[3] A photograph, however, is also a record of presence, of someone, or at least a camera,

*being there*, bodily or physically, in occupation. By the act of recording a social, real-world space a photograph translates space into 'place'.[4] The photographs discussed in this book, diverse and different as they are, constitute a series of ways of trying to understand a place, somewhere historical and lived in. Somewhere with a present and a future. Looking through the photographs in this book, you will see a striving for comprehension, carried out with restrained empathy and with a knowledge that the frame of the photograph does not contain the wholeness of the world. There is a modest but powerful ambition in these photographs, and above all a belief in the importance of the quotidian – a conviction that what you see in the frame is a portal to seeing what is beyond the frame.

This books covers a period from around the beginnings of the 1980s up to the present day. All such historical divisions are, of course, arbitrary, and the fine-art documentary photography which the book concentrates on has roots stretching back well beyond the 1980s, and influences drawn geographically from outside Northern Ireland, Ireland and the British Isles. It would equally have been possible to fill out the 1970s more fully with the sudden stream of photographic images which news media of various types produced in order to convey the events of the late 1960s and 1970s in the North. Media imagery of Northern Ireland in those years was often sensationalist, simplistic and biased. Newspaper (and television) reportage was usually quite literally on the side on the establishment, with the camera pointed at protestors and rioters. This type of image was, however, countered by community photographers and those who were committed, either out of a sense of the integrity of documentary truth or the importance of an alternative politics, or both, to telling the story differently. Some examples of such work are discussed in Chapter One on 'The Troubles'.

It has been said that the early fine-art photo-documentary practices which arose in Northern Ireland, or among Northern Irish photographers, were developed as a reaction against the misrepresentation of the North which occurred in mass media in the first decade and a half of the conflict. Fiona Kearney summarizes this version of the recent history of Northern Irish photography succinctly when she suggests that it can be understood

> as a critical response to the way in which Northern Ireland has been represented in
> the mass media for the last thirty years. [These] photographs are seen as an alternative
> to the propaganda of conflict perpetuated in newspaper coverage of the violence.[5]

This is partially true. The idea that the visual 'struggle for legitimacy'[6] (as David Miller describes the tussle for power over representation of the North during the Troubles) so upset budding art photographers that they set out to correct the record is to look only at the parish for an explanation of something with multiple and global causes. Coverage of the North in visual media often involved the swift arrival and departure of globe-trotting cameramen who brought with them a modus operandi honed in conflict zones around the world. As a reaction to this, there is, at times, and especially in the work of some photographers 'native' to the North in the 1980s, an implicit claim for insider status, or an underwriting of the image by the 'authenticity' of indigenousness. Most often this comes with a form of self-scrutiny which recognizes that

**Mary McIntyre**
**Untitled (after Caspar David Friedrich) I**
**2002**
Colour lightjet photographic print.
122cm x 152cm.
© Mary McIntyre.
Courtesy of the artist and the Third Space Gallery.

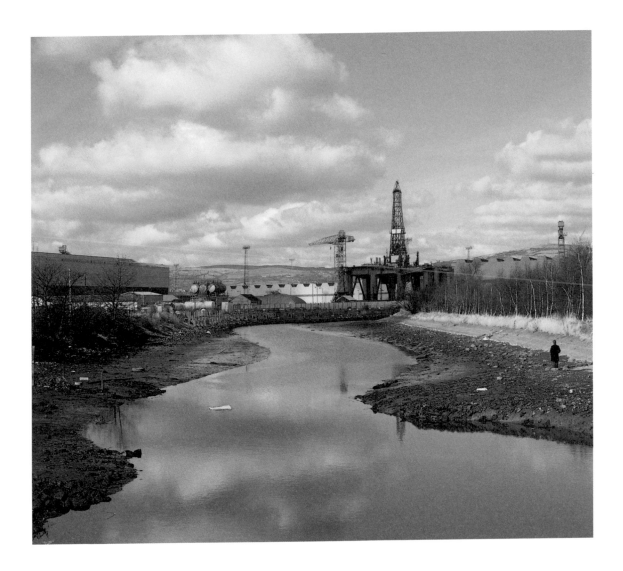

Introduction: 'an invitation to observe'

being a photographer and taking a photograph immediately displaces the individual photographer, and cuts her or him off from the community. However, the images which the art photographers starting to work in Northern Ireland at the end of the 1970s made were shaped primarily by patterns derived from the art and photographic worlds, rather than because they were 'not mass media' photographs.

<div align="center">★</div>

A man – it seems to be a man – is standing in an unlikely place on the southerly bank of the Connswater River. He is looking, and he is contemplating. It could be the river which he is thinking about, or possibly the shipyard behind it. He stands in a way which suggests that he is someone who gives deep consideration to things. Because of his contemplative stance we might imagine that he is someone who would like to gaze romantically, who would like to able to blot out the contemporary, and to see beyond those blank and modest buildings which contain what's left of industry in this part of Belfast. If so, it's probable that he looks past the filthy river to the waving crest of the hills and the impossible blue of the sky and that, for a moment, he imagines a pristine landscape without the intrusive foreground. But it would be difficult enough for him not to see the oil rig which is waiting to be floated out to sea. And he could hardly ignore the smell of the river, or the damp in his shoes.

Mary McIntyre's 'Untitled (After Caspar David Friedrich) I' is from 2002. It is a slightly unusual photograph in McIntyre's work, almost out of synch with her minimalist landscapes and echoing interiors.[7] The coloration in this image is bright in comparison to her usually subdued tones. The title of McIntyre's photograph is a guide as to how it should be read. 'Untitled' has, ironically, become a common enough title in twentieth- and twenty-first-century art. Initially the term denoted a scholarly inability to find a title for an historic work. Then it functioned as a kind of abstraction or refusal of realism, suggesting that to title a work of art was to imply an ability to represent, or to symbolize, which the artwork could not sustain. Finally, 'Untitled' became a title common enough to be something of a cliché, so that it is now often ironized by the addition of information which ensures that 'Untitled' is, in fact, a title.[8] Cindy Sherman's photographs, for example, are almost all 'Untitled' in titled ways. So McIntyre's photograph declares itself to be 'art' from the outset, though art with a slight discomfort at declaring itself so – hence the tinge of self-parody in the title 'Untitled'. It is also a work of art which is close to being a different kind of image. It might almost be a glossy image for a coffee table book or a tourist brochure, were it not for the filthy river and the strange man. 'Untitled' moves towards and then, with its allusion to painting, draws itself away from, being a photograph that might function as a kind of PR shot for contemporary Belfast. In doing this it tells us something important about 'art' photography in Northern Ireland. In photographing Northern Ireland, art photography summons the ghost of publicity (the news item, the feature, the enticement to visit) into every image.

McIntyre uses her title to suggest that Caspar David Friedrich, the nineteenth-century German Romantic painter, is a touchstone for thinking about this photograph. Friedrich's best-known painting is 'Wanderer Above the Sea of Fog' (1818), in which a solitary male figure surveys, from the top of a mountain, the landscape unrolled before him. Seen from the back, as many of Friedrich's observers are, this man is the

Caspar David Friedrich
**The Wanderer Above the Sea of Fog**
**1817**
Oil on Canvas
94.8cm x 74.8cm
© BPK, Berlin/Hamburger Kunsthalle/Caspar
David Friedrich.
Courtesy of BPK.

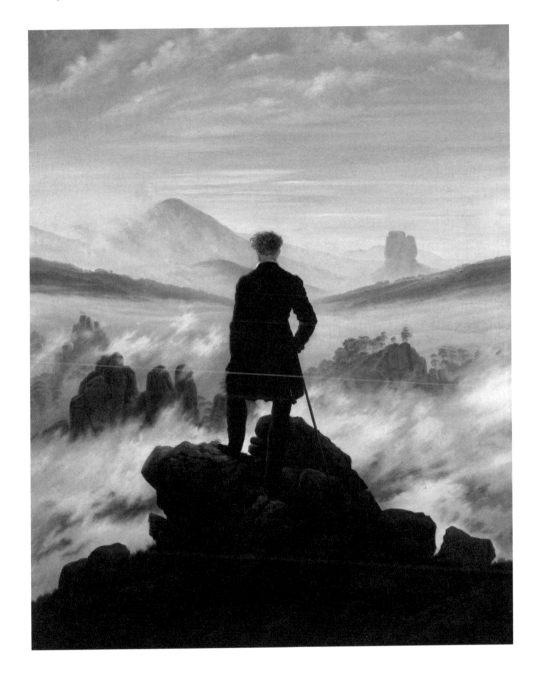

Introduction: 'an invitation to observe'

figure of the romantic philosopher, the viewer of the painting (suggesting, in his pose, how the painting should be looked at) and the painter, taking in nature in readiness for making a representation of it. A standard view of Friedrich's version of the sublimity of natural landscapes is that 'the puissance of nature [is] revealed before the observer dwarfed under this grandeur',[9] though Friedrich's 'wanderer' is a little caught between being a masterly surveyor and being a man of sensibility, bowed by the awe of what he sees.

McIntyre's allusion to Friedrich is most obviously to the 'Sea of Fog' painting, if only because that painting is now the visual cliché of Friedrich's work, and because the male figure in 'Untitled' adopts a pose modestly similar to the wanderer's. But the title of 'Untitled' does not tie the photograph specifically to the 'Sea of Fog' painting, and so other Friedrich paintings begin to push their way in. For example, Friedrich also liked to paint at sea level, usually looking out from the shore, and often with both observers (frequently with their backs to the viewer) and ships in the frame. The ships are important. Friedrich was not just a painter who sought out vantage points from which the world could be seen as a majestic natural phenomenon. The 'Sea of Fog', in which the human presence is reduced to just one person, has come to dominate our sense of his work so much that we forget how fascinated he was by landscapes which are both peopled and inhabited by technology. Friedrich was not an escapist. He was no return-to-nature obsessive. Even in the 'Sea of Fog' his 'wanderer' wears modern clothes and carries a walking stick. He stands in the manner of a man of means. He is at leisure. Therefore he is relatively wealthy. Meanwhile, the ships in paintings such as 'The Stages of Life' are visual replicas of the people in the painting – echoing each other's vertical lines in the determinedly horizontal landscape, they both, people and ships, signify commerce, work and civilization, with the rising moon or the setting sun or the horizon as a backdrop. Friedrich was, thus, contemporary, even, at times, documentary. He painted places and people at the time at which he was alive, and he wondered and fretted about the distance between what the landscape might signify and the lives that people lived in that landscape. In this, he is, unlikely as it might seem at first, a perfect artistic analogy for the art-documentary tradition of photography which has unfolded in Northern Ireland in the past thirty years or so. That new 'tradition' has faced up to the two-fold problem of distance in photography which has a documentary strain to it – that the people and places photographed may or may not 'represent' the whole society of which they are a part, and that the photographer, while wishing for immediacy, finds herself or himself creating a social chasm through the lens, an unbridgeable distance from the 'real'.

In suggesting that 'Untitled' is 'after' Friedrich, McIntyre is asserting that this photograph fits into an artistic tradition – one which has landscape painting, going back to Courbet and continuing, through Friedrich, to the present, in its fabric. That, the title says, is how you'll have to understand this photograph. As well as incorporating the form of a photograph which might advertise the city, 'Untitled' is, its title insists, something like a landscape painting. And so, initially, the image is asking its viewers if they can manage to see this view as 'sublime', if they can get from it that calm thrill which is the ideal emotion, in the Romantic tradition, that should arise from looking at a landscape. But the image knows that a view of the Belfast shipyards and the Connswater River is not going to be seen as 'awesome' without some effort (and here the photograph is in another sub-tradition which nods to John Luke's painting

Introduction: 'an invitation to observe'

'Connswater Bridge' – a slightly different view, but also a work which tinkers with the construction of this part of Belfast as a beautiful, artful landscape[10]). As a work of art, 'Untitled', in its title and then in the formal allusions to its own construction, is self-conscious. It shows us a place which is geographically, socially and politically identifiable, and it adds a visual and textual apparatus which prevents us simply seeing the photograph as either a straightforward rendering or a celebration of that place. It is both documentary and art at the same time. While this is not a simple conglomeration of modes, it is the matrix which best explains most of the work discussed in this book.

<p style="text-align:center">★</p>

In recent decades there has been a shift in the art world's perception of photography as a category, allowing photography into the ever-expanding capaciousness of 'art'. Julian Stallabrass, discussing the work of Sebastião Salgado, creates the category of 'Fine Art Photojournalism' to explain how Salgado's work came to be predominantly seen within art galleries and art books.[11] For Stallabrass this change in the estimation of photography is a melancholy sign that the mass media no longer allows photojournalism to have a critical edge or an enquiring eye (and, he would argue, the more jejune liberal politics of 'documentary' photography – as opposed to the more radical inquiry of true photojournalism – have also been subsumed by the art world). Therefore, in Salgado's case, his social polemic, which is clearly part of Salgado's work, means that he 'has been pushed to the borders of the fine-art world'.[12] Stallabrass understands the fine-art world itself *as* this unfortunate border, and thinks that good photography has been washed up there, separated from the historical traditions of Cartier-Bresson, Capa and 'Chim', shipwrecked by the rightward lurch in Western mass media in the 1980s. Photography with a sense of a pressing need for social change and with a documentary or activist agenda then ends up in the art gallery by default, as a second-best outlet for its impact. Being in an art gallery changes its sense of audience, its urgency and its aesthetic practice. And for Stallabrass this is, largely, lamentable.

The story may not be quite so simple. Stallabrass himself suggests that there is photojournalism and then there is documentary photography and that the two overlap but are not the same. Much Northern Irish fine-art photography grew out of, or existed alongside, a much more participatory and engaged form of photography, while the art-documentary photographic work which began to be produced in and about Northern Ireland in the early 1980s was spurred by a new, global aesthetic in photography, embodied most prominently in the work exhibited under the title *New Topographics* in the USA in 1975.[13] This exhibition brought together the work of Robert Adams, Lewis Baltz, the Bechers and Stephen Shore, amongst others, and its elevation of commonplace landscapes to gallery walls was an important model for young photographers in the 1980s, revivifying documentary, liberating it through a 'powerfully revelatory' scepticism about 'signs of an illusory reality'.[14] Alongside this work was the phenomenon of the colour images of William Eggleston, the remnants and rediscovery of the German New Objectivity, and the general acceptance of photographic documentary as worthy of exhibition space. The prominence of the ordinary in such photography, and its European and American antecedents, allowed Northern Irish photographers a way into aesthetic modes which could begin to make sense of the chaos of the Troubles.

These are very particular photographic traditions upon which to draw. They may look like they are 'rejecting' photojournalism, but they are also notably not taking up other possible lines of influence. It is difficult to find, in Northern Irish photography in the 1980s or '90s, imitators of the intense confessional work of Nan Goldin, or the playful identity adoption of Cindy Sherman, or the stretching of the real which occurs in Diane Arbus's work, for example. And these names, all of them arguably influential in other areas of Irish and Northern Irish art, should alert us to the fact that the photographers discussed in this book are predominantly male, at least until more recent years. This might also suggest that the issues implicitly and explicitly figured in Arbus's, Goldin's and Sherman's work were not quite ripe for transposition into the context of Northern Irish photography – at least, not if the context of Northern Ireland was taken to be dictated by the 'national' question, by politics on a public, identitarian scale. Goldin's politics, as with Arbus's and Sherman's, are 'personal' in the sense that they revolve around sexuality, autobiography and private mythologies made public. The influence of this type of art photography can be seen occasionally, of course, but the ways of seeing epitomized by, for example, the *New Topographics* (1975), or Robert Frank's *The Americans* (1958), or Szarkwoksi's *The Photographer's Eye* (1964), come, in the context of Northern Irish photography, to dominate and, therefore, to set the terms of the debate.

<center>★</center>

This book traces some of the patterns which can be discerned in photography in Northern Ireland over the last thirty years or so. It starts with the early years of the Troubles, and the way in which the events of those times, and the photographic/documentary assumptions which underlay reporting of the Troubles, might help to explain not so much the origins of art-documentary photography in Northern Ireland, but rather the preoccupations which dominated photographic practices when they looked at the North during the Troubles. Here reportage, personal experience and the difficulty of taking or not taking 'sides' are crucial. A subgenre of this period, the city as the subject of photography, is discussed in Chapter Two – the urban is a compact manifestation of how Northern Ireland became a sectarian space, delimited and curtailed. Those sectarian–geographical divisions which criss-cross Belfast, Derry, Portadown and other urbanized areas of the North also become concentrated and compounded along the border, that line on the ground which defines 'Northern Ireland'. The intensity of the politics of the border have produced their own kind of photographic responses, from the ominously militaristic to the parodic, and those considerations of the border form Chapter Three.

I began writing about photography in Northern Ireland because of a very specific conviction that I had around the turn of the millennium, and that was that Northern Irish writing, which had always been my primary academic interest, was unable to register the changes which were taking place in the North in the wake of the Downing Street Declaration, the IRA ceasefires and then the Good Friday Agreement. My diagnosis was simple and, in retrospect, completely wrong. What I thought was that the Troubles had worn a conceptual and ideological path which Northern Irish writing (poetry, novels and drama) had difficulty leaving. This path was defined by an elevated, intelligent, refined form of liberalism, a middle ground that disavowed sectarianism and looked towards a 'shared' future (or a shared past). It seemed to me that

Northern Irish writing (with a few exceptions) was not able to meet the challenge of the Peace Process because, in the end, sectarianism had won out in the Good Friday Agreement, an Agreement which gave up on the insistence on reaching a shared vision and instead managed the acrimony of Northern Ireland through contingent political structures. This had profound and immediate legacies – for example, the history of the previous decades became awkward to talk about in a delicately balanced peace. Meanwhile, the need to keep the peace just because it was peaceful and the necessity to create an economics rather than a politics of the future seemed to be the only common ground produced by the Good Friday Agreement. I thought Northern Irish writing was largely being made quietistic by the Peace Process. This wasn't the best analysis of literary history I've ever come up with. Northern Irish writing has indeed broached and been formed by these very issues since 1998. But my impatience with the literary did lead me to look at how photography was placed to deal with the same concerns, and it seemed to me then, and still does now, that photography in the North had cumulatively acquired the capacity to see the ghosts of the past in the present and to critique the state of the peace in ways which are unique, subtle and profound. In Chapter Four I discuss how photography in Northern Ireland has seen the Peace Process and its aftermaths.

Photographs have always gathered themselves together, as if for strength in numbers. Photography has a long history of existing in or being used as an archive, a collection of images which seems to embody knowledge about a subject. Such aspirations to the comprehensive are both an impulse within the 'science' of photography and a desire which it is impossible to fulfil. Photography's seeming gift for the encapsulation of experience means that it is irresistible to those who feel that history is happening without being duly recorded, or is slipping away without proper acknowledgement. This archival craving has led to photographic projects which document the North in various ways, from the ordinariness of everyday life during the Troubles to the time of the Peace Process when history seems to wish to shuffle all of its Northern Irish contents into a filing cabinet. Chapter Five discusses the archival as a feature of photography in Northern Ireland.

Many of the photographers discussed in this book have established global reputations for their work. To label any or all of them as Northern Irish could easily be seen as narrow-minded and limiting, though many of those who now work outside Northern Ireland take some of the original inspiration for their work from the experience of photographing the North. The final chapter of this book looks at work by some of the photographers discussed in earlier chapters, and sees them take their cameras to places outside of the North. At times these outbound journeys have led to images drawing on a style and aesthetics of camerawork which may have a grounding in Northern Ireland, whether that be in terms of the photographing of conflict, or the threat of urban violence, or the processes of historical rupture and change. The broad church of photographers who constitute any attempt to describe 'Northern Irish photography' includes those whose nationality might be, for example, Irish or German, as well as those who have that awkward nomenclature 'Northern Irish'. But tentatively it might be suggested that there has been established something of a core of practitioners working in the North in recent decades. The thriving photography scene, especially in Belfast around the University of Ulster and the Belfast Exposed Gallery, has given institutional structure to this 'school'. But where there is the genesis of consensus in

photography there is, as with any properly radical political movement, the early hint of new dissenting modes emerging, both within and from outside the centres of power. This book ends by turning towards emergent photographers in Northern Ireland to see how their work points to the future.

We like to think of photography, when it is associated with a place, as giving us a flavour, maybe even an essence, of that place. Sometimes we even wish that photography would delineate that place exactly and show it as it really is. But photography does not do this. It can't. No representation of a place, or a people, or one person or thing, *is* that thing, person or place. Even a map, done with exactitude and care, is not really 'like' the place that it wants to depict. Back in 1894 the archaeologist Lavens Ewart wrote a long article listing all known maps of Belfast.[15] He finished his survey by discussing a map from 1864, published by Marcus Ward & Co., the foremost fine-art book and literary printers in the city at the time. Ewart noted how excellent Ward's map was. Ward's had derived their map from the Ordnance Survey's original, and augmented it with a bird's-eye view of the city and the city crest. Ewart noted, however, that the map that Ward's produced is actually a photograph of an original map, and moreover that it is a reduced photograph. So the inch: mile scale, he politely points out, is now completely wrong. The photograph has skewed the precision of the map. And this is what happens with photography. It takes a thing that is there and represents it faithfully but, in doing so, photography's processes and technologies distort the original. This out-of-scaleness, the accident which disturbs the otherwise wonderful Ward map of Belfast, is the enigma of photography and it is what makes the wealth of photography which has built up in Northern Ireland in recent years so fascinating and so valuable. It is the *incapacity* of photography, not its ability to produce a 'detailed inventory'[16] or to prove anything, which makes it so powerful an art form, and makes it worth looking at.

1   Susan Sontag, 'War and Photography' in Nicholas Owen (ed.), *Human Rights, Human Wrongs* (Oxford: Oxford University Press, 2003), p. 273.

2   John Whyte, *Interpreting Northern Ireland* (Oxford: Clarendon, 1990), p. 248.

3   Mary Price, *The Photograph: A Strange, Confined Space* (Stanford: Stanford University Press, 1994), p. 177.

4   See Yi-Fu Tuan, *Space and Place: The Perspective of Experience* (Minneapolis: University of Minnesota Press, 2001 [1977]).

5   www.source.ie/issues/issues0120/issue17/is17artaltpro.html

6   David Miller, *Don't Mention the War: Northern Ireland, Propaganda and the Media* (London: Pluto, 1994), p. 12.

7   There is another image by McIntryre, accompanying this one: 'Untitled (after Caspar David Friedrich) II' (2002).

8   Dale Jacquette in 'Untitled', *Philosophy and Literature*, 19: 1 (1995), 102-105 comically deals with the problem of having to give a title to a genuinely untitled piece of art or writing, given that 'Untitled' now has a meaning in and of itself.

9   Ruth Ronen, *Aesthetics of Anxiety* (New York: SUNY, 2009), p. 109.

10  On Luke see, most recently, Joseph McBrinn, *Northern Rhythm: The Art of John Luke (1906-1975)* (Belfast: National Museums Northern Ireland, 2012).

11  Julian Stallabrass, 'Sebastião Salgado and Fine Art Photojournalism', *New Left Review*, 223 (1997), 131-161.

12  Stallabrass, 'Sebastião Salgado and Fine Art Photojournalism', 134.

13  See the reprinted and revamped version of the original exhibition catalogue, Robert Adams et al., *New Topographics* (Centre for Creative Photography/ Eastman House/Steidl: Tuscon/New York/Göttingen, 2010).

14  Britt Salvesen, 'New Topographics' in *New Topographics*, p. 21.

15  Lavens M. Ewart, 'Belfast Maps', *Ulster Journal of Archaeology*, 1: 1 (1894), 62-69.

16  'There were no photographs, no detailed inventory and no detail ...': Ian Paisley, Statement by Ian Paisley, then leader of the Democratic Unionist Party, on the Decommissioning of Weapons by the IRA (26 September 2005): http://cain.ulst.ac.uk/issues/politics/docs/dup/ip260905.htm

# Chapter One
# The Troubles: 'unreliable witnesses'

*'His hands are moving in No. 11 and I think he died as I took 13 and 14.'*
Gilles Peress, written evidence to Widgery.[1]

*'I present photographs as unreliable witnesses.'*
Willie Doherty[2]

When Gilles Peress gave his evidence to the Widgery Inquiry into Bloody Sunday in 1972 he was meticulous, patient and detailed. In the devastating detail quoted above we hear witness of, or rather we poignantly and precisely miss, the awful death of Patrick Doherty. Peress's evidence was later to be quoted in a re-examination by Lord Saville's *Report of the Bloody Sunday Inquiry*, which was published in 2010. In the testimony quoted in the *Saville Report*, Peress notes that frame 12 on his roll, the one not referred to above, was taken when he turned his camera 'in another direction along the building on my right'.[3] Saville's use of the photographic evidence gathered on Bloody Sunday by Peress, Fulvio Grimaldi and other photographers was, not surprisingly, much more respectful than how the Widgery Inquiry viewed media testimony. The *Saville Report* reproduces successions of photographic frames in an attempt to minutely piece together the evidence which they might reveal. The *Saville Report* annotates photographs, considers their sequencing, and considers what is not there, as well as what is. The *Saville Report* also positions not only those in the photographs, but the photographer at the moment of taking the image, so that the photographers become privileged witnesses to murder, x-marked on their own spots.

The *Saville Report* may be, in a way which is incidental to its real purposes, one of the most forensic critiques of photojournalism ever undertaken. It stretches the possibilities of photojournalism as knowledge, and it recognizes the active (as opposed to passive or invisible) nature of the photographer in a moment of conflict and war. Saville collected 13 volumes of photographs as evidence. The Inquiry pursued the fate of individual photographs. Eamonn Melaugh, for example, an amateur photographer and civil rights activist, handed some of his photographs to a *Time Out* journalist and never saw them again. The Inquiry tried to trace these images. Saville considered the fate some of Ciaran Donnelly's

Bloody Sunday photographs, lost in a flood in the *Irish Times* offices.[4] Summarising its collection of photographic evidence, the *Saville Report* notes that it

> found many photographs to be of great value in seeking to ascertain what happened on Bloody Sunday. However, we have nothing that suggests to us that photographs taken by these people that we have not seen, would have added materially to our knowledge of the events of central importance.[5]

Looking back at Bloody Sunday the *Saville Report* incidentally revealed the wealth of still images by which Northern Ireland was understood and catalogued at the beginning of the Troubles. Northern Irish art photography in the 1980s had to find a space for itself in this visual milieu, in which the camera as a mechanism of public record was integral to reportage. The intense media coverage of the events which became the confusion of Bloody Sunday was a culmination of not only local and national but international coverage of Northern Ireland in the late '60s and early '70s. And newspaper, magazine and television reporting on Northern Ireland in the 1970s had settled into patterns which were stubbornly conditioned by conflict photography more generally. Many of the photographers who worked as press reporters in Northern Ireland travelled the war zones of the world and inevitably brought with them a way of seeing which sacrificed its capacity for local empathy to the necessity to produce good copy. Where *Saville* retrospectively turned the press photograph into a meticulously reconstructed piece of evidence in an investigator's narrative, art photography was as unconvinced as Saville about the truth-telling certainties of photojournalism, if more in thrall to what it promised and how its pledges might be stretched to convey a different kind of truth and be, more honestly, an 'unreliable witness'.

Abbas's 'Belfast', of 1972, is in many ways a symptomatic agency photograph of the period. Abbas worked with Magnum and in that sense was beholden to its ethos: to chronicle with vision (and to sell that vision to the print media). Abbas's 'Belfast', this near-moving image of a falling building, is at once utterly 'true' and 'made' at the same time. It shows the damage being done to the urban fabric of Belfast by the IRA bombing campaign. It conveys real information and does so with a distinctly Magnum atmospheric. Yet Abbas's 'Belfast' is unsatisfactory. That all-encompassing title, which it has come to be known by, illustrates the problem. It implies that at the time at which this image was taken, this is what Belfast was. A falling wall and a tragic spectacle. As a photojournalistic image this has to ignore the rest of the city and the aftermath of the event. It also ignores the politics of the event, since that is not required of it as an image, and it replaces the politics which made the event with the spectacularity of the event.

Abbas's 'Belfast' is exaggeratedly typical of another problem with documentary and media-based photography which niggles away at some of the indigenous photographers who began to work in Northern Ireland in the late 1970s and early 1980s. 'Belfast' is a well-made image. It sees the world by means of a signature methodology of Magnum. For John Szarkowski, in his vastly influential exhibition and book, *The Photographer's Eye* (1964/1966), the 'good' photograph became a 'picture' at what Cartier-Bresson famously called the 'decisive moment'. In the section of *The Photographer's Eye* entitled 'Time' one of the images by

22

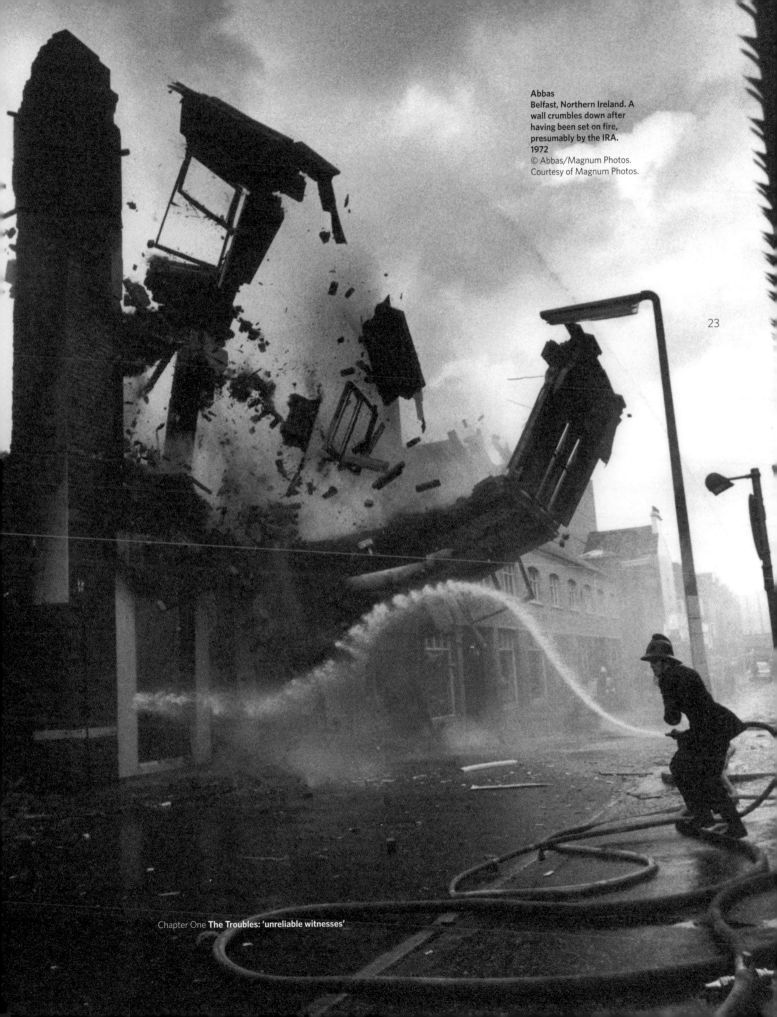

23

Chapter One **The Troubles: 'unreliable witnesses'**

Cartier-Bresson which Szarkowski includes is 'Children Playing in Ruins, Seville, Spain, 1933'. This is, though the context of *The Photographer's Eye* does not acknowledge it, a war photograph. It is also an image which was worked at by Cartier-Bresson, one of a series which was whittled down to this last, because it best fitted his urge for symmetries of geometry, for 'coincidence of line'.[6] Cartier-Bresson was one of the founders of Magnum and the aesthetic of neatness, of 'balance and clarity and order',[7] as Szarkowski calls it, carries over into the complex heritage of Magnum. Abbas's image, with its snaking, falling building, echoed in the curls of the fireman's hose and the curve of water, its pathos of human frailty in the nervous, absorbed fireman, and, above all, its drama of the unrecapturable moment, is entirely in the tradition of Magnum and of Cartier-Bresson.

This is a way of looking that is very close to that of much art-documentary work in Northern Ireland. But the anxieties which an image such as Abbas's provokes mark the point at which the differentiation from photojournalism begins. Magnum's work is at the most thoughtful and complex end of the photo-journalistic spectrum (and has, since the 1970s, and, specifically in the North, through Donovan Wylie, in turn absorbed the modes of art-documentary photography). Nevertheless, distrust of such a neat photographic summary of a political situation is one root cause of work which seeks to represent Northern Ireland more fully, if not more 'truthfully'. Indeed the approach of the Saville Inquiry is, retrospectively, instructive in its awareness that photographs are half-truths and partial evidence only, and that what is missed by the camera may be read into the image which it seizes.

One logical way in which to counter the predisposition of mainstream photojournalism was to assume that its methods were not the cause of its inability to render the North truthfully, but that its politics were. That is, there was a strand of photographic practice in Northern Ireland in the first decades of the Troubles which was entirely convinced that photography could access the truth of life in the North but that corporate photojournalism was necessarily on the side of the establishment narrative.

A landmark event in the history of photography in Northern Ireland was the publication of a special issue of *Camerawork* on 'Reporting on Northern Ireland' in 1979. *Camerawork* was, at the time, in the vanguard of left-wing theory and practice as it worked its way through a burgeoning consciousness about the possibilities of photography. In a wider context, *Camerawork* can be seen as part of a Marxist intellectual movement devoted to the study of culture in Britain and framed by the cultural studies movement in the polytechnics and forward-thinking universities. Sociologically-inclined and indirectly informed by Gramscian and Althusserian Marxism, *Camerawork* had its origins in the Half Moon Photography Workshop, which in turn originated in the radical theatre group at the Half Moon Theatre.[8] *Camerawork*'s special issue on Northern Ireland is primarily intended to throw a light on the discourse and politics of the press. In this way, and like many British Marxist interventions in the Troubles in the 1970s and 1980s, it seems more interested in lambasting the British establishment than it does in Northern Ireland itself. The major photographic presence in the special issue is Chris Steele-Perkins. Steele-Perkins was to join Magnum in the same year as the *Camerawork* special issue was published, and his images in 'Reporting on Northern Ireland', under the title 'Catholic West Belfast', show him working

at the point at which leftist radicalism and the demands of a Magnum photographer meet, with a keen sense of being on the side of both human interest (which tends towards generalities of empathy) and a specific left-wing viewpoint. Steele-Perkins's 'Catholic West Belfast' is an act of uncovering, a reminder to British viewers (especially those of a leftist bent) that the situation in Northern Ireland is a British problem. The images in 'Catholic West Belfast' mix riots with an anthropology of poverty and dereliction, and use pathos, empathy and shock for impact. Standing alone as relatively typical photo-documentary images, Steele-Perkins's 'Catholic West Belfast' photographs are stitched in to the politics of *Camerawork* by supplementary texts. The leading image in Steele-Perkins's section of the magazine is a riot scene, an action shot which could stand as a model of press photography at the time (though the angle of the shot places the photographer closer to the rioters' side than the police's). Underneath the image the text tells us that 'Rioting is the familiar image of Northern Ireland' – a self-reflexive recognition that the photograph itself tells us nothing new. The text goes on: 'This is not simply another random act of violence. It is happening because the British Army and RUC are seen by many Catholics as the strong-arm of the social and economic repression they experience in housing, employment, law and basic human rights.'[9] This was written by Steele-Perkins himself and its re-directing of the photograph stresses the passion of his commitment to the place he is photographing. It also reveals the potential shortcoming of such images, since in these comments there is an anxious knowledge that, left to themselves, they may not tell the story that he wants them to tell. Steele-Perkins's image of a riot needs this verbal supplement because it looks pretty much like other press images of riots and this suggests, not a deficiency on Steele-Perkins's part, but the difficulty of inserting committed politics into the wave of media imagery which washed over Northern Ireland in those times.

Steele-Perkins's words and images are clearly aimed at a British leftist audience, and the polemic contained within them is trying to cement the notion that the Troubles are a class war – hence the stress on employment and housing, echoing one aspect of the Civil Rights Movement at the beginning of the Troubles. To further emphasize this analysis this special issue of *Camerawork* gives it centre pages over to a feature on 'Pictures from Protestant Ulster', with photographs by Bo Bojesen and other photographers, including Buzz Logan. In the midst of this sequence is an image by Neil Goldstein of a family group, including two smartly dressed young boys waving mini Union flags and with the explanation: 'Happy and loyal: the Protestant middle classes are least affected by the troubles'.[10] The stress here is on class solidarity and the commonality of the experiences of the working classes across the sectarian divide. Laudable as this aim is, it suggests again that the photographic and editorial eye which views the North here has decided to see what it was always going to see.

Writing in 1983 the critic Belinda Loftus examined what she saw as the failings of *Camerawork*'s special issue on the North. Loftus rehearses the arguments about press photography in Northern Ireland and its clichéd representation of the conflict. She also goes further, criticizing photographers such as Don McCullin and even those who work for left-wing publications, such as Philip Jones Griffiths and Clive Limpkin. The basis of Loftus's argument is that such photographers (and artists) '[whatever] their form of employment and their political stance, [do] a quick in-and-out job, looking for good, in other words[,]

Chris Steele-Perkins
'Catholic West Belfast', published in *Camerawork* 14:
Reporting on Northern Ireland
(Half Moon Photography Workshop).
1979
Scanned image.
© Camerawork.

26

**4**

# CATHOLIC WEST BELFAST
Pictures and captions
Chris Steele-Perkins

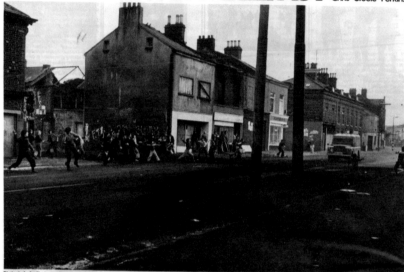

Rioting is the familiar image of Northern Ireland – here a Royal Ulster Constabulary Landrover is stoned on the Falls Road in Catholic West Belfast. This is not simply another act of random violence. It is happening because the British Army and RUC are seen by many Catholics as the strong-arm of the social and economic repression they experience in housing, employment, law and basic human rights. The occasion for the incident is the anniversary of the British policy of internment without trial (August 9). Although this policy is no longer in effect, its memory is lasting and bitter.

The Catholic sense of community is strong; here kids dance at a 12 hour marathon disco to raise money to improve their community centre.

Chris Steele-Perkins
'Catholic West Belfast', published in *Camerawork* 14:
Reporting on Northern Ireland
(Half Moon Photography Workshop).
1979
Scanned image.
© Camerawork.

**6** <span style="float:right">CAMERAWORK</span>

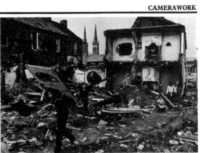

The Divis Flats tenants group has pressurised the Norther Ireland Housing Executive into recognising the inadequacies of the flats, and offering five million pounds to refurbish them. But tenants insist that the flats are so appalling that the money should be spent on building new houses in their place.

Collecting firewood from the rubble of redevelopment in the Lower Falls. Since the start of the troubles, sectarian threats and violence have caused over 60,000 mainly working-class Catholics and Protestants to move from religiously mixed areas to 'safe' ghettos. This has overstretched an already appalling housing problem. A family is still living in a house on the left.

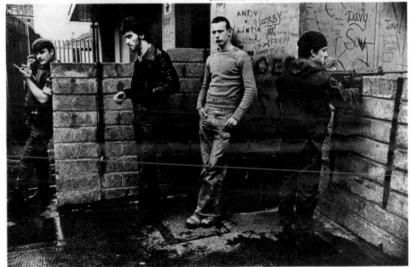

Two youths are held for an identity (P) check outside the city centre.     They are bored and resentful of a procedure which is a part of daily life for many Catholics, particularly the youths.     It is very simple for the army to abuse this security measure and employ it as a form of harassment.

Unemployed youths on a street corner, Lower Falls. Catholic unemployment is 2½ times that of Protestants, and in the ghetto areas like this, unemployment runs at about 40%.

The Youth Employment Scheme pays £20 per week and trains both sexes in manual skills. However, the fundamental problem of a massive job shortage remains unchanged. The gun is a toy. Many Catholic kids identify with the Provisional IRA who they refer to as the Army – British soldiers are simply 'Brits'. Identification will continue to change into membership so long as they feel oppressed and harassed by 'Brits'.

Chris Steele-Perkins
'Catholic West Belfast', published in *Camerawork* 14:
Reporting on Northern Ireland
(Half Moon Photography Workshop).
1979
Scanned image.
© Camerawork.

28

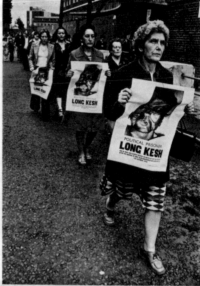

Although the Catholic Church still dominates the education of children, its spiritual presence is felt most strongly by the older generations.

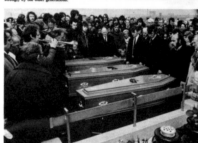

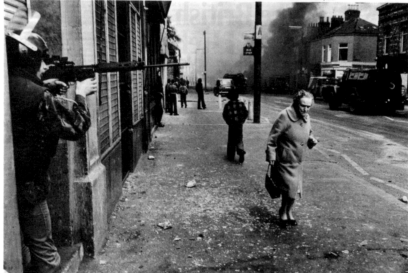

The funeral of three IRA men who were shot by the army and RUC while planting a bomb at an industrial site in Belfast. The shooting was so indiscriminate that a Protestant passer-by was also killed. Almost 19,000 people, including army and RUC, have been killed, and almost 20,000 have been injured in Northern Ireland over the last 10 years.

One of the regular marches in the Falls Road demanding political status for the Republican prisoners in H-block of Long Kesh prison. Almost 400 prisoners are naked, except for a blanket at night; living in filth and squalor, refusing to wear prison uniform or undertake cleaning duties until they are accorded political status. Some of the prisoners have been 'on the blanket' for over 2 years.

A soldier peers down his telescopic sight; in the background hijacked vehicles burn to mark the anniversary of internment.    As long as the British Government fails to take any initiative for the removal of British troops from Northern Ireland, 'solutions' will be backed by violence, and the army will be increasingly seen – both here and abroad – as an army of occupation.

Bo Bojensen, Buzz Logan, Homer Sykes,
Neil Goldstein, Bill Kirk
'Pictures from Protestant Ulster', published in *Camerawork* 14:
Reporting on Northern Ireland
(Half Moon Photography Workshop).
1979
Scanned image.
© Camerawork.

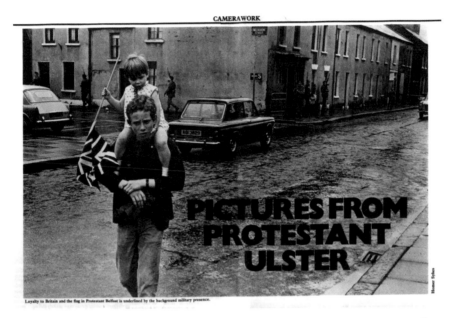

aesthetically satisfying photographs'.[11] Loftus's objection to *Camerawork* 14 is that, for all its avowed socialism, in the main it reproduces the conventions and tactics of war photography which are visible in the mainstream press. Loftus makes an exception for Steele-Perkins and Gilles Peress, and the grounds on which she praises them highlights the knife-edge on which photographic distinctions around right and true representation are made. Both Steele-Perkins and Peress meet with Loftus's approval on grounds of residency – that is, they have stayed in the North for long enough to build up 'a considerable rapport with the people there'.[12] This leads to photographs which break with 'the hackneyed conventions of war photography by returning to the personal commitment of documentary photographers of the 1930s and Second World War'.[13] The sense of Loftus's argument is easily understood. Photographers must get to know a place and its contexts before exposure. Intimacy is necessary to break the conventions of public address in daily newspapers. But this definition of 'good' documentary photography is treacherously slippery. How long and with what degree of empathy must a photographer stay in a place? How is it that Peress's sequences in the *Sunday Times* are, according to Loftus, better at conveying everyday life in Northern Ireland than the *Camerawork* special issue, which explicitly sought to do so?

Loftus's argument is tentative and important, because it sits poised at the last conceptual point at which authenticity of experience and representation are the viable basis for a judgement as to how to take photographs of the Troubles. Loftus believes in lived experience and local knowledge as a prerequisite for political understanding, and this trumps ideological commitment in her critique. A photographer can be a committed socialist but will still fall prey to the established patterns of war photography if he or she has not grasped the context of Northern Ireland. In the case of *Camerawork* this becomes even more specific. The *Camerawork* special issue begins with a timeline of Irish history derived from a slideshow lecture by the Troops Out movement. Its leftist credentials are impeccable, but, as Loftus herself notes, they are largely a form of English leftist self-laceration. Political positioning is then, for Loftus, no substitute for anthropological time spent on the ground.

Historically, Loftus's article was published at a time when Victor Sloan, for example, was beginning to create work out of a mélange of exactly the same issues. Sloan's work in the early 1980s, as we will see, circled around the press photograph as a mode of rendering the North and added to it something of the anger that is detectable in Loftus's critique of Chris Limpkin or Don McCullin. Sloan values the presence of the photographer and interrogates the tension between reporting what you know and the way in which an image, placed into circulation, becomes a stereotype drained of meaning at the point of reception. Additionally Sloan's use of his own authorship, in the seeming violence of his markings on his images, has parallels with the work that Peter Kennard did in the late 1970s, in which Kennard made political art around specific issues (such as the torture of prisoners in Northern Irish gaols) using montaged photographs. Loftus singles out Kennard for adulation and in doing so points to another troublesome aspect of what happens to photography at the point at which propaganda countered with reality spirals into a never-ending argument around authenticity. That is, when 'art' intervenes in photography as the next step in the progression of representation, a different form of aesthetics takes over, and new judgement calls have to be made. Loftus is unimpressed by Christine Spengler's *Streets of Derry* series of postcards

from 1974, but sees Kennard, despite (or perhaps because of) his left-wing 'inward-turning, incestuous English concern',[14] as being able to show real links between state violence in Britain and Ireland.

The slightly tortuous process of critical discrimination which Loftus finds herself in is explicable because of the turn towards 'art' and away from reportage which she identifies at the end of her article. Others in Northern Ireland took up the challenge of creating a community-based photography with real energy. The *Camerawork* ideal, for example, was apparent in the work of another group called Camerawork, this time in Derry. Derry Camerawork was a citizens' photography movement which wanted to show the nature of everyday life in Derry, as against the stereotypical imagery of riots which dominated media reportage of the city in the early decades of the Troubles.[15] In the Channel Four/Faction documentary *Picturing Derry* (1984), participants in the Derry Camerawork collective attest to their need to depict the lives of their community (highlighting unemployment; saying that they did not use images of the RUC or army; and noting in sophisticated terms the politics and propaganda of newspaper imagery and headlines). The impulse behind the desire to see Derry and the North as 'ordinary' quickly becomes intertwined with a sometimes reluctant, sometimes angry acknowledgement that the North is different (to the rest of Britain, the rest of Ireland, to orthodox ideals of Western society) and this makes for an assertive stance which is at once social and political, and in which the two sometimes counteract or pull against each other. Inevitably their stress on social documentary cannot keep out imagery of the Troubles. In Trisha Ziff's *Still War* (1990), a book which collects some of the work done by Derry Camerawork alongside images from 'professional' photographers, interplay of the social and the political is treated with an abrupt forthrightness:

> Some of the scenes in the photographs would not look out of place in Manchester, Liverpool or Bradford. The difference being that these streets are occupied with soldiers and the paraphernalia of war. The images are familiar and yet strange. The people similar but of a different culture. This is Ireland not Britain.[16]

The ever-decreasing political circles which the political advocacy of Loftus and Ziff finds itself in, their defensive sense of what is true and what is right being the opposite of propaganda and deliberate political ignorance or bad faith – this way of defending photography, and its logical extension in community activist photography, were under pressure from larger historical forces at the end of the 1970s and beginning of the 1980s. The critic John Roberts has argued that the period from the 1920s to the 1980s saw what he calls the 'progressive triangulation of cultural and political forces' that brought about a change in the very basis upon which documentary photography is understood and received. In this 'triangulation' there was once a belief that photography could speak the plain truth to power, that it could be a medium for counter-cultural movements at a grassroots level and that photography would provide a democratic form of access to artistic skill and expression. Roberts suggests that changes in old class structures, the effective bourgeoisification of the working classes, which intensified in the West in the years leading up to the 1980s and was cemented by the victory of Reaganomics in that decade, were the major catalysts for this process.[17] As Roberts points out, the conquest of culture by mass culture presents us with a new

32

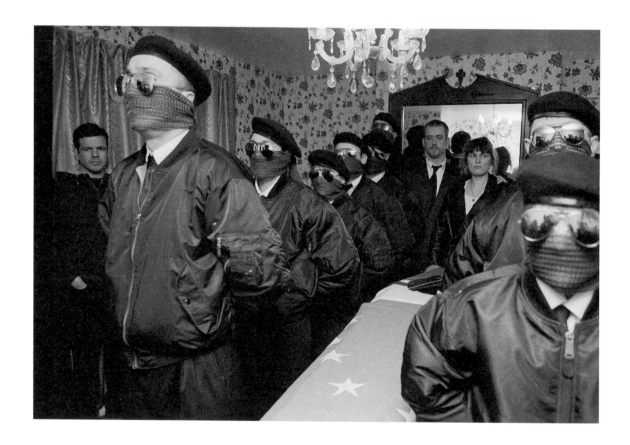

bifurcation, replaying an older one – a mass culture which desires images which are transparently what they are and nothing else, while critically-aware high culture ponders the framework of the image. The death of the potential of community activist, working-class photography which this would seem to signal might be seen as the end of photography's quest for democracy, as that energy is hived off into mass consumption for most and high-level connoisseurship for the rest. The recalcitrance of the Troubles, which has its origins in social inequality and historical injustice, snags against the modernizing tendencies of the West in these decades, but it can't resist the stream of history, and so the changes to the way in which photography functions are visible and particular. Community activism takes on specific and contested meanings and 'art' photography remains entwined with documentary while looking for intelligent ways in which to bring together, to use Roberts's terms, the documentary and the symbolic.

Willie Doherty, interviewed for *Picturing Derry* and quoted in *Still War*, perhaps takes us to another level in trying to uncover the layers of meaning in art photography in Northern Ireland, since for Doherty it is not misrepresentation as such that he identifies as the photographic experience that provokes his imagery. Misrepresentation, once identified as such, immediately asks for true representation. And this is not Doherty's dialectic. Instead, Doherty reminds us that this society was one in which watching, seeing and visually recording were so universal that they disturbed the subconscious:

> What is important is what is not shown. The things one cannot see are those that impinge most on your life … that you are being watched, and that surveillance happens continuously. You cannot photograph these things. They are not public. They are not seen. How can one photograph a psychological state that you experience daily[?] Surveillance is a condition – it happens all the time. It is like weather in winter, constantly grey. There is no break.[18]

The conviction that photography could convey, commemorate or even celebrate the truth of experience, and that in doing so it could express a kind of democracy of vision, is a belief that does not simply fade away in the years of knowing and wary scepticism after the 1970s. Much as the participants in Derry Camerawork wished to convey the reality of their lives through photo-documentary from the ground up, so Belfast Exposed (founded by Danny Burke, Sean McKernan and a loose collective of community photographers in 1983) gathered together visual experiences from across the city. It is striking in both initiatives that the activism of photography is as important as the image which is made. That is, the idea that photography is a decision and a participation in the world, especially in the pre-digital era, when a camera was not a phone. Both of these collective enterprises are reminders of the way in which taking a photograph then involved preparation and self-consciousness and thus became a moment of communal self-scrutiny. This was photography with an educative and interrogative function, and while it may have led to the reinscription of existing convictions and beliefs, to recognition of the self or identity that was perceived to be already there, it also fought against the distance and falseness of the 'failed' press photograph. For example, in the many images of funerals which are held in the Belfast Exposed archive (such as those by Sean McKernan and Mervyn Smyth) there is a quality of seeing which is often intimate

**Bill Kirk**
**Security Gates, Donegall Place**
**1983**
Black-and-white photograph.
© Bill Kirk.
Courtesy of the artist.

**Bill Kirk**
**Street Preacher, Ann Street**
**1983**
Black-and-white photograph.
© Bill Kirk.
Courtesy of the artist.

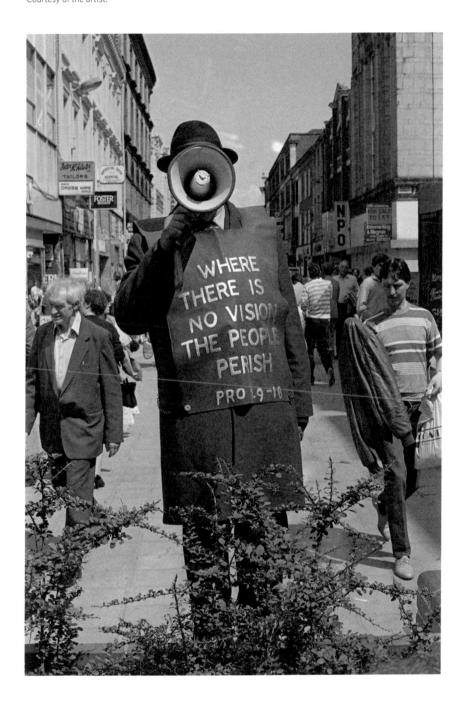

Chapter One **The Troubles: 'unreliable witnesses'**

and immediate in photographs which are clearly framed and taken in a manner different from and anathema to press photographs of the same events. Here, in the shock and despair of violence, and often its attendant state or paramilitary trappings, there is a fierce and raw vision which comes close to the spirit of pure documentary. Elsewhere the tradition of street photography, for example, was often crossed with a newsy documentary mode, as in the work of Bill Kirk and Brendan Murphy. Kirk's 'Security Gates, Donegall Place' tells a story about Belfast in the Troubles in the way that a good photo-documentary image should.

The gates are a frame within the frame of the image. There is wry comedy in the graphic of the female line and underneath the actual woman entering under the gate. And there is the nicely captured look back of the male figure, creating a gaze within a gaze in the image, and a sense of surveillance, which is really what the image is about. Kirk's 'Street Preacher' is another work in the tradition of street photography, a Doissneau/Cartier-Bressonesque tradition, which involves mild pathos. And here the irony is of the proclamation of the necessity for 'vision' from a man whose face is obscured.[19]

At around the same time the *Irish News* photographer, Brendan Murphy, was working both inside and outside the newspaper's remit on what became a very particular view of Belfast. Murphy's sense of the city is often tragic but underwritten with a strong belief in the decency of the place. The collection of his work published as a retrospective in his book *Portfolio* gives a good sense of the threads of his photography, with the grit of boxing bouts and preparations for fights interspersed with reverent portraits of Seamus Heaney or Hilary Clinton. Murphy's Troubles images have a clarity of focus on the individual in the midst of conflict.[20] 'Walking Home, Belfast 1988', for example, pictures two men, who have the appearance of father and son, with shopping bags and quizzical, worried looks on their faces, while behind them is the chaos of burning vehicles. They are very much the typical Murphy residents of Northern Ireland – with a modesty and decency which is surrounded by conflict but not blotted out by it. (The same could be said of the patrons of the Klondyke Bar in Bill Kirk's book of the same name.)[21] Murphy's image from 1997, on the verge of the Belfast Agreement, of Martin McGuinness at a press conference, has that same sense that a different Northern Ireland resides below the public and political face of the province. In Murphy's photograph a cat cleans itself in front of a serious and engaged McGuinness. McGuinness is out of focus, the cat is in focus. It's primarily amusing, but it also expresses Murphy's underlying attitude (one which developed over the course of the Troubles) and is thoroughly humane in its scope, full of the expectation that the better parts of the people will live on through the conflict. And throughout the Troubles Murphy continued to depict a 'normal' Belfast and, even more pointedly, an antiquated Belfast which persisted despite the trauma around it. 'Junk Shop' from 1978 is a documentary image which implicitly looks backwards, with 'vernacular sentimentality',[22] and sees the junk shop as a surviving island of pre-Troubles Belfast, and as the real Belfast tenaciously continuing through the unreality of the conflict.

Murphy conveys this hopefulness partly through a symbolism which is constant both in his work and that of many other press photographers, and that is the image of the child or children within the conflict zone. 'Aftermath', Murphy's 1981 image of a child standing on a burnt-out car, carries with it a silent commentary on the state of childhood in a conflict zone, and on the effects on the young of the normalization of violence.

**Brendan Murphy**
**Junk Shop – A junk shop in Divis Street, Belfast in 1978**
**1978**
Black-and-white photograph.
© Brendan Murphy.
Courtesy of the artist.

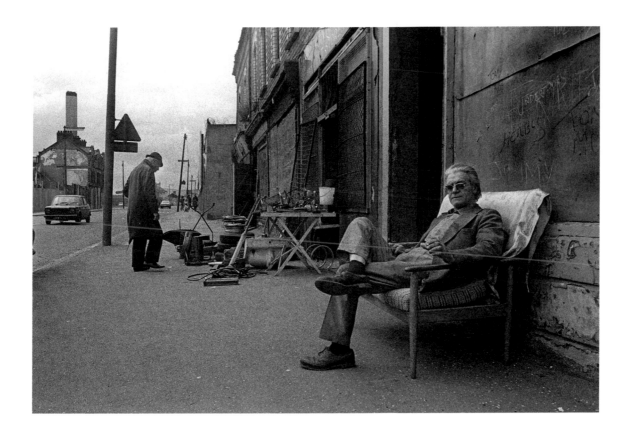

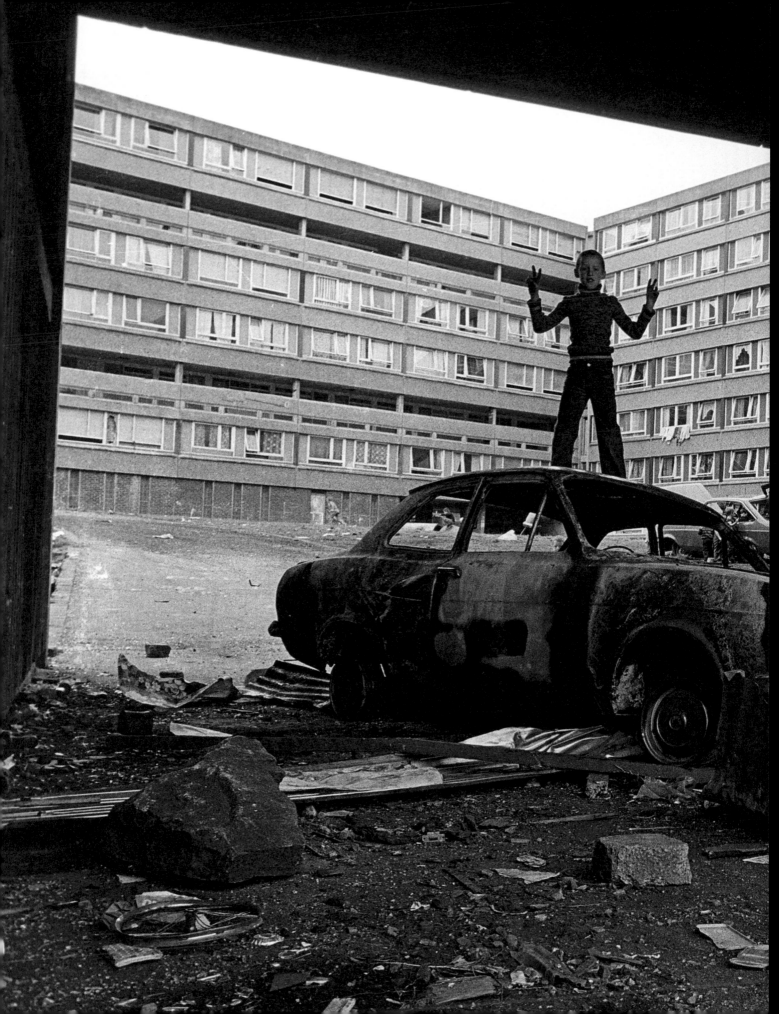

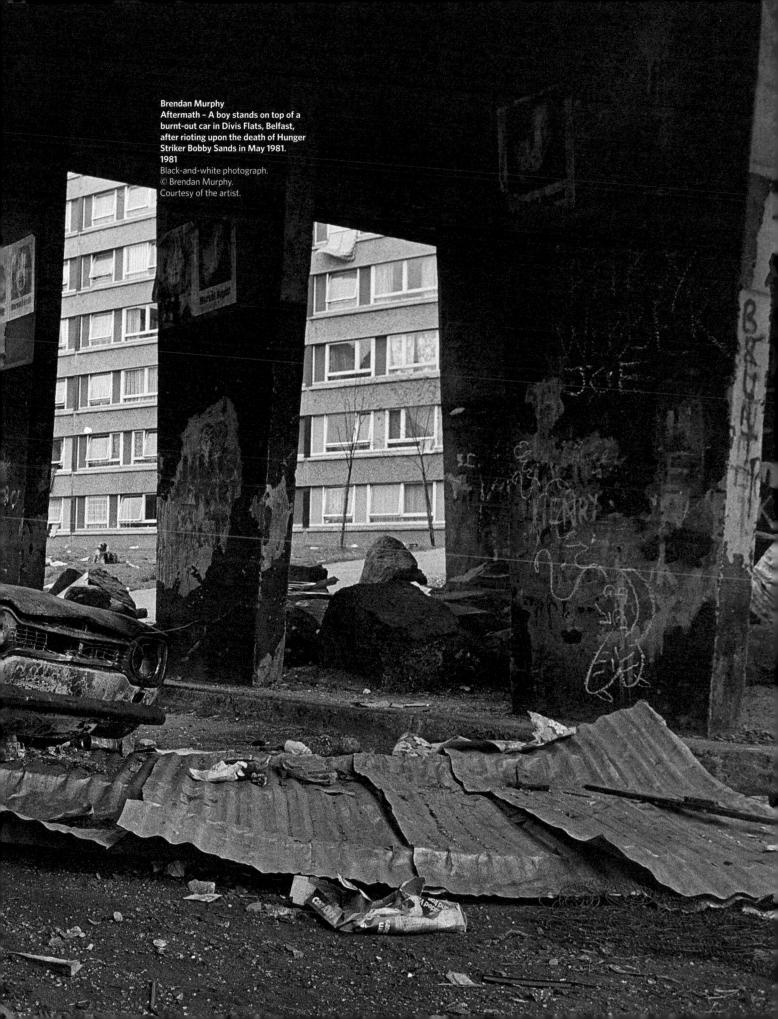

Brendan Murphy
Aftermath – A boy stands on top of a
burnt-out car in Divis Flats, Belfast,
after rioting upon the death of Hunger
Striker Bobby Sands in May 1981.
1981
Black-and-white photograph.
© Brendan Murphy.
Courtesy of the artist.

**Peter Marlow**
**Northern Ireland. Londonderry. Riots following the deaths of two Catholic teenagers who were accidentally killed by British Army troops who drove into a group of rioters hurling petrol bombs. The rioters throw rocks and petrol bombs and the police respond with plastic bullets.**
**1981**
© Peter Marlow/Magnum Photos.
Courtesy of Magnum Photos.

40

The child as the concentrated point at which the usually uncommitted (and therefore, and by default, liberal) press photographer conveniently gathers the drama of Northern Ireland is a common feature of the 1970s and 1980s. Magnum photographer Peter Marlow has visited Northern Ireland at various points over the last few decades and, while there is much variety in his work, his focus on riots, and action shots from riots, is further signed by a repeated interest in both children and masked faces – and sometimes children with masked faces. Marlow's Belfast is a place of looming figures, full of movement and the swaying of bodies throwing missiles, running, absorbed in what they are doing. Like any good photojournalist, Marlow has a style of his own, so we can see his vision of Northern Ireland reappearing in his work during race riots in London in the 1970s. This kind of international visual language of civil unrest, given a personal signature by an individual photographer, is more interesting when compared with the work of other photographers working in a similar mode. Marlow has a fascination with the masks which rioters wear. There is a useful visual shorthand here, the mask working to make the rioter typical rather than individual, representative of the story rather than someone with a peculiarity or quirk which might disrupt the shape of the news story. It is perhaps for this reason that press photography which was made on the documentary rather than newsprint end of the spectrum liked the masked rioter as a subject, and used the child in the midst of conflict as a symbol of the ways the forces of history overwhelmed the individual.

The view of Northern Ireland which is implicit in in such journalistic work is one which became typical of how the conflict was seen by the media, and probably by most of the population of Britain, Ireland and beyond. That is, that the violence was incomprehensibly internecine and tribal, and that some pre-modern forces of history were being played out anachronistically to a violent conclusion. The child, his or her innocence corrupted by conflict, provides a focus for pity, though not comprehension. Indeed it often seems as if comprehension is anathema to most press images of the Troubles. There is, though, a potentially revealing, if unconscious element to such images, because, in their masking of the individual and their fascination with the unformed adult in the child, they perhaps realize that one cause of the conflict, the very idea of 'identity', is impossible to photograph. The child or the masked adult can then stand in the place of a fuller identity, with all its historical weight, its lived experience, its horrible complexity and its uncompromising absolutism. In art photography – that which develops in parallel with and, arguably, over against press imagery – there is also a realization that identity is unphotographable without reducing it to a pre-existing simplicity. More circuitous methods of understanding the effects of identity politics in the North need to be found. Photo-documentarists solve the problem through the headline or the tagline, so that rioters, who usually just look like rioters, are given a 'side' and perhaps a context. In contrast, the art photographers who worked in Northern Ireland during these years realized that identity embodies a paradox, something which Theodor Adorno defined. Identity, he writes, '[appears] as something violent and extraneous' yet it 'has no substantial reality for humans'.[23] To photograph a mask is inadvertently to agree with this, though it is also to turn away from it at the same time. In order to see this paradox of the simultaneous reality and unreality of identity at play, different strategies are needed.

The photo-documentary mode has clear limitations everywhere in the world. In the case of Northern Ireland, as the Troubles wore on and the kinds of images made by even the better press photographers

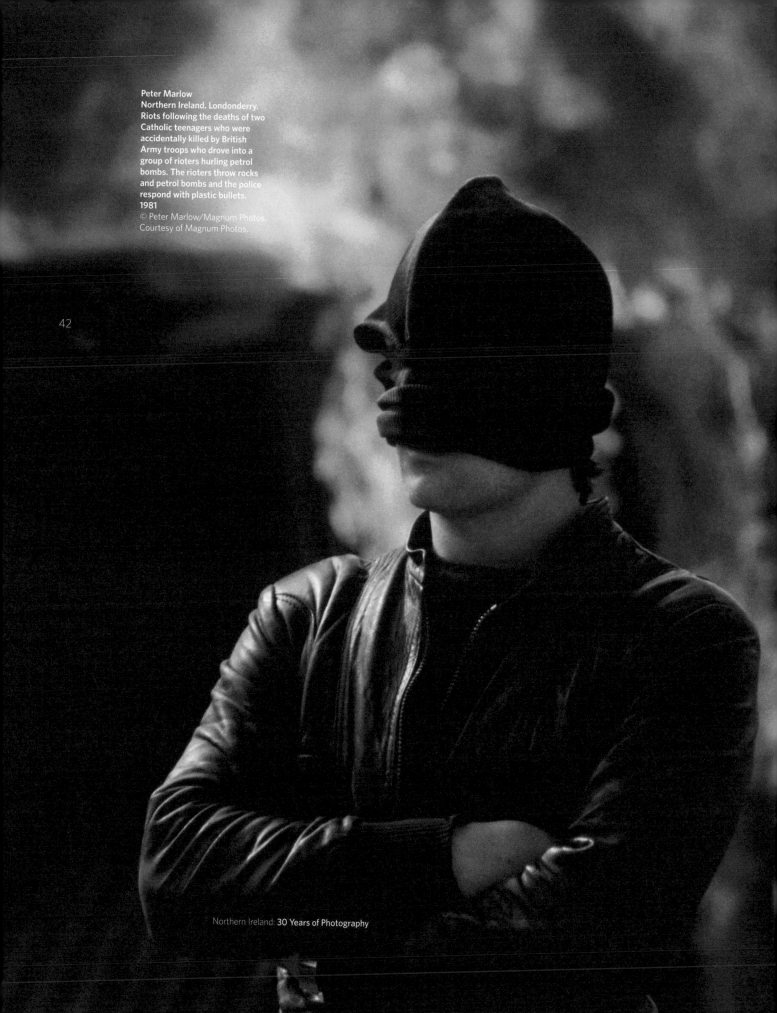

Peter Marlow
**Northern Ireland. Londonderry. Riots following the deaths of two Catholic teenagers who were accidentally killed by British Army troops who drove into a group of rioters hurling petrol bombs. The rioters throw rocks and petrol bombs and the police respond with plastic bullets. 1981**
© Peter Marlow/Magnum Photos. Courtesy of Magnum Photos.

42

shifted from post-Vietnam-influenced riot snaps to a stance of general bewilderment at the internecine smallness of the conflict, frustration with and variation upon the photojournalistic mode encouraged – and sometimes it seems as if it forced – new work to come to light. Seán Hillen, for example, began his creative career as a photographer in Newry and Belfast, accumulating a voluminous archive of images of the Troubles, most of which would fit relatively seamlessly into a photojournalist's portfolio were it not for the intensity of his curiosity and the persistence of his gaze. Hillen's early photographs are like Magnum with added participation, since they often deliberately get the angle of the camera to imitate the point of view of a marcher. Or sometimes Hillen photographs like someone who has stopped and looked at slightly the wrong thing. Hillen's early photography became revivified and of greater importance later, when he went to study art at the Slade. Here his work brought together the two localities of his life, London and Newry, in a series of photo/postcard montages which led to his later, and celebrated, *Irelantis* series. His fictional LondoNewry in effect addresses the same issue which *Camerawork* sought so earnestly to talk about – that is, is simple terms, the British presence in Northern Ireland. Hillen's merging of original photographs and postcards, however, says much more. The postcards signify tourism and living somewhere which is not home, while the original photographs might be thought of as 'authentic' versions of home. But Hillen never allows such a straightforward dichotomy to remain in place. LondoNewry is a new, fantasy world, a vision held in place by one person's life experiences. It is also a way of seeing the collapse of the personal into the public realm of history. The fantasy, the creative act of dystopian fiction which LondoNewry becomes, is a plaintive attempt to overcome the forces of history by making something new from them. Constructed from the same basic materials as Chris Steele-Perkins's photographs of 'Catholic West Belfast', 'LondoNewry' is a very different visual landscape, and an alternative thesis on the fate of the journalistic photograph in the context of the Northern Troubles. The art photography which emerges in the Troubles has, then, a close relationship both with the genre of photojournalism and, more importantly, with the conceptual issues which photojournalism finds itself facing when confronted with the North. How to be 'authentic'; how to contain and convey the fabric of lives hurled into a time of ferocity; how, or whether, to account for the reasons why the Troubles are happening – all of these nag at the photographers who begin to photograph Northern Ireland in a new way. Put simply, this mode is artistic rather than media-based. It is a photography not for sale to the newspapers, magazines or media corporations or syndications, but a photography which might end up on a gallery wall, in an art book, or with a collector – though the market for such photography was much smaller and less certain in the 1980s than it is now. Fine-art photography in the North largely continued to nod to a documentary mode, and in that it drew still on the 'newsy' element in photography, largely because its concern continued to be with history as a public event and with place as a site of the political life. It is not surprising then that some of the early pioneers in this arena produced images that were similar to those they supposedly reacted against.

An example of this visual coincidence, and the distinctions of genre and intention which arise from the comparison, can be seen by looking at three images. The first is Philip Jones Griffiths's Magnum photograph of a British soldier behind a shield, from 1973. In the full Magnum caption for this image the overblown rhetoric links the shield with 'ancient times' and notes how the plexiglass of the shield carries the marks of 'repeated blows'.[24] The stoic soldier has that look of suffering duty which marked so many

**Seán Hillen**
**LondoNewry, A Mythical Town, #3**
**1988**
From the series *LondoNewry*.
Photocollage incorporating original photograph.
19cm x 28cm.
© Seán Hillen.
Courtesy of Maeve Hall.

44

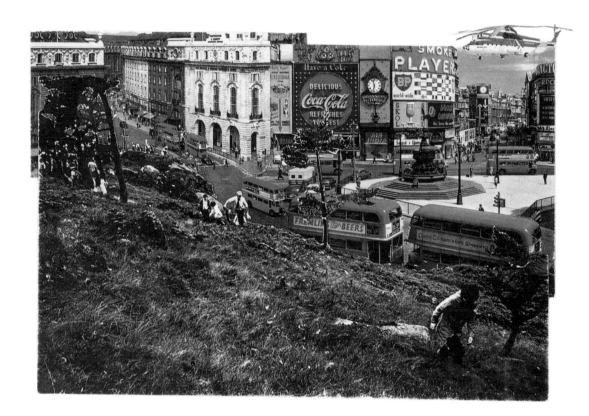

Seán Hillen
**LondoNewry, A Mythical Town, #5**
**1983**
From the series *LondoNewry*.
Photocollage incorporating original photograph.
36cm x 30cm.
© Seán Hillen.
Courtesy of Oliver Sears.

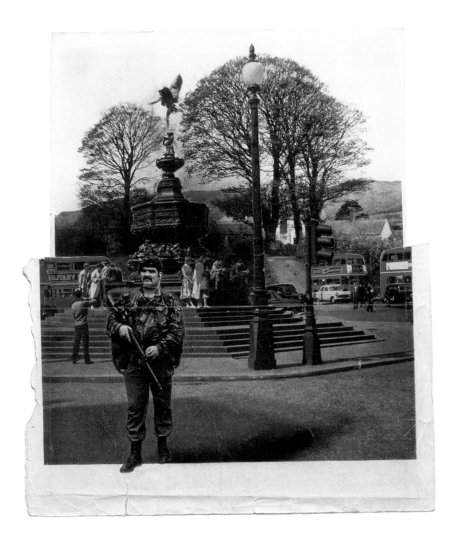

46

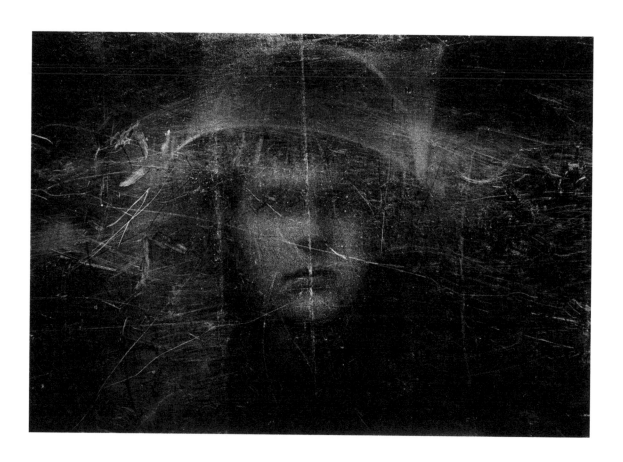

Vietnam photo-documentary works – indeed Jones Griffiths's soldier seems to be framed is such a way as to echo Don McCullin's 'Shellshocked soldier' of 1968.

The second example which helps give a shape to what emerges in art photography is a set of images which were investigated by the Saville Inquiry. Ciaran Donnelly, an *Irish Times* reporter, testified that he had given over his 'photographs' (presumably the negatives, though this is not clearly stated in the *Saville Report*) to the Widgery Inquiry. Donnelly's testimony to Saville was that some of the images were taken at the very moment at which two men were killed on the barricades. As well as considering, and rejecting, the claim that some sinister hand could be proven to have destroyed some of Donnelly's photographs, Saville also looked at whether two remaining photographs were evidence of such destruction, since they are scratched *'as though some attempt has been made to distort or destroy part of the negative in some way'*.[25] Rightly or wrongly, Saville dismissed 'sinister purpose' in the accumulation of scratches on these photographs, and we are left with images which look time-worn and as if they have been through some kind of strenuous historical process. The *Saville Report* reproduces Donnelly's photographs, but only, in effect, to show that they show nothing except their marked surfaces. And the longer we look at them the more appropriately battered by their own existence they seem to be.

Explaining the background to Victor Sloan's early work, Brian McAveara notes: 'In the North, twenty years of photojournalism and television pictures have reinforced the truism that photography lies'.[26] Sloan's response to the monocular media saturation was to intervene in the images he made, both ideologically and through his aesthetic practice, by scoring and marking his negatives and/or his prints. Sloan's images were still capable of, and often functioned by, retaining the compositional norms of the photojournalism which he was repelled by. McAvera writes: 'What Sloan offers is a complexity of response. The manipulated image is the method by which he bypasses the soiled coinage of photographic "honesty", "truth" and "authenticity"; the method by which he introduces a complex personal response into a seemingly documentary photograph'.[27] To set Sloan's 'Belfast Zoo, No. 3' beside Donnelly's recovered images and Jones Griffiths's neatly symbolic solider is to see the different paths along which superficially similar photographs are moving. Sloan plays, first of all, with allegory – that allegory which is contained in his title 'Belfast Zoo', as if the whole city, the whole society, is a containment of the wild. The chimpanzee's humanoid expression asks to be read as metaphoric, and might be taken as a comment on the way in which Northern Ireland was regarded, at that time, by some elements of the British media in a time-dishonoured tradition which assumed that Irish political violence was primitive and racially inherited.[28] But Sloan's 'Belfast Zoo, No. 3' does much more than this. Whereas Jones Griffiths's 'Soldier Behind a Shield' dares to turn reportage into significance, Sloan turns documentary photography into a potentially symbolic semantics, an image which pushes towards a meaning without allowing final meaning to accrue. And where Donnelly's photographs have, presumably accidentally, through natural wear and tear, gathered their scratches, Sloan deliberately photographs the scratches on the surface of the glass of the monkey's 'cage' (including the gouged 'IRA'). These marks of history, their venting of fury, are commented on and added to by other images in the *Belfast Zoo* series in which Sloan imitates the fingerprints and smudges on the zoo's plexiglass (that same military material which the soldier hides

behind). As Sloan's work changes and develops over the 1980s so these marks and signs of his intervention become signatures to his work, both in the sense of being distinctive of his artistic practice and also signs of individual presence; often Sloan's work in this period seems to be concerned with the way in which the patterns of political history delete the capacity for individuality, and the swirling, sometimes forcible incisions and erasures which he makes on his negative and prints are a deliberately failing rebellion against the voicelessness which the Troubles and their causes enforce.

In Sloan's art the documentary as a mode is deployed in serious mimicry, never intending to jettison 'honesty', 'truth' and 'authenticity', but refusing to assume their easy existence as consequences of the mimetic mechanism of photography itself. As such, Sloan's work takes part in the debates which animated photography criticism in the 1980s, when he was making this work. John Tagg summarises this as a debate about 'the prerequisites of realism'.[29] In the most fundamental sense an intervention into the image, such as Sloan's, creates an aesthetic disturbance which rails against a simple assumption of photographic mimesis, and provokes a recourse to situational, formal and ideological readings. W.J.T. Mitchell, coming back to this 1980s debate in the 1990s in a discussion of Victor Burgin's criticism, finds himself returning to a persistent question: 'How do we account for the stubbornness of the naïve, superstitious view of photography?'[30] The ability of the photograph to create a readable account of the world, one which passes for truth, however temporarily, is thus both a curse and restriction on photography, and the source of its contortion of artistic form. Mitchell finds some satisfaction in citing Roland Barthes, and his paradoxical notion that the photograph can be 'at once "objective" and "invested", natural and cultural'.[31] Imprecise as this is, it is a way to think about the relationship between an actual, physical and ideological world and a photography which is impassioned enough to wish to record that world, while being either angry or cautious enough to refuse to record with the fallacy of transparency. It is through trying to keep together the two poles of Barthes' 'photographic paradox' that Northern Irish photography, like many other forms of photography, begins to formulate itself, as it moves away from photojournalism.

Victor Sloan's photographic art, as the 1980s and 1990s progress, articulates a visual vocabulary which expands the scratches and explosive markings of the *Belfast Zoo* series in a variety of ways, and the options which Sloan takes along this trail show how his work thinks again and again about the boundaries of the photographic image and how that can enable a contemplation of other boundaries. In 'Car Wash, Craigavon', part of the *Moving Windows* series from 1985, Sloan's camera looks out through a car window and simultaneously sees into the rear-view mirror. The windows of the car are streaked with water, the image itself is grainy, so that clarity is aspired to (through glass and the mirror) but never achieved. The images in this series have the feel of the undercover and the furtive, as if they are hasty evidence gathered by a secretive force. The water on the window in 'Car Wash' transmogrifies into the eerily detonating window (which is lit by sunlight) in 'Shop, Dungannon'. In all the work in the series the car's interior is a framing device, and something akin to a getaway vehicle. But with its combination of the enclosed capsule of the car interior, the glass in the windows and the mirrors (the wing mirror which is visible in 'Road, Portadown', for example), the car itself has all the elements of a camera, so that as it moves and takes and makes images, we think not only of the foreboding atmospherics of the resultant photographs,

**Victor Sloan**
**Belfast Zoo III**
**1983**
Silver gelatin print, toner, oil pastel and torn paper.
25cm x 25cm.
© Victor Sloan.
Courtesy of the artist.

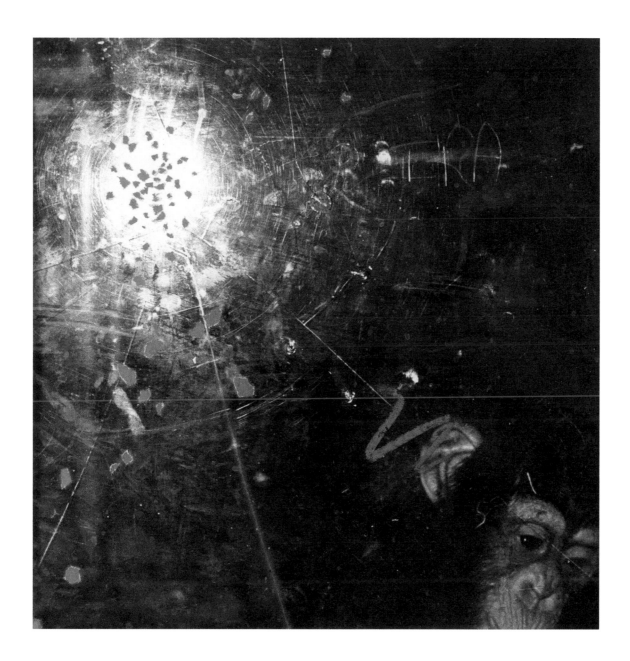

**Victor Sloan**
**Car Wash, Craigavon**
**1985**
Fro the series *Moving Windows* (1985).
Silver gelatin print, toner and gouache.
23.5çm x 23.5cm.
© Victor Sloan.
Courtesy of the artist.

50

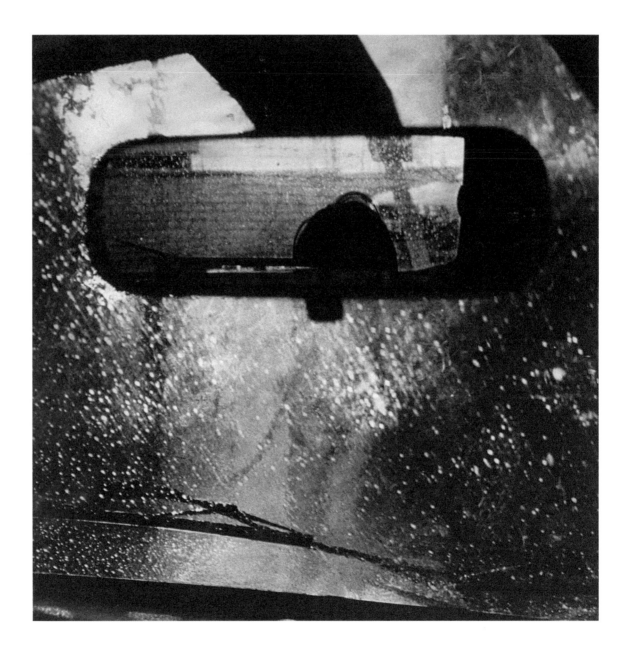

Chapter One **The Troubles: 'unreliable witnesses'**

but reflect on the fleeting nature of the camera as it scurries past moments of possible significance. Sloan's recognition here of the 'moving' nature of photography, its incapacity for settled truth and wisdom, is as important to the work as the sense that we are experiencing his Troubles locale in enigmatic glimpses.

These elements of movement, locality and the oppressive ubiquity of sectarian politics are subtly woven into Sloan's photography at this time. One of his most productive periods came around the time of the Unionist protests against the Anglo-Irish Agreement in 1985. His *Day of Action, Bangor* series catches the town in a state of inaction, with the politics happening off-stage. Bangor is then rendered as an almost sepia, out-of-synch place, with Sloan's ghostly markings swirling over the vista. These are images which seem to wish for presence and participation, but which take the opportunity of the political protest elsewhere to seize possession of the place. And it was a place which Sloan had photographed previously, and also by 'moving', in his *Promenade, Bangor* series of 1984, in which he allowed a camera to take unposed and 'random' shots of fellow promenaders.

Sloan then brings together his interests in his own inhabitation of Northern Ireland, the denotation of his presence in his interventions in the image, and the way in which one can inhabit a space by moving through it, in the various pieces he made around loyalist protests and marches in the second half of the 1980s. *Drumming*, *The Birches*, *Walls*, and *The Walk, the Platform and the Field* all increase the stakes involved in the co-existence of the photograph and the artist's manipulation of the photograph. His *Radio Telefís Éireann* from 1986 shows that underlying the work of this period is a persistent interest in the public projection of images of the North, and his other work then becomes about claims made on and about the territory of Northern Ireland, as Orangemen march to lay their presence over the ground and Sloan dares to scratch his will into the air around the marchers. 'Marching I', from *Drumming*, is typical, and has that stunning moment of caution and withdrawal, characteristic of many of the images from this period, in which Sloan leaves the head of one of the marchers almost entirely intact, his anger and frustration being brought to a halt, and being shown to be brought to a halt, at the face of the individual. Hanging over this image is the direction of movement, which is the road sign, the deadpan official directive about who goes where.

That Sloan sees the tension between a personal autobiographical narrative and a large and overwhelming political narrative as central to his work is clear enough from the photojournalism/artist's mark dichotomy which structures his work at this period. In 'Self-Portrait II' he turns that method back on himself to concentrate on the family narrative, and the personal signature markings here are made in such a way that they look like that most public of personal signatures, graffiti. Set alongside the rest of his work at this time, 'Self-Portrait II' is important because in the replication of the methodology of the other work it implies that the causes of the sometimes near-frenzied markings on the 'public' photographs can be turned inward on to the family archive. The marks in Sloan's work cut deeply.

Paul Seawright's photography, starting with his *Sectarian Murder* series in 1988, is both insistently first-hand and, like Victor Sloan's, unflinchingly involved. On initial impression Seawright's *Sectarian Murder*

**Victor Sloan**
**Self-portrait II**
**1993**
Silver gelatin print, with coloured pencils.
60cm x 50cm.
© Victor Sloan.
Courtesy of the artist.

54

is reportage after the fact. But Seawright builds in a delay in his report, so that his images have a memory which lasts longer than a news story. Seawright took a series of images of sites around Belfast where killings had taken place; most were murders from the early 1970s, while the photographs date from the late 1980s. Photographically, *Sectarian Murder* dramatizes and questions the point of view and the innate curiosity of the photographic lens.[32] The images of the Giant's Ring, for example, are typical of how Seawright uses low camera angles and an eerily lit, out-of-focus foreground, to make his photographs an act of remembrance for those whose deaths momentarily dominated these spaces – indeed Seawright's images in *Sectarian Murder* come close to a spiritual empathy with the dead. 'Tuesday 30th January 1973' (the date on which a 14-year-old Catholic boy, Philip Rafferty, was murdered) lights the ancient stones at the centre of the Giant's Ring, but they reflect back merely a significant blankness. Their position just left of the centre of the shot suggests something missing from the frame, as if it has just been vacated and has left a place unoccupied. The text accompanying the image uses anonymous media reporting. If a photograph is, as Barthes suggests, always a 'certificate of presence'[33] then this photograph exists spectrally as proof of the space taken up by the dead. The out-of-focus dog in the near foreground of 'Friday 25th May 1973' looms into the frame, which is otherwise focussed, like the other Giant's Ring image, on the stones. 'Friday 25th May 1973' takes its point of view from grass level, and again the brightly lit foreground suggests some kind of emission of light from the point at which the lens is positioned. Seawright seems to project his dead as ghosts, whose vision we take up as observer. The emptied-out victim position goes unnoticed by passers-by throughout the *Sectarian Murder* series. More importantly, Seawright makes the attempt to put himself in the place of the dead, using photographic technique (lighting, point of view) to signify their presence, allowing their spirits to haunt these spaces and the North's history.

Seawright creates an ethics of responsibility and responsivity which allows those who cannot be photographed, and whom media photography replaces continually with new victims, their disturbing presence, throwing the exactness, the centrality, the logic of the photograph out of kilter. In her classic *On Photography*, Susan Sontag wrote that the 'ethical content of photographs is fragile'; 'most photographs do not keep their emotional charge' and 'tend to be swallowed up in the general pathos of time past'. For Sontag the passage of time bleaches the ethics out of a photograph, which then assumes 'the level of art'. [34] In *Sectarian Murder* that ethical fragility is protected by the simplicity of its status as art-already. Seawright's framing, for example, whether with the dog at the Giant's Ring, or using, as Victor Sloan did, the car window ('Saturday 3rd February 1973'), is knowingly 'artistic'; it foregrounds the photographer – but it also presses the photographer into the position of the victim (or killer), and in doing this it insists that photographer and viewer have an ethical responsibility, not only to remember what happened here (for its own sake and as a way of knowing Northern Ireland), but to try to put themselves, absolutely and without protection, in this historical place.

Seawright's 'solution' to the problem of how to photograph the Troubles is a kind of empathetic positioning which sometimes visually and sometimes tangentially places the photograph in a carefully imagined proximity. In his *Orange Order* the camera becomes 'of' the crowd and the marchers, who are too close individually to fit fully into the photographic frame. We could read this as a de-individualization

**Paul Seawright**
**Tuesday 30th January 1973**
**1988**
From the series *Sectarian Murder*.
Framed C-type print with text.
75cm x 100cm.
© Paul Seawright.
Courtesy of the artist.

56

**Tuesday 30th January 1973**

'The car travelled to a deserted tourist spot known as the Giants Ring.
The 14 year old boy was made to kneel on the grass verge, his anorak
was pulled over his head, then he was shot at close range, dying instantly.'

**Paul Seawright**
**Friday 25th May 1973**
**1988**
From the series *Sectarian Murder*.
Framed C-type print with text.
75cm x 100cm.
© Paul Seawright.
Courtesy of the artist.

**Friday 25th May 1973**

'The murdered mans body was found lying at the Giants Ring
beauty spot, once used for pagan rituals. It has now become a
regular location for sectarian murder.'

**Paul Seawright**
**Belfast**
**1990**
From the series *Orange Order*.
C-type print.
101 x 101 cm.
© Paul Seawright.
Courtesy of the artist.

58

the subjects here, as if the bandsmen had become merely their uniforms and only the 'identity' which the uniform espouses. But the *Sectarian Murder* series shows that Seawright is interested in the experience of viewing these images, as when standing looking at them on a gallery wall, where, by default, we adopt the positioning which the camera imitates. The works in *Orange Order* then pull the viewer, closely and claustrophobically, into the crowd. They also implicate the photographer with the gathering of subjects in the image, rejecting the neutral, observational stance which photojournalism wishes to use. In doing this Seawright turns his own 'indigeneity', his coming from this place, into something which constitutes the focal distance and framing of the image itself.

One of the strategies of Seawright's early work during the Troubles is to use a photographic and cultural zoom effect to destabilize any potential neatness within the image, anything which might imply that it is possible to stand back and see everything in its right place in Northern Ireland (his series *Police Force* [1995] includes more examples of this technique). In contrast, Willie Doherty's early art tends to look at the North using a wide-span and often a horizontally-stretched landscape format. Doherty's work begins by being rooted in a dialectic which considers the material world, its politics, ideologies and physical substance on the one hand, and on the other the stories and possible existences which that world contains and constrains. Doherty's photographic works from the 1980s dwell on the binaries of Northern Irish politics as they play out their deadly ironies over contested land. But in these early images there is an itch of recognition of a larger field of contestation, signalled by the land itself and by a natural order of which the human is part. It is often remarked that the English artist Richard Long (who has made work in Ireland many times) looks like an influence on early Doherty, with his over-written landscape photography. Long's work very consciously includes the traversing of geography as part of the work of art, so that it is a record of a journey. Doherty's sense of the landscape of the Troubles, however, is of a place foreshortened, both geographically and politically. Doherty's photograph-and-text pieces explore the failure of 'truth' which occurs in both the image and the word. 'The Blue Skies of Ulster' caustically takes its text from Edward Carson via Ian Paisley to prick the rhetoric of unionism (and more widely the identitarian non-thinking of the Troubles). The two individual works which make up the diptych 'Stone Upon Stone', meanwhile, deal with the claustrophobia of binary thinking, and ponder the naturalization of identity into geography, as the two opposite banks of the river take on republican and unionist tinges. The visual relationship between the fluidity of the river and the hardness of the stones replicates the certainty of the capital letters and what they proclaim, but so much so that two 'truths' stand facing each other in Cold-War defiance. Doherty's 'Stone Upon Stone' could also be seen as something of a historical 'correction' to Long's sense of Irish geography – Long's 1974 trip to Ireland, for example, involved leaving a stone as a marker of his journey at every mile.[35] Doherty's image suggests that it is historical accumulation and depth, not the journey across the land, which means most and weighs most heavily in this part of Ireland. Near-mythic in their iconography, Doherty's early inscribed landscapes, as we will see again in the next chapter, carry the burden of an enormous dichotomy.

By the 1990s Doherty's work, which is one of the most substantial bodies of artistic practice to have emerged from the North in the period, had begun to move towards other ways of comprehending the

WE SHALL NEVER FORSAKE
FOR THE GREY MISTS

HE BLUE SKIES OF ULSTER

AN IRISH REPUBLIC

**Willie Doherty**
**Stone Upon Stone**
**1986**
Black-and-white photograph with text.
1 Diptych: each panel 122cm x 183cm.
© Willie Doherty.
Courtesy of the artist, the Kerlin Gallery, Dublin, Matt's Gallery, London
and Alexander and Bonin, New York.

**Willie Doherty**
**Strategy: Sever/Isolate**
**1989**
Chromogenic prints mounted on aluminum.
Diptych: each panel 121.9cm x 182.9 cm.
© Willie Doherty.
Courtesy of the artist, the Kerlin Gallery, Dublin, Matt's Gallery, London
and Alexander and Bonin, New York.

**Willie Doherty**
**Minor Incident I**
**1994**
Cibachrome photograph.
76cm x 101.5cm.
© Willie Doherty.
Courtesy of the artist, the Kerlin Gallery, Dublin, Matt's Gallery,
London and Alexander and Bonin, New York.

**Willie Doherty**
**Minor Incident II**
**1994**
Cibachrome photograph.
76cm x 101.5cm.
© Willie Doherty.
Courtesy of the artist, the Kerlin Gallery, Dublin, Matt's Gallery,
London and Alexander and Bonin, New York.

Chapter One **The Troubles: 'unreliable witnesses'**

**Willie Doherty**
**Minor Incident III**
**1996**
Cibachrome photograph.
76cm x 101.5cm.
© Willie Doherty.
Courtesy of the artist, the Kerlin Gallery, Dublin, Matt's Gallery,
London and Alexander and Bonin, New York.

**Willie Doherty**
**Minor Incident IV**
**1996**
Cibachrome photograph.
76cm x 101.5cm.
© Willie Doherty.
Courtesy of the artist, the Kerlin Gallery, Dublin, Matt's Gallery,
London and Alexander and Bonin, New York.

legacy of the Troubles and other ways of investing a photograph with the magnitude of the conflict. Always interested in surveillance, Doherty became a photographer with a flair for the forensic detail as way to imply a narrative. This technique is used in both his video work and his photography. In the *Minor Incident* photographs (from 1994 and 1996) the landscapes of Doherty's early work are contracted to a close-up in which the trace of the human on the ground implies a sinister happening. Or we read it as such, and realize that we ourselves assume that a photograph, taken in this manner, is, with its harsh and artificial light, an exhibit. Either way, these photographs work to reveal how, as with the tyre tracks on the ground or the piece of fabric which seems to be emerging from leaf and loam, our sense of the landscape of Northern Ireland is one of terror and violence imbricated with the clay and flora. The *Minor Incident* images were being made and shown at around the time at which the first public moves towards an IRA ceasefire, and when the first machinations of the Peace Process, were visible (the Downing Street Declaration came, for example, in 1993). If we look back to Doherty's earlier landscapes (such as 'Stone Upon Stone') we might think that, finally, the human emerging from the land in *Minor Incident* signals some grotesque hope for the future. However, if we look past these images to some of Doherty's more recent work, such as the *Dead Pool* series, which seems to have an almost obsessive eye, searching the bogs of Donegal for signs of human remains, it seems more viable to suggest that *Minor Incident* foretells the continual uncovering of the past (and equally constant attempts to re-bury it) which the Peace Process brought about.

The small-scale detritus of the conflict which Doherty constructs in the *Minor Incident* series is part of a larger and more general aesthetic of decrepitude which characterizes Northern Irish photography in the Troubles and post-Troubles period. Ruination and decay signal well the effects of the conflict. The blank surface and the disused space imply a story which cannot be seen. Paul Graham's work in Northern Ireland, collected as *Troubled Land* (1984–86), is one example of a restrained version of this aesthetics of landscape as foreboding detritus. The exaggerated colour of 'BEWARE' in 'Graffiti, Ballysillan Road' underscores the message which other images in *Troubled Land* convey more quietly. And that is that this is a landscape waiting for something to occur. The way in which urban materials, tarmac and concrete for example, fill the lower part of the frame in Graham's work was to become influential on later photographic accounts of the North. The blankness of much of the landscape photography in *Troubled Land* means that Graham is able to create a canvas for cultural signification on a small visual but large semantic scale, such as in 'Union Jack Flag in Tree, Co. Tyrone', in which, as with images which are interrupted by lines of sectarian colouring on kerbstones, the Troubles are signalled as being central to the banal landscapes which Graham stands back from.

One phenomenon in photographic practice in recent years has been the notion of the 'aftermath', a contemplative form of documentary which renders conflict visible by the effects it leaves behind. 'Aftermath is a phenomenon that is utterly lacking in epic qualities', as Simon Winchester puts it.[36] In photography in Northern Ireland this non-epic quality of the aftermath has had much purchase, though not necessarily through the organized collective enterprises which Winchester is involved in. However, the mode is apt. The creation of a time-lag between event and image has, in a simple sense, liberated a

**Paul Graham**
**Graffiti, Ballysillan Estate, Belfast**
**1986**
From the series *Troubled Land*.
Medium colour coupler print.
89.3cm x 127.5cm x 3cm.
© Paul Graham.
Courtesy of Wolverhampton Art Gallery.

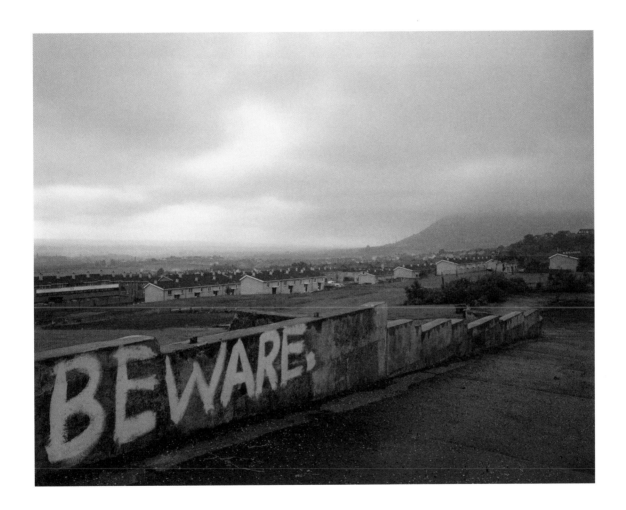

**Paul Graham**
**Union Jack Flag in Tree, Co. Tyrone**
**1986**
From the series *Troubled Land*.
Medium colour coupler print.
Dimensions 97.8cm x 115.6cm.
© Paul Graham.
Courtesy of Wolverhampton Art Gallery.

critical space in the photograph, a time for thinking as well as for looking. In the 'aftermath' of peace in the North this led to a photography which was able to subtly imagine the present while looking not just to the past but to the future. But that story comes later in this book. A more straightforward way to see the aesthetics of 'aftermath' is in Donovan Wylie's *Mid-Ulster: Abandoned Homes* series from 1999, part of a larger body of work which Wylie made during that year and which together considers the melancholy, out-of-time fate of unionism and its associated institutions (the Orange Order and the RUC) in the year after the Good Friday Agreement. The abandoned homes of Wylie's images show both displacement and emigration, and they point to an unspoken Troubles legacy. In Wylie's work the camera, that 'clock for seeing',[37] visualizes time past in a way which prompts the possibility that the past lives on. It is this very specific version of the 'aftermath' which comes to be symptomatic of the relationship between photography and Northern Ireland in the time of the Peace Process.

There have, also, been more direct documentary-photographic re-emergences in the years since the end of the Troubles. Most notably, the combatants who were once least likely to have taken part in 'representing' Northern Ireland (but who were part of the body which surveyed the province most acutely) have made public their archives of images and placed them within the context of 'art photography'. Craig Ames trained to become an 'evidence photographer' with the British Army. His work has looked at the legacies of recent wars which the British Army has been involved in – specifically Iraq and Afghanistan. Photographs which he took in a less studied way while on active service in Northern Ireland in 1991 have become part of his *oeuvre*, and they are characterized by an immediacy and a soldier's eye-view which would once have been kept within the confines of the army's archive. Similarly Stuart Griffiths's photographs of his time with the Paras in Northern Ireland have a desire to make sense of the army life that they reveal, and to understand whether it is deadly or comic, ironic or fated. As with Ames's work, Griffiths's on-service army photographs were published as a kind of genealogy of his later work, as if his army experiences and his training in Northern Ireland are what lie behind the photographs he now takes. The opening which Griffiths gives us into this closed world retains its esoteric nature for the outsider: a world of men inside an institution in which the mystery for us in looking at them is in how to understand the degrees to which they give themselves over to the job, and whether we should see their signs of individuality as expressed within or against the army and its ways. Photography's existence inside the contemporary 'art world' means self-consciousness is an assumed default position, especially for the apparently documentary – as if the actually documentary, the personal record, is impossible. Griffiths's and Ames's army photographs, taken in a world under pressure, and of men under threat, represent a challenge to the complacency of knowingness with which we regard the politics of art photography. These 'straight' documentary images from personal archives remind us of the existence of a vast set of experiences, images and, presumably, photographs of the Troubles which will stay forever private and secret.

The ending of the Troubles brought about a different kind of photographic work in Northern Ireland. Much of this drew on the lines of thought and influence established by photographers who worked during the 1980s and 1990s, and, of course, those photographers continued to work, adapt and develop their own ways of seeing. One photographic after-effect of the Troubles has been an occasional, potentially

74

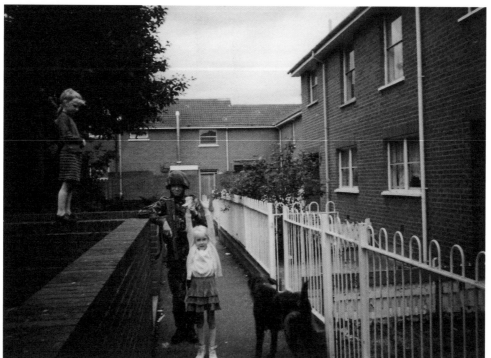

Craig Ames
**On standby in soldiers' accommodation block, North Howard Street Mill**
**1991**
From the series *Tour Photographs*.
© Craig Ames.
Courtesy of the artist.

Craig Ames
**Using children from a nationalist estate as human shields, near Divis Tower**
**1991**
From the series *Tour Photographs*.
© Craig Ames.
Courtesy of the artist.

Craig Ames
**View from Top Sanger of the 'peace-line' and army base's security measures, North Howard Street Mill.**
**1991**
From the series *Tour Photographs*.
© Craig Ames.
Courtesy of the artist.

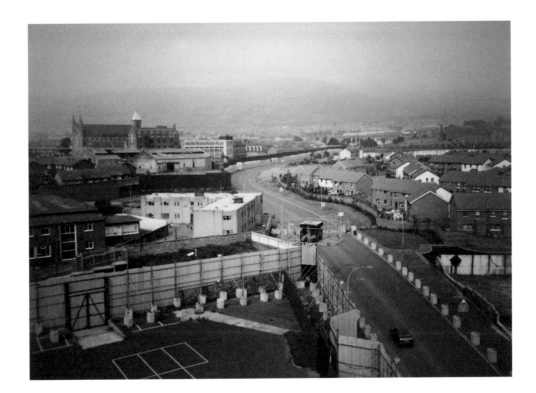

Chapter One **The Troubles: 'unreliable witnesses'**

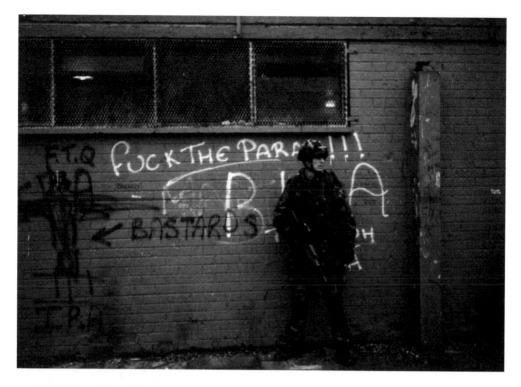

76

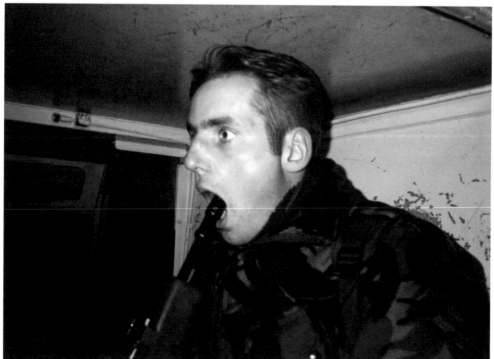

**Stuart Griffiths**
**Fuck The Paras**
**1991**
From the series *The Myth of the Airborne Warrior*.
Digital drum scan from 35mm colour negative.
© Stuart Griffiths.
Courtesy of the Artist.

**Stuart Griffiths**
**Loaded SA80 Rifle**
**1991**
From the series *The Myth of the Airborne Warrior*
Digital drum scan from 35mm colour negative.
© Stuart Griffiths.
Courtesy of the Artist.

**Stuart Griffiths**
**Foot Patrol**
**1991**
From the series *The Myth of the Airborne Warrior*.
Digital drum scan from 35mm colour negative.
© Stuart Griffiths.
Courtesy of the Artist.

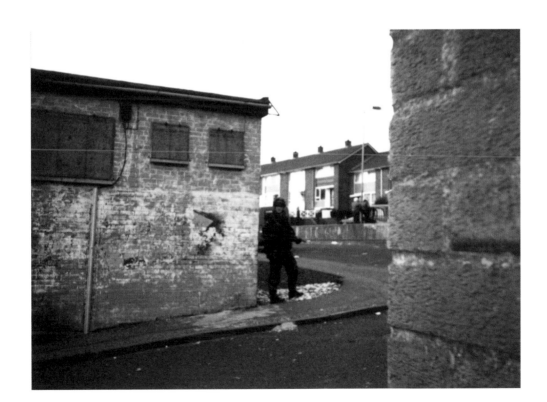

Chapter One **The Troubles: 'unreliable witnesses'**

**Donovan Wylie**
**Mid-Ulster. Abandoned home**
**1999**
© Donovan Wylie/Magnum Photos.
Courtesy of Magnum Photos.

78

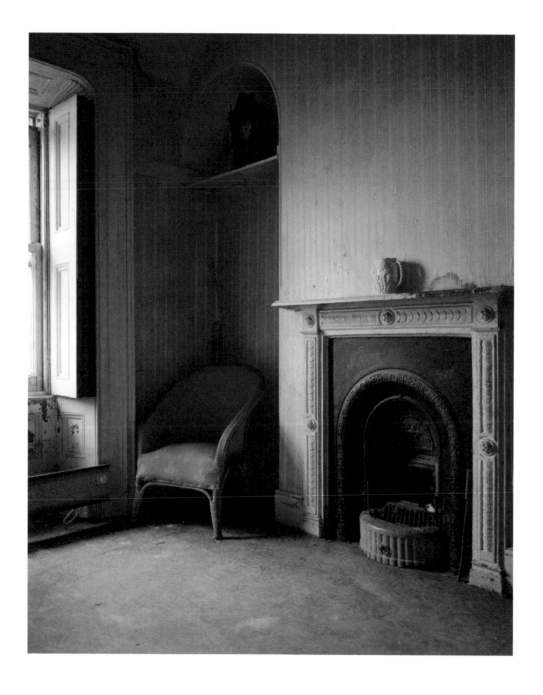

**Summary of Ciaran Donnelly's evidence from Report of the Bloody Sunday Inquiry.**
Original content of the report
© Controller of Her Majesty's Stationery Office
2010.

photographs is that they were at some stage discarded because they showed nothing of any relevance to the circumstances in which people were shot. This was probably because, in accordance with Army orders, the photographers were generally deployed along the containment line and did not enter the areas of the Bogside in which the shooting took place.

¹ Paragraphs 9.443–449    ³ FS7.203; FS8.277-284
² FS1.35–121

175.2    In turn representatives of the soldiers submitted that some of the photographs taken by civilian photographers on Bloody Sunday were missing. In this they were correct. They further submitted that "There may of course be an 'innocent' explanation for some cases of missing civilian photographs. But there are clear instances where the absence of such photographs is indicative of a reticence by the photographer (whether or not coerced by the IRA) to avoid disclosure of materials showing civilian wrongdoing such as rioting, or, worse, of materials showing the presence or activity of the IRA."¹

¹ FS8.284

175.3    We now turn to consider the photographers in question.

## Ciaran Donnelly

175.4    Ciaran Donnelly was a photographer for the *Irish Times*, who took a number of photographs to which we have referred in the course of this report. He told us that he believed that he had shot between four and six reels of film on Bloody Sunday and had taken them that evening to Dublin, but that only a small proportion of these survived as a flood damaged the *Irish Times*' photographic library.¹

¹ M22.22

175.5    In his oral evidence to this Inquiry, Ciaran Donnelly told us that all the photographs taken by him were supplied to the Widgery Inquiry.¹ He also told us that among the photographs that were now missing appeared to be some that he had taken "at the very time when two men were being shot on the [rubble] barricade".²

¹ Day 71/78-79    ² Day 71/75

175.6    There is no doubt that these photographs might well have assisted us in our examination of the events at the rubble barricade. However, we reject the submission that "Serious questions arise as to why it is that the photographs that are missing are of such an

---

important and controversial area".¹ As Ciaran Donnelly told us, these were only some and not all of the pictures that were missing. Furthermore, we have no reason to doubt his explanation as to why some photographs did not survive.

¹ FS8.297

175.7    It seems to be suggested that there was some sinister reason why two of the surviving photographs taken by Ciaran Donnelly (which we have also shown and discussed in the course of considering the events of Sector 3) showed what was said to be deliberate scratches, "as though some attempt has been made to distort or destroy part of the negative in some way".¹

¹ FS8.297; FS7.207

79

---

175.8    The images have clearly been scratched at some stage, but we can find nothing that suggests to us that this was done deliberately for some sinister purpose.

175.9    What it is important to remember is Ciaran Donnelly's evidence of what he saw at the rubble barricade. This was that while he saw youths throwing stones, at no stage did he see weapons fired or nail bombs thrown from the rubble barricade or anything that could have justified soldiers shooting people there. He said that he would have immediately left the area had he seen guns or heard bombs. We have no grounds on which to question this account and it was not suggested to him when he gave evidence that he was not telling the truth about this.¹

¹ Day 71/27; Day 71/53-55

## Eamon Melaugh

175.10    Eamon Melaugh was a member of the local branch of Northern Ireland Civil Rights Association (NICRA). He was also an amateur photographer who took a number of photographs on Bloody Sunday, to some of which we have referred elsewhere in the course of this report. He told us that his recollection was that he had taken photographs when the shooting had stopped of, among other things, bodies at the rubble barricade.¹ He also told us that one of the photographs he had taken at this stage was of Michael McDaid alive and standing on the rubble barricade. He said to us:²

"A. After I took the pictures we were discussing about at the barricade. There were three bodies at the barricade or three people lying there. I was not aware they were bodies at the time, they were very probably dead and I took a series of pictures. These are the pictures we are talking about and one of these pictures, when I showed to an individual several days later, he identified the well-dressed young man standing on top of the barricade as being the individual we are discussing, James McDaid. I was not aware who he was. I was not even aware that he had been shot."

¹ Day 145/54    ² Day 145/57

175.11    Eamon Melaugh took photographs of Barrier 14, Rossville Street and elsewhere. In his written statement to this Inquiry, Eamon Melaugh described in some detail the photographs he took and what happened to them. We set out part of that statement, not because the detail is particularly relevant to this part of the report, but because it is an illustration of how photographers made their work available to others and that it was not always returned to them.¹

---

176.10    There is film evidence that the knife rest was not pulled across the road when the marchers were making their way down Rossville Street before 1 PARA came into the Bogside.¹ There is also evidence to show that the fence was moved to block the road shortly after soldiers drove into Rossville Street. Peter Lancaster told us that he was involved in doing this² and Michael Owens and John J McLaughlin stated that they saw this being done.³ William Vincent Hegarty told the Widgery Inquiry that the fence was pulled across the gap in the rubble barricade after a number of civilians had surged forward in response to the arrest of William John Dillon,⁴ to which we have referred in the course of our consideration of the events of Sector 2.⁵ It would seem that the knife rest was moved across before any firing was directed towards the rubble barricade. This conclusion would seem to be supported by the photograph shown below, taken by Ciaran Donnelly.

¹ Vid 68 03.30    ⁴ AH65.1; AH55.3
² AL4.6; AL4.3    ⁵ Chapter 33
³ AO73.1; AM034.4

176.11    There is photographic evidence that indicates to us that the knife rest might have remained in position until the APC went forward to collect the bodies at the rubble barricade¹ and if so, it must have been moved in order to allow access to the APC and the civilian ambulance that passed through to the southern side of the rubble barricade.² There was no evidence that at some intermediate stage the knife rest was opened, or opened and shut again, though it is possible that this happened.

¹ IP1166-1168; Vid 48 12.35    ² P423; P425; P667; P774; P513-515

**Donovan Wylie**
**2009**
From *Scrapbook,* published by Steidl Publishers,
Germany, 2009.
Scanned image.
© Donovan Wylie.
Courtesy of the artist.

80

**Les Levine**
**The Troubles: an Artist's Document of Ulster**
**1972**
Archival cibachrome.
Unframed: 27.9cm x 35.6cm.
© Les Levine.
Collection Irish Museum of Modern Art. Donated by the artist in
memory of his parents Muriel McMahon and Charles Levine,
2010.
Courtesy of the Irish Museum of Modern Art.

82

**Les Levine**
**The Troubles: an Artist's Document of Ulster**
**1972**
Archival cibachrome.
Unframed: 27.9cm x 35.6cm.
© Les Levine.
Collection Irish Museum of Modern Art. Donated by the artist in
memory of his parents Muriel McMahon and Charles Levine, 2010.
Courtesy of the Irish Museum of Modern Art.

morbid, and almost inexpressible nostalgia for the past Northern Ireland. Or, more accurately put, there is a question which hangs in the air of Northern Irish life as to what happens now to the experiences of the 1970s, 1980s and 1990s. What is the remaining validity of a 'time which was supposed to have been consigned to history'?[38] Donovan Wylie and Timothy Prus's *Scrapbook* (2009) takes the form, in paper texture, size and format, of an actual scrapbook. Its act of imitation recalls a personalized archiving of experience, one which fixes the ephemeral with the importance of permanence, and acts as a reminder of who an individual was and what was once important to them. Through a personal scrapbook a child or adult gives some shape to their own story. Wylie and Prus use *Scrapbook* to imagine a collective memory for Northern Ireland in the late 1960s, '70s and '80s. Its mixture of photographs, newspaper clippings and fugitive texts ranges across paramilitary, military and civilian experiences of the Troubles. The times that are documented and remembered are both public and private – memories are evoked which are so intensely personal as to be obscure and yet the burden of them is felt in the way in which they are intertwined with a wider history. In his introductory note Prus writes: 'Sometimes the texture of real life is felt best in the style of the homemade'.[39] Wylie and Prus's project is a self-conscious recuperation of a disappearing visual experience. Its faded and patched-together nature is testimony to the way in which a personal story is interwoven with 'public images' and how, in a time of conflict, the nature of political and public imagery becomes a part of the self. Once the politics of conflict are put aside it can feel as if the personal memories which are entangled with that conflict are also to be locked away, and so part of the self is lost at the very moment at which it might be thought to have been saved.

In 2011 the Irish Museum of Modern Art showed Les Levine's *Mindful Media: Works from the 1970s*, an exhibition which brings us full circle to the beginnings of the Troubles. Here an artist who has always been 'mindful' about media returns to photographs made during the early days of the Troubles (in 1972), in the apparent spirit of photojournalism, but with an ability to get just too close to the action, to be a little too fascinated by people to be 'good' photojournalism. Resurrected in dying colours, Levine's images, seen again in 2011, looked like a memory of the Troubles, a past that is still alive and contained in the always continuing quotidian.

1   Gilles Peress, from his written statement to the Widgery Tribunal of Investigation into Bloody Sunday. Peress is referring to the death of Patrick Doherty, who was shot and killed on Bloody Sunday. See *Report of the Bloody Sunday Inquiry* [*Saville Report*] (London: TSO, 2010), Vol. vii, chp. 117.21 (p. 36).

2   Willie Doherty, quoted in 'Willie Doherty: Language, Imagery and the Real', *Circa*, 104 (2003),  51-54.

3   Peress, quoted in *Saville Report*, Vol. vii, chp. 117.21 (p. 36).

4   *Saville Report*, Vol. ix, chp. 175.4-175.24 (pp. 87-94, covering the nature of the evidence provided by Donnelly and Melaugh).

5   *Saville Report*, ix, 175.33, p. 96.

6   Henri Cartier-Bresson, quoted in Peninah R. Petruck (ed.), *The Camera Viewed: Writings on Twentieth-Centurv Photography, Vol. II* (London: Dutton, 1979), p. 18.

7   John Szarkowski, *The Photographer's Eye* (New York: Museum of Modern Art, 2007 [1966]), p. 100.

8   For a summary of Camerawork see Jessica Evans, 'Introduction' in Jessica Evans (ed.), *The Camerawork Essays: Context and Meaning in Photography* (London: Rivers Oram, 1997), pp. 11-35.

9   Chris Steele-Perkins, 'Catholic West Belfast', *Camerawork*, 14 (1979), 4.

10  'Pictures from Protestant Ulster', *Camerawork*, 14 (1979), 10.

11  Belinda Loftus, 'Photography, Art and Politics: How the English Make Pictures of Northern Ireland's Troubles', *Circa*, 13 (1983), 10.

12  Loftus, 'Photography, Art and Politics', 12.

13  Loftus, 'Photography, Art and Politics', 14.

14  Loftus, 'Photography, Art and Politics', 14.

15  See David Fox and Sylvia Stevens (dirs), *Picturing Derry* (Faction Films, 1984).

16  Trisha Ziff, 'Preface' in Ziff (ed.), *Still War: Photographs from the North of Ireland* (New AmsterdamBooks: New York, 1990), p. 11.

17  John Roberts, 'Photography after the Photograph: Event, Archive, and the Non-Symbolic', *Oxford Art Journal*, 32: 2 (2009), 284. See Robert Castel's, *From Manual Workers to Wage Laborers: Transformation of the Social Question* (New Jersey: Transaction, 2002).

18  Willie Doherty, quoted in *Still War*, p. 21.

19  For extensive interview with Bill Kirk, see http://www.source.ie/audio/interviews/index.html.

20  See Brendan Murphy, *Portfolio* (Belfast: Brehon, 2008) and Brendan Murphy and Seamus Kelters, *Eyewitness: Four Decades of Northern Life* (Dublin: O'Brien, 2003).

21  Bill Kirk, *The Klondyke Bar* (Belfast: Blackstaff, 1975),

22  This phrase is used in a slightly different context by Richard Kirkland, writing about Gerry Adams's fiction, in *Identity Parades: Northern Irish Culture and Dissident Subjects* (Liverpool: Liverpool University Press, 2002), p. 159.

23  Adorno, quoted in Judith Butler, *Giving an Account of Oneself*, (New York: Fordham University Press, 2005), p. 5.

24  See http://www.magnumphotos.com: Philip Jones Griffiths, 'Solider Behind a Shield', Image reference NYC36084.

25  *Saville Repor*t, ix, p. 88. The italics are in the original and are there to signal that they are quoted from testimony provided to the Inquiry.

26  Brian McAvera, *Marking the North: The Work of Victor Sloan* (Dublin/York: Open Air, 1990), p. 13.

27  Brian McAvera, *Marking the North*, p. 13.

28  See L.P. Curtis, Jr., *Apes and Angels: The Irishman in Victorian Caricature* (London and Washington, DC: Smithsonian Institution Press, 1971).

29  John Tagg, 'The Currency of the Photograph' in Victor Burgin (ed.), *Thinking Photography* (London: Macmillan, 1982), p. 114

30  W.J.T. Mitchell, *Picture Theory* (Chicago and London: Chicago University Press, 1994), p. 283.

31  Barthes, quoted in W.J.T. Mitchell, *Picture Theory*, p. 284.

32  Paul Seawright, *Paul Seawright* (Salamanca: Centre for Photography of the University of Salamanca, 2000), pp. 15-27.

33  Roland Barthes, *Camera Lucida* (London: Vintage, 2000 [1981]), p. 87.

34  Susan Sontag, *On Photography* (London: Penguin, 1979), p. 21.

35  See Richard Long, *Heaven and Earth* (London: Tate, 2009), p. 96.

36  Simon Winchester, 'The Aftermath Project' in Jim Goldberg et al. (eds), *War is Only Half the Story* (New York: Mets & Schilt/Aperture/The Aftermath Project, 2008), p. 6.

37  Roland Barthes, *Camera Lucida*, p. 15.

38  David Sharrock, 'They Call This a Ceasefire', *Telegraph*, 22 August 2000 (http://www.telegraph.co.uk/news/uknews/1367154/They-call-this-a-ceasefire.html).

39  Timothy Prus, in Timothy Prus and Donovan Wylie, *Scrapbook* (Göttingen: Steidl, 2009), n.p..

# Chapter Two
## The City: 'embodiment of hope'

87

*'The city has always been an embodiment of hope and a source of festering guilt.'*
Jonathan Raban[1]

Photography has loved and abhorred, hoped for and felt rueful about the city in equal measure. Cities offer photography a magnetic concentration of human life. At times the camera in the city has found its 'truth-telling' niche by cataloguing with conscience the hidden parts of cities, showing those things and people which are put away, actually and symbolically, from view. Photography has also allowed itself to be the awestruck celebrant of the city, a seer of portents in the urban present. Either way, the city stands in photography as proof of Vilém Flusser's disarming assertion that cities have human importance because 'villages cannot have temple mounts'. By which Flusser intends us to understand that once the texture of life becomes intellectually self-conscious, then a city is made. Taken literally, the idea is fanciful, of course, but it is also meaningful. Clearly cities arise through conflations of geography and economics, and not by what Flusser calls 'theory'. But, he writes provocatively, 'as soon as villagers theorize, village life becomes citified'. For Flusser, cities represent the intricacy of humanity en masse, and the web of relations and materials from which cities are made.[2]

In Northern Ireland, from the 1980s on, art photography which sought to see the North as a site of complexity faced the citified village life of the North with exactly that simultaneous hope and guilt which Raban describes. In the striations of sectarian division in Belfast, Derry and the other urban centres of the North which became more pronounced and violently defended during the Troubles, the urban geography of Northern Ireland was increasingly marked by wastelands and local borders. Turning away from obvious signifiers of destruction and affiliation, art photography sought out such apparently empty non-places in Northern cities and realized that to look at these was to see something more than the obvious news story.

The photographed city as a place of material degradation is a phenomenon almost as old as photography itself. An early urban photographic landscape of ruin, telling the story of what was, effectively, a civil war, is found, for example, in images of the Paris of the Second Commune in 1871. There J. Andrieu produced

a series of photographs to which he gave the title *Désastres de la guerre* and which blended the picturesque tradition of classical ruins with a new and melancholy urban sublime. Andrieu and his compatriot photographers were clear that the visuals of the *Désastres* were also an economic opportunity for the discipline of photography. They pitched their images of postwar Paris to a wide social audience, for whom their work served as 'historian and souvenir, fact and memory'.[3]

The advent of modern urban warfare may have offered the chance for photography to bring together old modes from painting with new historial realities, but the legacy of photographers such as Andrieu was to be in the muted mundanity and not the spectacularity of the cityscape. So Paris in Eugène Atget's early twentieth-century photographs was characterized by what is 'unremarked, forgotten, cast adrift'.[4] The sense that photography can catch this flotsam of the urban in its nets persists to the present day. In parallel with this faith in the scrutinizing capacity of urban photography, the 'New Photography' of the early twentieth century saw a move towards a socially-oriented image-making which drew on the density of life found in Western cities, most obviously New York, but also Berlin, London and Moscow.[5] This mobile and open-air documentary tradition mixed with a more industrial landscape tradition which used the photograph to memorialize the material achievements of urban human endeavour, in buildings, machines and streetscapes. As the twentieth century moved on, the dichotomy which Raban describes can be seen enacted through iconic urban European and American city photographs. Doisneau's kissing Parisian lovers, for example, are the hopeful gloss on a city which is emerging and rebuilding, once again, this time from the devastation of the Second World War. Weegee's contemporaneous New York, on the other hand, as rendered in his *Naked City*,[6] sets urban glamour in constant darkness, its otherwise furtive shoddiness only illuminated by the flash of Weegee's enquiring camera.[7]

Raban's balanced scales, with hope and guilt on either side, are a good rough guide to the possibilities of urban photography. The blending of the two often results in a twentieth-century phenomenon, the nostalgic city. The city, when looked back at affectionately, is a curiosity, a place in which warmth and comfort is sought in the most unlikely of landscapes. As Svetlana Boym puts it:

> The past of the city … is not entirely legible; it is irreducible to any anachronistic language; it suggests other dimensions of the lived experience and haunts the city like a ghost.[8]

In recent decades the *désastres* of Belfast have often been given the fig leaf of photographic nostalgia in the republication of old photographs of the city of Belfast – by Alexander Hogg, for example, or Robert French.[9] And Belfast is one city among many caught up in the phenomenon of urban photographic nostalgia in recent years, made material through the small-scale publication of heavily illustrated local photographic histories.[10] In the Northern Irish case it is possible to see the urban ghosts in these old photographs as pre-Partition shades which are being used to chase away the more recent spectres of the Troubles. A Belfast of *Titanic*-era commercial activity is, clearly enough, an avatar for the future city which tourist advertising and business interests would like to promote now, leaping over the awkward

histories which lie between and underneath these nostaglic pasts and futures. And city nostalgia can take more contemporary forms. The Belfast page at http://www.geograph.org.uk/, for example, includes a page of photographs of demolished buildings in Belfast, many from just before or during the early years of the Troubles, recorded for posterity in an unselfconsciously deadpan series of images which stoically bemoan the lost urban spaces of the recent past.

George Steiner has noted that even as far back as Heraclitus the city or 'polis' was 'the locale where the density [and] the specific gravity of discourse are greatest'.[11] Cities, in the Greek tradition, were places of coming together in both community and conflict, and, for the Greeks, cities were the site of art-making. All of Northern Irish history is, arguably, a breach in history which was covered over, so that the 'density' of Northern Irish cities became fixed in place. This suppressed the ideal of the city – its capacious humanity, its 'gravity', its function as a site of refuge. But this ideal is, I want to suggest, discernible within the art-documentary photography made in and about Northern Irish cities since the 1980s. The documentary element in this work keeps alive the 'humanistic'[12] drive of the documentary tradition, but in an interrogative mode derived from the broad influence of the New Objectivity and its photographic 'cool persona'.[13]

Partition created a state which immediately assumed that it had always existed, and Northern Ireland's cities became places where people had always lived. 'Migration', as a group of historians have recently argued, 'still needs putting into the history of Belfast'.[14] Because of this, the cities of the North have tended to be seen as settled, with geographical and sectarian divisions put in place by historical inevitability, and with populations which are inherently urban. The expansion and flux of urban populations (their suburbanization, their relocation to housing estates) is easily neglected in the midst of the Troubles. Photojournalism, seeking out clear narratives, often avoided the intricacies of affiliation and confusion in the streets of Belfast and Derry. Belinda Loftus notes, for example, that the photojournalist Clive Limpkin decided to go to Derry at the beginning of the Troubles because it had a geography of conflict which was less confusing and more predictable than that of Belfast.[15] It is, in effect, this reduction of geography to the *absurdum* of a dichotomous sectarianism that inspires some of the early Derry-based work of Willie Doherty.

In Doherty's 'The Other Side' (1988) the words on the image proclaim the suffocating contortions which cultural geography layers over physical geography in Northern Ireland – the twisted logic which can blankly assert that 'west is south' and 'east is north'. Here the banks of the river and the two geographical 'sides' of the city of Derry battle semantics to stay in tune with the split national geography. The words imposed over the landscape take precedence in the image, and are pivoted around 'THE OTHER SIDE', the artist/author's comment on what marks the politics of this place, and the city which is subsumed by the land. Such is the power of the way in which these words score the work that it is easy to miss the other binary which holds this image together by splitting it. Not a land which is only either 'ours' or 'theirs', but a land which is rural and urban. It is an interspliced binary which Doherty makes use of throughout his work – the constructed against and in the natural, the human against and in the landscape, the

**Willie Doherty**
**The Other Side**
**1988**
Black-and-white photograph with text.
61cm x 152cm.
© Willie Doherty.
Courtesy of the artist and Kerlin Gallery, Dublin,
Matt's Gallery, London
and Alexander and Bonin, New York.

90

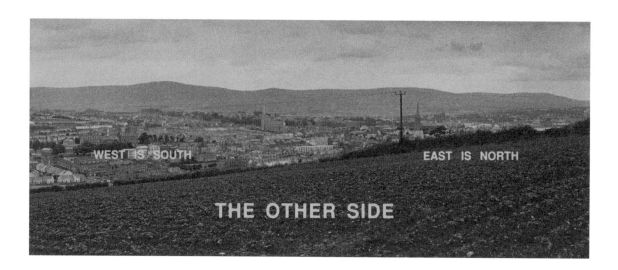

manufactured and built intertwined with the organic. 'The Other Side' may be visually overlain by words, but it is also cut across by the dark outline of a hedge bordering a field, marking the gap which divides ploughed land from houses. It is a double division of words and images which should alert us to the further meanings of 'the other side' – there is, in Doherty's work, not just the process of thinking about the politics of borders, or cultural histories, or cultural languages, but a deeper sense of the difficulties of visual and linguistic communication, of how to see through an image to its other side. As Doherty's work changes through the 1990s and into the current century, the white, inscribed words, with their assertive upper case, begin to disappear from his work; the application of conceptual pressure to political definitions remains – constantly challenging their meanings by consideration of the borders which give definitions to things, keeping them apart and holding them together. Doherty's work stays rooted in the cultural and political divisions which are signalled in the writing on 'The Other Side'.

Out of this starkly split Derry origin, Doherty's geographical sense delves into the metaphysics underlying the North's cultural stasis and taps the ennui which this politics generates. So from around the same time as 'The Other Side', 'God Has Not Failed Us' uses its text to bind together two sides of dereliction divided by a strip of urban nothingness. The symmetries of this image are taut, pointing upwards towards the lonely flag and sideways to the blind, claustrophobic sides of a despoiled walkway. The middle 'O' of the text encircles a perfect blackness. Irony at the expense of a rhetoric of certainty is one of the few tools left in such enclosed circumstances. The apparent assertion which is the text of 'Shifting Ground' (1991) is really more of a question, and when the two possibile intonations of the phrase are heard together, they create a wry, or even plaintive tone, rather than one that is sure of itself. So 'Shifting Ground' uses the enfenced walls of Derry to photograph a non-place which holds apart two entities which are sure about what they are. Like tectonic plates, they might move imperceptibly, a sign of change to come. Or they might be as still as the image they are in. The longer one looks, the more 'Shifting Ground' becomes a question unanswered. That unknowability, the slippage across word and image, is what characterizes much of Doherty's work later in his career and its origins are here, in the spaces between things in the urban geography of Derry.

Derry, as Clive Limpkin realized, was a city with an easily comprehended map and a stark history which was being fought out in the present, and this seemed to provide the clarity necessary for photojournalism. Local photographers working in a journalistic mode were also drawn to the severity of the city's internal borders. Barney McMonagle's *No Go: A Photographic Record of Free Derry* is one such record of the fight for the city's streets.[16] Photojournalism in Derry after Bloody Sunday took on a heightened role since, as we saw at the beginning of the previous chapter, from the very moment at which Bloody Sunday unfolded the images taken by the press on that day turned from reportage into evidence. The potential truth content of these photographs gave them an additional emotional charge at a time when the truth was being denied. Abbas, for example, captured this in his 1997 image of a mural which, according to the accompanying text, is based on a photograph by Peress. Abbas is here working for Magnum and photographing Magnum at the same time, since Peress was also a Magnum photographer. As Tom Herron and John Lynch point out, this particular mural (or a later, slightly amended version of it) is in fact a conglomeration from the

**Willie Doherty**
**God Has Not Failed Us (The Fountain, Derry)**
**1990**
From the series *The Fountain Derry*.
Black-and-white photograph with text mounted
on aluminium edition of 3 + AP.
122cm X 183cm.
© Willie Doherty.
Courtesy of the artist and Kerlin Gallery, Dublin,
Matt's Gallery, London
and Alexander and Bonin, New York.

92

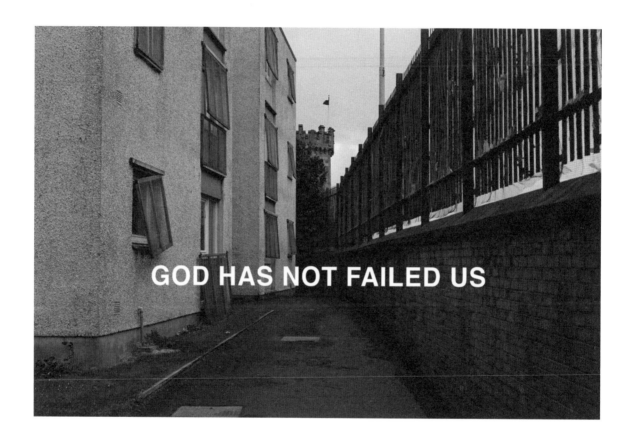

**Abbas**
**Mural inspired by photo of Gilles Peress 'Bloody Sunday'**
**and Gilles Caron (Gamma)**
**1997**
© Abbas/Magnum Photos.
Courtesy of Magnum Photos.

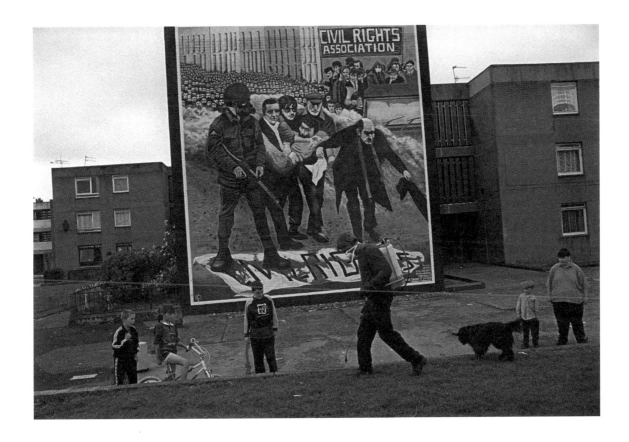

'image bank' of Bloody Sunday. Herron and Lynch's discussion of the mural suggests that its origins are a little less Magnum-inspired than Abbas believed. In any case the events of Bloody Sunday have here produced their own photographic iconography. Herron and Lynch note about the mural:

> There is no suggestion here that anyone is being airbrushed out of history, but what the elision [in the mural] reveals is the difficulty of achieving a form of representation that effects an adequate balance between artistic freedom and ethical responsibility, between the [dictates] of aesthetics and the demands of a community-embedded project.[17]

The difficulty is a familiar one. Photojournalism, like this mural, wants to attest to the truth, but in conveying that reality its mediation can become entangled in its proclamation, and so it tries again, and becomes further enmeshed in its own claims. As Herron and Lynch point out in their work on Bloody Sunday, it was (up until Saville, at least) the portrait photographs of the dead of Bloody Sunday, taken initially from family snaps, which most effectively drew continual attention to the 'untimeliness' of their deaths, as they were carried in procession on the annual commemoration of Bloody Sunday.[18]

In Doherty's work it is sometimes as if the image has given birth to the text – or as if the camera has the capacity to see these words in the landscape. Victor Sloan's early photographic interventions, as we have already seen, also deploy a method in which the image contains something more than itself, in which the artist adds to what the camera can produce. But the effect, thought about for long enough, in both Sloan and Doherty, can be that the words and the marks on their photographs are like emanations rather than additions – as if these scores and comments were already there when the photograph came into being. Sloan's forays into Derry in the late 1980s produced work which conceived of the city as buzzing with sectarian static. 'Ferryquay Gate, Derry' brings down a portcullis-like structure on a parade at the access points which the gate allows, while above the structure the air is rent by fierce incisions. Similarly the parade which crosses the image in 'Market Street, Derry' does so in a storm of dynamic violence, as if the walkers, or the event of their walk, have produced all this high-voltage interference in the city. Sloan and Doherty are most easily thought of as 'authors', that is as artists who add to and sign their work, because the photograph, at this early stage in their careers, is found to be insufficient and saturated with meanings which they do not wish for. But they might also be thought of as conjurers of the spirit of place, magicians of the urban *spiritus locus*, divining the split ground of Derry.

Belfast too had, of course, been photographed both as an urban centre and a site of conflcit through the early years of the Troubles. So many photographers had visited the city that they had a hotel, the Camera, named after them, since many had stayed there. The world, however, eventually wearies of the same images and in the 1990s small shifts in photojournalism had begun to reflect a different kind of aesthetic. Perhaps for the first time, fine-art photography was beginning to visibly influence photojournalism. One example of this in the North can be seen in Patrick Zachmann's visit to Belfast in 1991. Zachmann had joined Magnum the previous year and in 1991 he found a Belfast which was still populated by soldiers.

**Victor Sloan**
**Ferryquay Gate, Derry**
**1989**
From the series *Walls*.
© Victor Sloan.
Courtesy of the artist.

**Victor Sloan**
**Market Street, Derry**
**1989**
From the series *Walls*.
© Victor Sloan.
Courtesy of the artist.

He used political murals as a visual shorthand, as many photojournalists had done before him and would do again after him. But what is most interesting about Zachmann's work is its dalliance with forms of visual ennui. Not only does Zachmann tone down the drama of his images, so that they are, at times, photographs of nothing or very little happening, he allows the frame to be dominated, especially in its foreground, by roads and urban wastelands. At times, as in 'Belfast. March 1991', the result is that the city as a living object recedes into a thin strip in the middle of the photograph and the emptiness of cleared urban space in the foreground of the image, and then the sky above, take up much of the frame. Journalistically this is a photograph which shows the effects of the urban clearance of old Belfast housing. It prequels regeneration. But aesthetically it is a photograph with an awful lot of nothing in it. And that says something, in passing, about Belfast. The aesthetic mode here is, arguably, a weak alliance of methods picked up from the New Topographics (and perhaps the early work of the Düsseldorf School). Frank Gohlke's or Lewis Baltz's landscapes may be more mannered than Zachmann's, but Zachmann is photographing that which had 'previously been cropped out'.[19] There is thus the inkling of a recognition in Zachmann's work that life in Belfast is ordered not just by its politics but by a more complex web of interaction between environment, history, class, poverty and violence. That leads to photographs which might be seen to suggest that Belfast is not, primarily and only, a city of the Troubles, but that there is more here, and that more is seen best by looking at less, or at blanknesses.

This haunting of the documentary mode by an aesthetic of vacancy and ruin is one way to see the work made by Paul Seawright in his *Belfast* series of 1997-8. In *Belfast* Seawright develops a poetics of Belfast dereliction, confronting head-on the detritus of conflict as it is manifested all over the material city. To do this, in *Belfast*, unlike in the *Sectarian Murder* series, Seawright stands to confront his subjects, with almost all the images being taken from standing eye-level. Rusted gates, disintegrating signs and still functional, if battered, walls and partitions ensure that these images have no long perspective – their view is cut off in the middle by insurmountable barriers, each etched in various ways with the markings of history. Seawright's gaze falls, for example, on a gate which is shaped like the Union flag, its rusting metal and wire mesh broken and twisted, while behind it lies the extra protection of barbed wire – behind that, more dereliction, tarmac, weeds, another messy wall, topped with corrugated iron. It is a gate keeping us from a landscape that it is unimaginable we would want to go into.

'Gate' offers itself as a sign of a decayed, lost unionism in 1997, the year the photograph was taken. The gate's similiarity to a Union flag shape is an accident of sorts; however, its political resonances are further amplified by comparing it to 'Cage 2', one of the 'Cage' images in Seawright's *Belfast* showing guarded entrances and doors. For anyone familiar with Belfast, 'Cage 2' is a reminder of (if it's not actually a photograph of) one of Orangeism's most besieged citadels within the city, Clifton Street Orange Hall. This building has a distinctive red-brick, pseudo-classical style and a continuing belligerence as it holds out against attack from a hostile community on one side of it and the Westlink motorway on the other. Like 'Gate', its near blankness as a sign is used to the maximum by Seawright. The cage around the doorway is unforgiving, and shows signs of having been attacked – there are hints of fire damage at the top. An almost homely doorbell stands out disingenuously, though the newly shining lock, which contrasts

**Paul Seawright**
**Gate**
**1997**
From the series *Belfast*.
C-type print on aluminium.
150cm x 150cm.
© Paul Seawright. Collection Irish Museum of Modern Art.
Courtesy of the artist.

to the battered rust of the cage itself, dispels any hint of welcome. The signs of occupation are there too – the domestic bottle of gas and the crates of empty Coke bottles (perhaps a reminder of a heritage of teetotalism). Like 'Gate', this is still a place of human activity. What is hidden and protected behind the door suggests a drama of a darker kind (the same is true of 'Cage 1' and 'Cage 3' which confront the point of entry into the social club world of loyalist paramilitarism).

Seawright's *Belfast*, with its challengingly inclusive title, continues the work that *Sectarian Murder* began. If that early series, pre-ceasefire, remembered the dead who were subsumed into the landscape, then the post-ceasefire *Belfast* also reminds us of the easily neglected in a city which is full of change, obsessed with its own new-found possibilities. *Belfast* takes us to the limits of unionism/loyalism, decaying but unaltered, social but unwelcoming. Seawright's 'Belfast' is a place which is caught out – the blankness with which the cages, gates, bricks and corrugated iron all respond to the camera is defiance devoid of substance, and it leads the viewer to increasingly see these images as reflective of a bewilderment, a lost stand still being made, its symbols decaying. Seawright turns the methods which are inherent in the New Topographics into ways of photographing which subtly allow for Belfast's particularities of landscape to creep in to the image. Whereas Baltz, for example, shows the utter cleanliness of the Amercian post-industrial landscape in 'South Wall, Unoccupied Industrial Structure',[20] with newly raked soil, unsullied tarmacadam and a perfectly painted wall, Seawright's 'Tree, Peaceline' combines the same visual elements, but allows rust, moss, weeds and stains on the brickwork to be a statement of place. This photograph may be 'of' the Peaceline, but it refuses to be dramatically about the division which the Peaceline symbolizes. Instead it is 'about' degradation in the broadest and deepest of ways. And its small variation from Baltz's model gives it proper, considered resonance, just as 'Untitled' suggests a society at a metaphysical as well as political dead end.

Towards the end of the Troubles and after the ceasefires, the physical fabric of Belfast was not just a reflection of the effects of the conflict. Belfast was a proxy site for an ongoing argument. On one side, supposedly, were those caught up in the backward-looking politics of violence. On the other was an orthodoxy within the ideology of the neoliberal state which believed that the real tragedy of the Troubles was that the conflict had stunted Northern Ireland's economic growth. For the 'business community' and the Direct Rule administrators any sign of normalization or 'rebirth' in urban Northern Ireland was an indication of actual and possible transformation in the future. So one Belfast planner noted in 1990 that

> the physical evidence of achievement in Belfast stares you in the face. Witness the commercial confidence and new prosperity in the city centre … The city is being rebuilt. For citizen and businessman what this signifies is a new spirit of hope and confidence in the future.[21]

The neutral equation here of buildings which are fitted out for commerce and shopping with signs of hope, progress and a positive future is very much a part of the rhetoric of the late 1980s and early 1990s, and the ethos which underpins such faith in retail and redevelopment continues into the present day.

99

**Paul Seawright**
**Cage I**
**1997**
From the series *Belfast*.
C-type print on aluminium.
188cm x 150cm.
© Paul Seawright.
Courtesy of the artist.

100

**Paul Seawright**
**Cage II**
**1997**
From the series *Belfast*.
C-type print on aluminium.
188cm x 150cm.
© Paul Seawright. Collection Irish Museum of Modern Art.
Courtesy of the artist.

Chapter Two **The City: 'embodiment of hope'**

**Paul Seawright**
**Untitled, Belfast**
**1997**
From the series *Belfast*.
C-type print on aluminium.
144cm x 183cm.
© Paul Seawright.
Courtesy of the artist.

102

Indeed Zachmann's work in Belfast in 1991 already hints at this, as it contemplates some of the first attempts by the state to redevelop its way out of the Troubles. This should recall for us, in looking at photographs of Northern Ireland's urban landscapes from the 1990s on, that the city's geography is contested not just in the sense that the historical causes of the Troubles might be regarded as geographical, and not just in the manifestation of that history in a 'divided city'. One outcome of this debate was that, even more forcefully than in cities which had not experienced civil unrest, cities and towns in Northern Ireland were under pressue to be 'modernized'. And further, urban space that was unmodern, ruined, decayed or unkempt, signalled much more than the consequences of the Troubles. It suggested an attitude, something suspiciously at an angle to urban improvement – at best nostlagia, at worst recalcitrance. This means that urban photography in Belfast, Derry and the other built-up areas of the North which refused the gloss of the future and lived messily in the present was displaying its own troublesomeness, its disbelief, its obliquity to the norm.

John Duncan's earliest work, *Sinster and Dexter* from 1992, has a strong sense of the power of the blank urban space to signify the idea of 'Belfast'. Duncan here observes the cityscape from mere yards away; he looks at and across things, and allows insignificant places to cut lines through the photographic frame. These depopulated, enigmatically arranged urban spaces ask to be seen as glimpses of a landscape which is never usually given any notice. Seen in retrospect, they are a preamble to Duncan's more geometrically exact photographs, such as one of the 'Untitled' images from *Be Prepared* (1998).

The near abstraction of this industrial rooftop, with the line of the hills just framing the corrugated metal, makes this image a kind of manifesto for Duncan's work. The precision with which the city's spaces are aligned with each other, the portioning off of areas of the photograph to near vacuity, the straight-on camera angle – all of these are slowly set in motion in Duncan's photography through the late '90s and early 2000s. *Be Prepared* also has some of those closed-up, vertically-divided spaces of *Sinster and Dexter*, and these will be returned to by Duncan in new variations in later work, as he adopts a 45° angle to cornered interstices. This is part of how Duncan is able to envisage a Belfast which is urban more than it is conflicted. Duncan's Belfast is a city in a state of ruination, closed off, walled, fenced and accumulating the filth of living. As his way of looking at Belfast becomes more empathically, deliberately repetitive (the influence of the German photographers Bernd and Hilla Becher is key to this aspect of his photography), the unoccupied spaces take on both formal and metaphoric qualities. They provide a distance from which things can be seen, so that a distended empty foreground becomes characeristic of Duncan's photographs, allowing for a more scrutinizing distance in the work. In 'Untitled' (10) from *Be Prepared*, Duncan's downward and close-up look hovers on the point of intimacy with (and claustrophobia in) the landscape. By the time of *Trees from Germany* (2003) he is persistently analytic in the viewpoint which he adopts, his camera steadily at eye level and parallel with the ground.

*Trees from Germany* is a series of photographs in which the textures of Belfast's urban geography are in the process of changing. Building work is in progress in most of the images, taking them on a step further from his work around the time of his *Boom Town* series, in which cleared urban spaces were dominated by

104

106

builders' hoardings showing pictures of the apartments, offices and civic buildings yet to be constructed.[22] Duncan's photographs in *Trees from Germany* are variations on a compositional theme in which the new and the old are juxtaposed under perpetually grey Belfast skies. In 'Berry Street, Smithfield', for example, a new multi-storey car park, partly built in a faux version of Belfast's Victorian redbrick, is obscured by a square of land which is partitioned off by decaying corrugated iron. From inside the corrugated iron square shrubs and buddleia scramble out, as if hanging over the edge of a plant pot. The textures here are key to the image; the corrugated iron (and its fading bills and posters) are reminders of the disappearing and dishevelled Belfast before 'regeneration': under-developed, derelict and unkempt. The weedy growth escaping from inside tells of the years of neglect. Yet now this rag-tag square of land is an anomaly, a symbol of the past surrounded by the visual language of development – the car park and the newly surfaced road and footpath, both tarmacadamed in imitation of cobbled streets. Smithfield was previously a part of the city known for its time-lag qualities – family-run businesses in small premises, selling cheaply and often second-hand. Now it is re-made, imprinted with faint simulacra of its previous self.

*Trees from Germany* as a whole attempts to catch a transitional phase in Belfast's physical and social being. Its images are structured in such a way as to condense periods of history (here, for example, nature, struggling always against the encroaching city; the ghost of nineteenth- and early twentieth-century commerce; post-industrial melancholy; post-Troubles 'regeneration'). Epochs of the city's history are traced over each other in an assemblage which constantly enlivens history with fading memory, and does so through the look of an ethical eye which insists on seeing this tracing. In this sense the radical possibility contained in the ethical gaze of Duncan's work can be '"read" *as if it were* the trace of an event, a "relic" of an occasion … laden with aura and mystery'.[23] The 'traces' in *Trees from Germany* are sometimes the old (often sectarian) Belfast as against a new 'asectarian' commercialism – as when the top of a loyalist, Twelfth of July bonfire protrudes into the carefully conceived skyline of the newly-built apartment complex in 'South Studios, Tates Avenue'. Throughout the series 'traces' are more likely to be literal marks on the cityscape made by developers and builders, such as the line made by the comically prostrate tree, which will soon be 'street furniture', on a traffic island, in a yet-to-be-used carpark. But their more profound significance is as traces in the sense in which Emmanuel Levinas describes 'the trace':

> Its original signifyingness is sketched out in, for example, the fingerprints left by someone who wanted to wipe away his traces and commit a perfect crime. He who left traces in wiping out his traces did not mean to say or do anything by the traces he left. He disturbed the order in an irreparable way.[24]

The 'crime' wiped away in Duncan's Belfast is a complex meeting point for a 'real', yet now only spectral form of material urban existence, and an obliteration of that past. As the developers move in and reconfigure Belfast, Duncan catches its last visible traces. And so he refuses to see the city as anything other than the new built upon the old. Levinas writes that the 'trace would seem to be the very indelibility of being … its immensity incapable of being self-enclosed, somehow too great for discretion, inwardness, or a self'.[25] The traces of Belfast in Duncan's work resist the sameness signified by the architectural newness

**John Duncan**
**Berry Street, Smithfield**
**2003**
From the series *Trees from Germany*.
© John Duncan.
Courtesy of the artist.

**John Duncan**
**South Studios, Tates Avenue**
**2003**
From the series *Trees from Germany*.
© John Duncan.
Courtesy of the artist.

**John Duncan**
**Harbour Exchange, Airport Road West**
**2003**
From the series *Trees from Germany*.
© John Duncan.
Courtesy of the artist.

**Claudio Hils**
**Tin-City, corrugated tin house fronts from 1970's**
**2000**
From the series *Red Land Blue Land*.
Colour print.
45.5cm x 36.5 cm.
© Claudio Hils.
Courtesy of the artist.

**Claudio Hils**
**Close Quarters Battle Range, car driver**
**2000**
From the series *Red Land Blue Land*.
Colour print.
45.5cm x 36.5 cm.
© Claudio Hils.
Courtesy of the artist.

**Claudio Hils**
**Close Quarters Battle Range, dead end street**
**2000**
From the series *Red Land Blue Land*.
Colour print.
45.5cm x 36.5 cm.
© Claudio Hils.
Courtesy of the artist.

of post-ceasefire Belfast and confront the city always with the past it would rather forget, the indelibility and fullness of its historical and contemporary self. This is seen in the the surburban utopia which is signalled by new housing developments over against a Peaceline – the new housing tries to block out knowledge of the Peaceline by walling itself in with effetely bourgeois fencing. More ominously the traces of the past break through in Duncan's photograph of the lower part of Chichester Street, where the (then) new Bar Library stands to the left of the photograph, while the tree to the right is the first sign that this tiny portion of Belfast, once a concentrated place of 'justice' during the Troubles, and once heavily fortified, is on the cusp of reconfiguration. In Duncan's image the fragile tree stand in symmetircal opposition to the Bar Library, and signifies exactly the same thing: a 'redeveloped' future for the city. Duncan's photography becomes a catalogue of change in Belfast. As the Peace Process unfolds, so the city, and the rest of the North, becomes a physically altered landscape. While a 'new' Belfast was being, is being, imagined by developers, politicians and bureaucrats, the problem of what to do with the 'old' city remains. A long look at the city in the present, the long look which art-documentary photography takes, inevitably means that the past beguns to puncture the gloss of the present.

In 2000 Claudio Hils, a German photographer, examined a very different version of the Northern Irish city. *Red Land Blue Land* is made up of a series of documentary images of the British Army training camp at Sennelager in North Rhine–Westphalia which includes a mock Northern Irish town. Hils's 'Tin City' photographs capture the weirdness of this military vision of Northern Ireland, yet because of the precision of Hils's eye, he also transforms himself into a surveillance operative, a sniper, a guard, and produces images which are threaded through with other cameras, viewing points and rifle-sites. On the most superficial level Hils's *Red Land Blue Land* gives us an insight into how the British Army regarded Northern Ireland as a theatre of war and how the Northern Irish city (an indeterminate amalgam of Belfast and Derry[26]) was filtered through the army's lethal mixture of friend and enemy, innocent and terrorist. His photographs suggest that postmodern theories of the 'Sim-City', and the idea that '[today], again more than ever before, hyper-reality visits you, in your homes, in your daily lives'[27] is terrifyingly resonant when set alongside Hils's photograph of a mother and child target in Sennelager's urban training ground. Hils's photographs of the breezeblock and corrugated iron town, and the tailor's dummy citizenship of the Northern city, show it as film set and ghost town. This frozen Belfast/Derry synecdoche is a mutilated, sneered-at version of a place known well and yet misunderstood (it's a community horribly held, politically and aesthetically, in the 1970s). This simulation of Belfast/Derry shows us that there were other photographic versions of Northern Irish cities around during the Troubles. These cities were surveyed, mapped and ordered by the military and that process is laid out in real imitation in Sennelager, which itself is the product of many types of camera – the layout of the training base, for example, is clearly dictated by the need for the officers to see, through CCTV, what the soldiers training there were doing at all times. The 'unreal city' of Northern Ireland, 'Tin City', is just another version of the North, seen through a different, powerful lens.

The shock of Hils's *Red Land Blue Land* lies partly in its strangeness, both cityscape and dummy population being weird parallels to the 'real' Belfast, Derry or Portadown. But perhaps an additional jolt comes from

comparing the army's version of the Northern metropolis with that of the other photographers discussed in this chapter. Because, underlying all of this work, is an assumption that, in the term which Jonathan Raban uses, a city should be an 'embodiment of hope' and that when it is not, that is a source of 'guilt'. The urban photographers who have examined the North in recent decades have wondered where that 'hope' might be found and have not quite given up on it. Jean Baudrillard, documenting a trip to the United States, asked: 'Why do people live in New York? There is no relationship between them.'[28] The photography which has come out of the North in recent decades holds on to the documentary interest (and belief) in the 'common man'.[29] Even, and especially, when there is no man, woman or living thing in the frame, the expectation of a 'relationship' between person and person, person and place, persists. Bordering on nostalgia, tinged with liberal humanism, the camera goes on searching out the real city beneath the surface.

116

1   Jonathan Raban, *Soft City* (London: Fontana, 1891), p. 17.

2   Vilém Flusser, *Writings* (Minneapolis/London: University of Minnesota, 2002), p. 175.

3   Alisa Luxenberg, 'Creating Désastres: Andrieu's Photographs of Urban Ruins in the Paris of 1871', *Art Bulletin*, 80: 1 (1998), 115.

4   Walter Benjamin, 'Little History of Photography' in Walter Benjamin, *Selected Writings: Volume 2, 1927-1934* (Cambridge, Mass.: Belknap, 1999), p. 518.

5   Ian Jeffrey, *Photography: A Concise History* (London: Thames & Hudson, 2006), pp. 110-111.

6   Weegee, *Naked City* (Boston: Da Capo, 2002).

7   Miles Orvell, 'Weegee's Voyeurism and the Mastery of Urban Disorder', *American Art*, 6: 1 (1992), 18-41.

8   Svetlana Boym, *The Future of Nostalgia* (New York: Basic, 2001), p. 76.

9   See Brian Mercer Walker and Hugh Dixon, *No Mean City: Belfast 1880-1914 in the Photographs of Robert French* (Belfast: Friar's Bush, 1984).

10  Examples are legion and include Joe Baker and Robert Kerr, *Snapshots of Belfast, 1925-1929* (Belfast: Glenrave Local History Project, 2008); Vivienne Pollock and Trevor Parkhill, *Belfast (Britain in Old Photographs)* (Stroud: History Press, 1997); Peggy Weir, *North Belfast (Images of Ireland)* (Stroud: History Press, 2007); and, Keith Haines, *East Belfast (Images of Ireland)* (Stroud: History Press, 2007)

11  George Steiner, 'The City Under Attack', *Salmagundi*, 24 (1973), 3-4.

12  Lili Corbus Bezner, *Photography and Politics in America: From the New Deal into the Cold War* (Baltimore & London: Johns Hopkins University Press, 1999), p. 3.

13  See Helmut Lethen, *Cool Conduct: The Culture of Distance in Weimar Germany* (Ewing, NJ: University of California Press, 2002), pp. 101-186.

14  Brian Lambkin, Patrick Fitzgerald and Johanne Devlin Trew, 'Migration in Belfast History: Trajectories, Letters, Voices' in Olwen Purdue (ed.), *Belfast: The Emerging City, 1850-1914* (Dublin: Irish Academic Press, 2013), p. 235.

15  Belinda Loftus, 'Art and Politics: How the English make Pictures of Northern Ireland's Troubles', *Circa*, 13 (1983), 11.

16  Barney McMonagle, *No Go: A Photographic Record of Free Derry* (Derry: Guildhall, 1997).

17  Tom Herron and John Lynch, *After Bloody Sunday: Representation, Ethics, Justice* (Cork: Cork University Press, 2007), p. 39.

18  Herron and Lynch, *After Bloody Sunday*, pp. 46-47.

19  Wendy Cheng, '"New Topographics": Locating Epistemological Concerns in the American Landscape', *American Quarterly*, 63: 1 (2011), 151.

20  Robert Adams et al., *New Topographics* (Tucson/Rochester/Göttingen: Center for Creative Photography/George Eastman House/Steidl, 2009), p. 110.

21  B. Morrison writing in *The Planner* in 1990, quoted in Frank Gaffikin and Mike Morrissey, 'The Role of Culture in the Regeneration of a Divided City: The Case of Belfast' in Frank Gaffikin and Mike Morrissey (eds), *City Visions: Imagining Place, Enfranchising People* (London: Pluto, 1999), p. 168.

22  Some of these images are reproduced in John Duncan, 'Boom Town', *Source*, 31 (Summer 2002), 28-36, others are in Nicholas Allen and Aaron Kelly (eds), *The Cities of Belfast* (Dublin: Four Courts, 2003).

23  W.J.T. Mitchell, *Picture Theory*, (Chicago and London: University of Chicago, 1994), p. 284. (Emphasis in original)

24  Emmanuel Levinas, 'The Trace of the Other' in William McNeill and Karen S. Feldman (eds), *Continental Philosophy: An Anthology* (Oxford: Blackwell, 1998), p. 183.

25  Emmanuel Levinas, 'The Trace of the Other', p. 184.

26  One photograph by Hils, 'Layout for operations in the training village, Tin City' shows that a main thoroughfare in the 'city', was labelled 'O'Connell Street' suggesting that at best the British Army was geographically inexact in this part of its training. Even less reassuringly, the map, with its flat, coloured discs, dark background and green markings for buildings, looks curiously like a range of bets laid at a roulette table. See Claudio Hils, *Red Land Blue Land* (Ostfildern-Ruit: Hatje Cantz Verlag, 2000), p. 67.

27  Edward W. Soja, 'Six Discourses on the Postmetropolis' in Sallie Westwood and John Williams (eds), *Imagining Cities: Scripts, Signs, Memory* (London: Routledge, 1997), p. 28.

28  Jean Baudrillard, *America*, translated by Chris Turner (London: Verso, 1999), p. 15.

29  Lili Corbus Bezner, *Photography and Politics in America*, p. 5.

# Chapter Three
# The Border: 'the idea of boundary'

The Centre for Land Use Interpretation (CLUI) was established in California in 1994, bringing together geographers, cartographers, sociologists and artists to study how humans transform the landscape. Their remit is a broad one, but they have always fine-tuned their projects by stressing the role of art and photography in recording what they often find to be the singularly peculiar monuments and shapes which human beings make on the ground that they inhabit. One of their projects is 'Points on the Line', which examines the west coast of the US. The researchers on this project point out that the exact length of this stretch of coastline, while clearly finite, is impossible to measure, because inlet leads to smaller inlet and then to outcrops and then to individual rocks and beaches, and the question of where exactly the line of measurement should be taken is unanswerable.

'Points on the Line', pursuing the absolute logic of cartography, charts its finitude between two fixed points, the two borders on the west coast of the US. The Mexican border at its westernmost extremity is marked, in a CLUI photograph, by what looks like a literal and physical manifestation of the political border – a fence that runs down a hill, across a beach and disappears into the sea, as if in a vain attempt to divide the moving waves into national territories, to make real the truism that a 'map always manages the reality it tries to show'.[1] At its northerly end the less fraught US–Canadian border is registered as a line spray-painted on the ground across a train track which runs north–south, and here the border fades into the sea in a line of poles which once supported groynes. Both the aggressive fence, intended to keep out migrants, and the spray-painted line are reduced, condensed versions of what a border is – an absolute marker of national difference, at a geo-political level, and an imaginary, immaterial entity at ground level.

Above ground, just above ground, politics is often made manifest by the building of military structures which fearsomely write the geo-political truth on the land. CLUI's wry accounts of landscape, continually returning to the absurdity of maps as against lived reality, seek to make us think about this interplay of idea and experience. A border is a coalescence of these two things. Contemporary visual art forms are drawn to the spectacle of the border, to its to-and-fro of 'studium' and 'punctum', the solidity of the official idea and its piercing by the out-of-synch or the everyday. Simone Bitton's film *Wall* (2006), for example, is a documentary account of the building and refortification of the wall which separates Israelis from

Palestinians. At the centre of this documentary is a panning shot taken from a moving vehicle driving along an old part of the wall that has now been incorporated into the line taken by the new wall. As the car and camera move we see a succession of people climb over the wall, going both ways, to work and to visit relatives. The permeability of the barrier tells a story on a piteous, human scale, in contrast to the vastness of the wall being built by the Israelis. Borders are both terrifying and preposterous, very real and culturally imagined. They say do not cross, but people cross.

One way in which to account for a border's cultural 'studium' is not to cross it but follow it. CLUI do exactly this. As did Simone Bitton. Borders do not wish to be delineated in reality. They prefer to be cartographic and political. Colm Tóibín's walk along the Irish border, later published as *Bad Blood* but first published as *Walking Along the Border* (in 1987, with photographs by Tony O'Shea) is a journalistic version of something which in more radical art terminology might be thought of as an example of the science of psychogeography. That is, a walk along a designated route, undertaken with a set of pre-established rules.[2] In Tóibín's case these include a promise to himself to undertake the border parts of his journey on foot. The act of walking sets Tóibín apart, ironically, from the locals, who wouldn't dream of walking to Lifford from Derry,. The intimacy of his method of researching and writing about the border allows his narrative to build up to its final, overwhelming, story of violent death. By visiting the border and siting his critical, enquiring, documentary eye in the border territory Tóibín allows for this revelatory narrative to be told. His presence on the border is often imagined, in the book, as being akin to an act of conspiracy or subterfuge, a movement against the flow. The border is a place which is not meant to be stopped at or pondered, so when a camera, or a writer, pauses and looks at it, the photographer, or writer, adopts the position of an alien presence or a recorder of evidence. Intimations of surveillance and scrutiny, along with an often surreal visual intensity and a compression of political meaning, are the key characteristics found in images of the Irish/Northern Irish border.

In the previous chapter I discussed Willie Doherty's early Derry photographs and the ways in which they embed the split nature of the city into their formal qualities. Doherty's video piece *Re-run* (2002) is a case in point. It shows a man of indeterminate identity running over the Craigavon Bridge in Derry. Why he is running and which side he is running away from or to are unanswered questions in the work. He is, however, trapped and in motion. Shane Alcobia-Murphy quotes Carolyn Christov-Bakargiev writing about this work, and she argues that *Re-run* does not have a 'binary vision of the world' because it is a montage on a loop.[3] This inbetweenness is hardly a decisive formulation about how Doherty configures binaries, division and otherness. Alcobia-Murphy argues more persuasively that Doherty never allegorizes the Troubles and *Re-run* is a piece which is 'self-reflexive', 'foregrounding its own construction of this scene'.[4]

When Doherty approaches the border with his camera the binaries which he reads in Derry's cityscape, and which split his images, find different ways of manifesting themselves. His works 'Incident' (1993), 'Border Incident' (1994) and 'Border Road' (1994) have become signature images and show, successively, two burnt-out cars and concrete roadblocks. They are accretions of dereliction in a rural landscape, an imposition of politics onto the ground. Taken in the wider context of Doherty's work around the border

at this time, these photographs might misleadingly give the impression that he is primarily interested in the border as a blockage or barrier. When Doherty's work which includes physical barriers across the border (such as 'Border Road II' [1994]) is set against other images which do not include such stockading structures, then the border becomes more of a metaphysical entity – not allegorical, as Alcobia-Murphy reminds us, but a consideration of the idea of the border.

Doherty's series of four photographs entitled 'At the Border' (I–IV, 1995) variously imply rather than show the border. In the first the frame is filled with the receding, straight road and the white line along the middle of the road divides the image. Printed on a large scale it has a dizzying perspective. Add to this the narrative hint in the subtitle ('Walking Towards a Military Checkpoint') and the ominous story of the four images begins to unfold through allusion and possibility. 'Low Visibility', the second image, much more clearly connotes a threat, with the sweep of tyre tracks and the headlights in the darkness. It is suggestive of various 'border incidents' in the Troubles, of checkpoints, getaways and assassinations, and it chimes with that mode of evidential-forensic photography which Doherty deploys elsewhere, here adding darkness and disorientation. The third of the four offers relief of a kind (it is subtitled 'Trying to Forget the Past') since it attempts to look at the rural Paul Henry-esque sky and mountain landscape. But still that persistent road marking of the white line intrudes, becoming 'The Invisible Line' of the final piece – invisible because somewhere in each image, unseen, a line cuts across the road and marks the border. Clearly these are photographs of that invisible entity, a line that defines everything and which agglutinates violence and terror along its double frontier. 'The Invisible Line' is a work which changes the light of the first image in the series to darkness. In doing so it also alters the perspective from vertiginous reality to something much more two-dimensional – the dotted line runs up the middle of a triangle to a receding spot. Looking back at the first and second images in the sequence we see that the same position is taken up by the points of light in both – the headlights in II and the brighter, ascending road in I. Doherty concentrates the line, the border, at this foreboding point of meaning, where something seems to be about to happen.

The Peace Process is a challenge to the meaning of the border. While the Good Friday Agreement arguably solidified the political status of the border it also rendered the border finally, practically, useless, and brought about its demilitarization. Eoin McNamee's 2004 novel *The Ultras* considers this new state of affairs by telling the story of a notorious figure in the history of the border during the Troubles, Robert Nairac. Nairac's secretive and bizarre existence in south Down and south Armagh as an undercover British operative makes him the perfect character for a McNamee book – inscrutably uncategorizable, Nairac is a focal point for paranoia and conspiracy theories. At one point in the novel Agnew, and other British undercover agents, head to a night-time rendezvous with Nairac:

> On the map Agnew could see the red line of the border cutting through the area in front of them. He knew that there was nothing to see. There were no markers or watchtowers. The border was notional. It was the distillation of the idea of boundary. It ran across damp boggy fields and low hills, rainy and remote pastures. It disappeared into rain-washed haze.[5]

**Willie Doherty**
**At the Border I (Walking Towards a Military Checkpoint)**
**1995**
Cibachrome photograph.
122cm x 183 cm.
© Willie Doherty.
Courtesy of the artist and Kerlin Gallery, Dublin,
Matt's Gallery, London and Alexander and Bonin, New York.

122

**Willie Doherty**
**At the Border II (Low Visibility)**
**1995**
Cibachrome photograph.
122cm x 183 cm.
© Willie Doherty.
Courtesy of the artist and Kerlin Gallery, Dublin,
Matt's Gallery, London and Alexander and Bonin, New York.
Collection Hugh Lane Gallery, Dublin.

**Willie Doherty**
**At the Border III (Trying To Forget The Past)**
**1995**
Cibachrome photograph.
122cm x 183 cm.
© Willie Doherty.
Courtesy of the artist and Kerlin Gallery, Dublin,
Matt's Gallery, London and Alexander and Bonin, New York.

**Willie Doherty**
**At the Border IV (The Invisible Line)**
**1995**
Cibachrome photograph.
122cm x 183 cm.
© Willy Doherty.
Courtesy of the artist and Kerlin Gallery, Dublin,
Matt's Gallery, London and Alexander and Bonin, New York.

In Doherty, as in McNamee, the border as 'distillation' and disappearance is a reality of political history rendered in their artistic 'style' – both see the border as elusive and as dissipating, and so as an epistemological threat.

For others the border has been a real living-out of the tensile politics strung along its course. The border has left a legacy of stories of grief, anxiety and pain of the kind which Tóibín found waiting to be told back in the 1980s. In the course of the Peace Process the difficult and politically fraught task of telling stories of the Troubles has left what Kirk Simpson calls a 'discourse "void"', a lack of validated opportunities for those who are victims of the Troubles, and have been left powerless and silenced in the wake of Peace, unable to 'retrieve crucial aspects of their past'.[6] A photographic project which tried to give some recognition to the unspoken experiences left over from the Troubles in the border region was *Borderlines*. Organized by the Gallery of Photography in Dublin, and funded as part of the cross-border initiatives which followed the Good Friday Agreement, *Borderlines* produced a book in 2006, a touring exhibition and an archive of photographs, interviews and recorded material. This format, and the dispersal of 'authorship' amongst a large number of photographers, researchers and writers, meant that the *Borderlines* project became, visually at least, about a series of possible ways in which to render the border. *Borderlines* included everyday images which look as if they are landscapes taken from inside a car, moments seen during an ordinary journey that assume great significance. There are, in *Borderlines*, Doherty-like barriers, gates and fences. There are signs of loyalism or republicanism – flags, 'sniper at work' signs, poppy wreaths. And, as often happens in the North, the camera is drawn to photograph other cameras and other photographs – these latter being the most poignant statements of loss, since they are memorials, either of those who have died, or of lives which are unimaginably in the past. Graham Dawson, in his book *Making Peace with the Past*, quotes J.E. Hazlett Lynch writing in the *West Tyrone Voice*:

> Those of us who have carried the wounds and the scars of their [referring to republican paramilitaries'] activities have been left, still with the pain. And there didn't seem to be any justice. There was a feeling throughout the Border counties that something will have to be done to ensure that we as victims are not forgotten. [sic][7]

Hazlett Lynch's plea is for recognition and the salving of wounds, and it is directed at an authority that is hard to pin down, in that it is difficult to know to whom the responsibility for hearing such stories falls. *Borderlines*, photographically and textually, is unashamedly a proxy form of the 'good listener', providing a cathartic forum. Photographically, *Borderlines* searches out the possible modes in which such empathetic understanding might find a parallel in visual representations of the border. Anthony Haughey was a key figure in the *Borderlines* project, and his collaborative work on that project overlaps with his own collection *Disputed Territory* (2006), made between 1999 and 2005. Here Haughey juxtaposes three European post-conflict zones (Ireland, Kosovo and Bosnia and Herzegovina). *Disputed Territory* is more than an opportune conjunction of three areas in which wars have recently finished. One of the writers whose work is included in the book of *Disputed Territory*, Natasa Govedarica, notes the liminality of the space which she inhabits:

126

I live on the border. This, officially, does not exist. Since the Dayton Peace Agreement ended the Bosnian armed conflict one country, Bosnia and Herzegovina (B&H), has been administratively divided into two entities: the Republic of Srpska, and the Federation of Bosnia and Herzegovina. However there are no checkpoints or border crossings between them. Accordingly, there is no border.

Nevertheless, ten years after the B&H conflict, there is a border.[8]

The photographs in *Disputed Territory* emphasize the in-between nature of the three borderlands which they study. Weeds and temporary fences are everywhere. There is neglect and there is waste ground, and patrolling it, officially or unofficially, there are men and soldiers whose machismo looks fragile and uncertain. Just as the *Borderlines* project interlaces photography with testimony, so Haughey's *Disputed Territory* includes personal attestations to the effects of military conflict in a borderland on those who try to live through the violence or who participate in it. The 'Kosovo' section begins with a close-up of a scar on someone's shoulder. The image is harshly lit and the face is out of the frame. It looks like a piece of evidence for a tribunal of inquiry. The scar on the body is emblematic of how Haughey sees these 'disputed territories', and in his photographs of the Irish border Haughey blends the continuing surveillance of the land with signs that the effects of division and violence remain in the borderland and are manifest on the landscape as striations, barrenness or infertility. His image of a field with a square of orange plastic netting in it is suggestive both of the site of a crime and an attempt to plant something new, and the same two drives, of 'death' and (re-)birth, are evident in other images in the 'Ireland' section. One is of a pile of shotgun cartridges in a Keith Arnatt-like heap, lying at the bottom of a mechanically-dug pile of earth. The conjunction of the two elements here suggests a place interpolated with the litter of violence, and Haughey nicely repeats the image of plastic cylinders emerging from the soil in another photograph which shows tree shelters on the bank of a stream. The unharrowed and untended ground in which they have been planted seems unpromising for their future and the shelters look like miniature versions of the military watchtowers which appear in other images in the sequence.

Haughey's setting of the Irish border in a wider context shakes any local Irish complacency about the fractures in history which borders cause. In Europe in general, since the end of the Second World War, borders have been so stable that conflicts over the minutiae of their alignment, in Ireland or the former Yugoslavia, caused bewilderment in the wider political establishment. As Tony Judt points out:

> At the conclusion of the First World War it was borders that were invented and adjusted, while people were on the whole left in place. After 1945 what happened was rather the opposite: with one major exception boundaries stayed broadly intact and people were moved instead.[9]

Border disputes had become anomalous in 'modern' Europe after the war (the 'European border' increasingly being the only one 'defended', against Cold War enemies and migrants). European history

**Anthony Haughey**
**Orange barrier, Armagh/Louth border, Ireland**
**1998**
From the series *Disputed Territory*.
C-type editioned Lambda print mounted on acrylic.
120cm x 122cm.
© Anthony Haughey.
Courtesy of the artist.

128

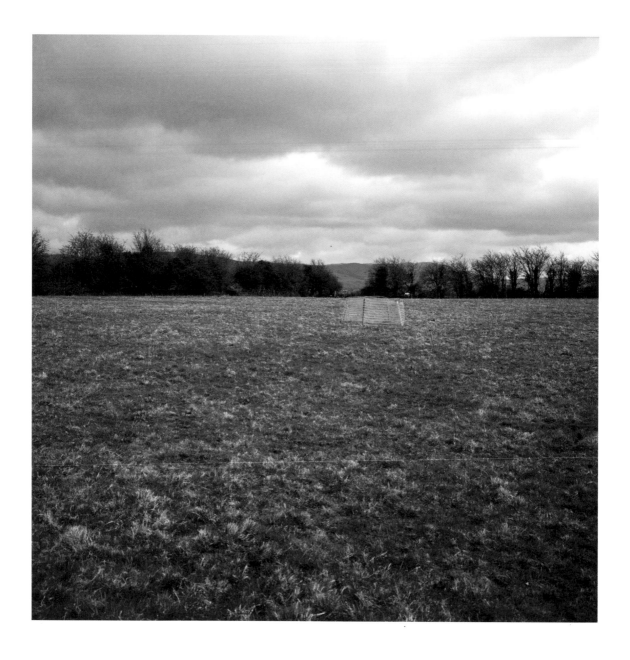

**Anthony Haughey**
**Shotgun cartridges, Armagh/Louth border, Ireland**
**1999**
From the series *Disputed Territory*.
C-type editioned Lambda print mounted on acrylic.
120cm x 122cm.
© Anthony Haughey.
Courtesy of the artist.

Chapter Three **The Border: 'the idea of boundary'**

**Anthony Haughey**
**Surveillance devices, S. Armagh, N. Ireland**
**2000**
From the series *Disputed Territory*.
C-type editioned Lambda print mounted on acrylic.
120cm x 122cm.
© Anthony Haughey.
Courtesy of the artist.

130

has relegated the idea of national territorial contests to the past and for this reason the Troubles or the Balkan conflict can only be viewed by those outside its events as anachronistic. *Disputed Territory* argues that the legacy of border wars continues to haunt the unsettled peace in these lines of tension running through Europe.

In *Disputed Territory* Haughey points to the importance of surveillance along the border, specifically the Irish border. The first photograph in the 'Ireland' section of the book version of *Disputed Territory* is of a CCTV camera seen from below, through a hedgerow. Contemporary photography is very aware that its roots in a liberal documentary tradition are tempered by photography's equally long history of providing powerful state institutions with a means of visual policing.[10] Surveillance is a trope in Northern Irish photography and art, as it is globally. In the post-Good Friday Agreement era structural changes in the militarized and hyper-monitored border landscape have been catalogued by two photographic projects: Donovan Wylie's *British Watchtowers* (2007) and, in the same year, Jonathan Olley's *Castles of Ulster*. Wylie's *British Watchtowers* follows on from his previous large-scale Northern Irish undertaking, *The Maze* (discussed in a later chapter of this book). Wylie draws on his Magnum background in photojournalism in making these images, so that they have a newsy feel to them in that they precede and predict the event of the watchtowers' being dismantled. However, Wylie also monumentalizes the watchtowers by nodding to the example of the water towers and industrial structures in the famous photographic series made by the Bechers. Wylie is able to enhance the notion that these are photographs of the demise of the watchtowers with his aerial views of the structures, which are taken as if from a departing helicopter. The photographs in *British Watchtowers* are, in essence, images of future empty spaces, 'landscapes of social memory' which 'illuminate hidden dimensions of the struggle to stabilize the ever evolving meanings of the past in the present'.[11] And here, because the temporariness of these structures is in play in the work, it is the question of whether they will mean at all, in the future, when they have gone, which is asked. As with *The Maze* project, Wylie uses the demolition of the built environment (of surveillance in *British Watchtowers*, and of incarceration and surveillance in *The Maze*) to contemplate larger issues in contemporary Northern Ireland, to wonder what future the past has.

Jonathan Olley's *Castles of Ulster* takes an approach that is more ground-level than Wylie's (most of Olley's images are made with the lens turned upwards to give an impression of the height of the buildings) and the monochrome, deep-grey to near-sepia which Olley uses is suggestive of a wry and more angular approach to the subject. Not all of Olley's 'castles' are on the border, but their architecture of fortification suggests siege and defence. Olley positions himself to see ironically mundane settings for some of the sangars and army bases that are stuck beside shops and houses, with very ordinary roads leading past or up to them. These buildings, once Olley has named them 'castles', take on the proportions and presumptions of the medieval redoubt, with all its paranoia and grandeur. They are testimony to the architecture of the Troubles, both literally and metaphorically, and they also, under Olley's sympathetic gaze, gather a kind of pathos and vulnerability around them, as if they have appeared in the wrong place, dressed in the wrong clothes. Olley allows for a spectrum of fortifications – from images which convey a sense of the aggressive enclosure of space undertaken by the military to near-absurd cohabitations of the

**Donovan Wylie**
**G 40 S/E**
**2007**
From the series *British Watchtowers*.
© Donovan Wylie/Magnum Photos.
Courtesy of the artist.

**Donovan Wylie**
**G 40 S/E**
**2007**
From the series *British Watchtowers*.
© Donovan Wylie/Magnum Photos.
Courtesy of the artist.

**Jonathan Olley**
**British Army firing range, Magilligan Point,**
**Lough Foyle, Co. Londonderry.**
**1998**
From the series *Castles of Ulster*.
Photograph, black-and-white, on paper.
34cm x 44.8cm.
© Jonathan Olley.
Courtesy of the artist.

136

Jonathan Olley
**Golf Five Zero watchtower (known to the British Army as 'Borucki Sangar'),**
**Crossmaglen Security Force Base, South Armagh.**
**1999**
From the series *Castles of Ulster.*
Photograph, black-and-white, on paper.
75.7cm x 99.5cm.
© Jonathan Olley.
Courtesy of the artist.

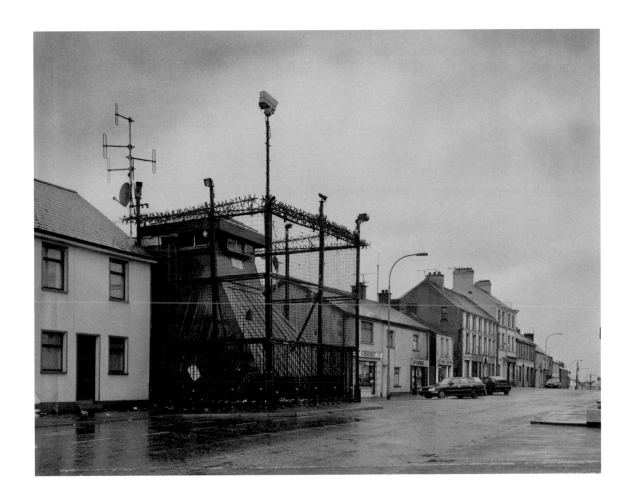

domestic and the martial. His photographic method (Type 55 Polaroid), and the fact that its exposure is often left visible on the final photographic prints, makes these images seem as if they have been laboured over. The photographic self-consciousness of the marks which originate in the film spreads through the entirety of the image to remind us that a camera and a photographer have sought out these places, catalogued them with determination, and searched for their collective meaning.

Olley's work elevates the status of the 'castles' only in order to deflate their importance with irony. Understated as a strategy in Olley's case, this has been more marked as a way of seeing Northern Ireland's heavily defended border in other photographers' work. We have already seen how Seán Hillen's art evolved from a photojournalistic mode into fantastical montages. Hillen's 'Newry Gagarin Crosses the Border' uses his own photograph of the army base outside Newry which once looked over the main Belfast–Dublin road. Hillen places above that an alter-ego figure named Newry Gagarin, who appears in a series of images from around this time, sometimes with Hillen's face inside the cosmonaut's helmet. Hillen explains that Yuri Gagarin (the first man in space) landed an hour before Hillen was born and in this work 'Gagarin' seems to be still *in utero*, floating above the border – getting perspective, perhaps, staying above the fray. The image is then a wish fulfilment (expressing the desire to rise back above the politicized ground) but it is also a recognition of the constant bringing together of disparate elements – which is what a border is. Here Hillen brings into contact the photograph and borrowed visual texts, Hillen and 'Gagarin', north and south. Hillen's work from around this period uses a garish form of kitsch to make sense of the harsh politics in his original photographs. For all Hillen's humour, it should be remembered that he makes this work through the cutting up of pre-existing images and that in that method there is the recreation of something violent and lacerating.

Such pointed humour at what the border signifies is turned satiric in John Byrne's multi-stranded conceptual 'event', *The Border Interpretative Centre* (2000). Byrne's project was centred around the staged (and video-recorded) opening of the 'Border Interpretative Centre' in a hut (formerly an official border post) marking the border on the Newry–Dundalk road. The project used photography, both in the standard art gallery way (though with parodic content) and postcards. One such postcard, 'Castles of the Border', has four images of fortified army bases (Cloghoge, Forkhill, Cullaville and Crossmaglen), each with red roses or fuschia in the foreground, à la classic John Hinde, while the white-lettered naming of each place is not only a pastiche of the picture postcard genre but also an affectionate sideswipe at Willie Doherty's early Troubles photographic art.

Brian Kennedy reported in *Circa* on the opening of the Centre and he recorded how Kevin McAleer, marking the inauguration, made a speech in which he said that he had visited many borders across the world 'but that our little border was the best border in the world', and warned visitors to the Centre to beware of threats to borders from centralized European policies which favoured the opening of borders.[12] McAleer went on to suggest that the border was the one thing in Ireland that everyone in Ireland had in common, and therefore that the border keeps us all together.

John Byrne
**At Last!! The Border Interpretative Centre**
**2000**
From the series *The Border Interpretative Centre*.
© John Byrne.
Courtesy of the artist.

140

**John Byrne**
**Castles of the Border, Crossmaglen**
**2000**
From the series *The Border Interpretative Centre.*
Postcard.
10cm x 15cm.
© John Byrne.
Courtesy of the artist.

THE HILLFORT AT CLOGHOGE COMMANDS SPECTACULAR VIEWS OVER THE
SURROUNDING HILLS AND VALLEYS

**John Byrne**
**Castles of the Border, Crossmaglen**
**2000**
From the series *The Border Interpretative Centre*.
Postcard.
10cm x 15cm.
© John Byrne.
Courtesy of the artist.

142

THE OLD FORTIFICATIONS AT CROSSMAGLEN REALLY SET OFF THE MAIN SQUARE

**Garrett Carr**
**The Map of Connections 3.0**
**2012**
Digital Print.
84cm x 118cm.
© Garrett Carr.
Courtesy of the artist.

# The Map of Connections 3.0

Unofficial and previously unmapped Irish border crossings

| stepping stones | ■ | ■ demoted road |
|---|---|---|
| **field link** | ■ | ■ **bridge** |
| path | ■ | ■ lane |
| **ford** | ■ | ■ stile |

In the exhibition of *The Border Interpretative Centre* Byrne included Perspex cubes containing bits of the border – the border's 'real' soil and grass. He also exhibited close-up black-and-white photographs of the border – more border grass. His joke here is at the zero sum logic of the idea of a border. Where exactly is it? How wide is a border, for example? The illogicality of such a powerful political idea when pressed to explain itself is an undercurrent of Colm Tóibín's journey along the border in *Bad Blood*, but a more recent version of the same walk takes that ambulatory scepticism much further.

Garrett Carr's *New Maps of the Border* is an ongoing project in which Carr walks the border with as much precision as he can manage. Using GPS maps and infinite patience, Carr has tracked the border exactly. While his journeys are themselves artworks, he also makes maps of the border out of this practice and his own training as a graphic designer.[13] One map, 'The Map of Watchful Architecture', marks out the border through military fortifications, beginning with prehistoric sites and continuing to the present day. Another, 'The Map of Encounters', includes drawings of events, people and objects which Carr met with along the border, and becomes a personal record of his walks. And 'The Map of Connections' shows crossing points on the border, places where the border is unofficially navigated. On this map Carr includes a set of landscape photographs, each one of which shows one of those lateral paths across the border. Some are obvious, some barely visible, some ingeniously devised, and each has a story. Carr's project is very much a post-Good Friday Agreement undertaking. Its scrutinizes the logic of a border which still exists as an historical fact and a political entity but which has much less meaning than it once had. Now the border is crossed freely and easily. Not long ago it was guarded and patrolled. Under Carr's interrogation the presence of the border assumes a kind of mystical quality. Nowhere on any of his maps is the actual cartographic line of the border drawn, even though that line is the one which he has assiduously followed and recorded. The border's legacy, and perhaps its truest existence, is also catalogued in the photographs which Carr has taken of each crossing point – the necessities of ordinary life (cattle to be moved, lovers to be visited) and intrigue (guns to be moved, fuel to be laundered) has led to these slight tracks, ad hoc bridges and opened fences across the dividing line between two states. As a documentary project Carr's *New Maps of the Border* inserts the presence of one individual consciousness into a meta-narrative of statehood which is uncertain of itself after the Peace Process. The border is not what it used to be, but nothing in Northern Ireland is.

1   Jerry Brotton, *A History of the World in Twelve Maps* (London: Allen Lane, 2012), p. 7.

2   Robert Macfarlane, reviewing Iain Sinclair's *The Edge of Orison,* in the *Times Literary Supplement,* provides a handy, if flippant, guide to the methodology of psychogeography:

    Unfold a street map of London, place a glass, rim down, anywhere on the map, and draw round its edge. Pick up the map, go out into the city, and walk the circle, keeping as close as you can to the curve. Record the experience as you go, in whatever medium you favour: film, photograph, manuscript, tape. Catch the textual run-off of the streets...

    Robert Macfarlane, 'A Road of One's Own', *Times Literary Supplement,* 7 October 2005, 3-4.

3   Shane Alcobia-Murphy, *Governing the Tongue in Northern Ireland: The Place of Art/The Art of Place* (Newcastle: Cambridge Scholars Press, 2005), p. 29.

4   Alcobia-Murphy, *Governing the Tongue,* p. 29.

5   Eoin McNamee, *The Ultras* (London: Faber & Faber, 2004), p. 129.

6   Kirk Simpson, *Truth Recovery in Northern Ireland* (Manchester: Manchester University Press, 2009), p. 138.

7   Quoted in Graham Dawson, *Making Peace with the Past? Memory, Trauma and the Irish Troubles* (Manchester: Manchester University Press, 2007), p. 207.

8   Natasa Govedarica, 'I am what I see?' in Anthony Haughey, *Disputed Territory* (Dublin: DIT/Gallery of Photography, 2006), p. 122.

9   Tony Judt, *Postwar: A History of Europe Since 1945* (London: Pimlico, 2007), p. 27.

10  See, for example, Jonathan Finn, *Capturing the Criminal Image: From Mug Shot to Surveillance Society* (Minneapolis: University of Minnesota Press, 2009).

11  Yvonne Whelan and Liam Harte, 'Placing Geography in Irish Studies: Symbolic Landscapes of Spectacle and Memory' in Liam Harte and Yvonne Whelan (eds), *Ireland Beyond Boundaries: Mapping Irish Studies in the Twenty-first Century* (London: Pluto, 2007), p. 196.

12  Brian Kennedy, 'Borderline Case', *Circa,* 94 (2000), 31.

13  See Garrett Carr, 'Remapping the Irish Border' in Kathleen James-Chakraborty and Sabine Strümper-Krobb (eds), *Crossing Borders: Space Beyond Disciplines* (Oxford/Bern: Peter Lang, 2011), pp. 149-158.

145

# Chapter Four
# Peace: 'present past'

When the text of the Good Friday Agreement was circulated to households in Northern Ireland just before it was put to a referendum in May 1998 its cover suggested that a new, peaceful leisure time awaited the North's citizens. The cover image was of a silhouetted family group, holding hands and looking out to sea at the setting sun – an appropriately warm sense of togetherness which was a little undermined by the oddness of the metaphoric connotations of a family fondly watching a sunset when a new political dawn was approaching. The Agreement's cover encapsulates the paucity of thinking around cultural identity which haunts the Peace Process and which indicates that, while photographing the Troubles was difficult, photographing the Peace wouldn't be any more straightforward.

On the day of the publication of this glossy version of the Agreement the editors of *Source* magazine contemplated the coup of having one's photograph appear on the doormat of every household in the North.[1] This led to a curiosity about who the unattributed photographer was, and the more curious question of which seaside view in Northern Ireland he or she had found which allowed an uninterrupted western vista. After calls to the Northern Ireland Office, then a photographic agency, and finally to a surprised German photographer who didn't know that his work had been used to promote an international treaty, the image which embodied the North's future turned out to be a standard agency shot which was actually of a white South African family somewhere near Cape Town – Cape Town having the advantage of a clear western Atlantic view. It would be reassuring to think that some kind of subliminal Peace Process analogy of hope was behind this transposition of one state's conflict onto another's, but the truth is more prosaic and haphazard. That the NIO designers could only find an image appropriate to the moment in something denuded of any specific reference to Northern Ireland (specificities such as the actual sea, land and sky of and around the North) shows how, to put it as benignly as possible, the visual future for Northern Ireland, after the Agreement, was unimaginable.

The end of the Troubles was a tortuously drawn-out affair. In his account of the multiple reasons as to why the Good Friday Agreement was the outcome of the Peace Process, Martin Mansergh, long-time advisor to the Irish government on Northern affairs and an insider in the negotiations, cites the accepted notion that, for the IRA and probably the British government, the military side of the conflict had reach

148

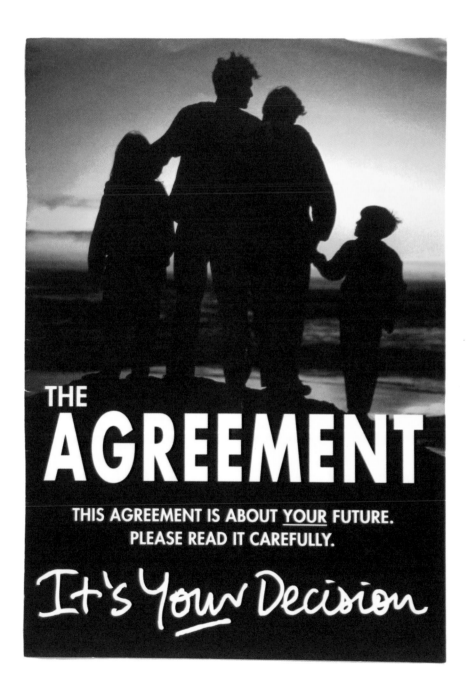

stasis and 'stalemate'.[2] The sense of exhaustion which the Troubles had engendered was obvious by the 1990s, though whether it and the 'stalemate' really were the key factors which brought about the end of the Troubles is debatable. Certainly photography, both photojournalistic and in the art-documentary mode, had begun to register both ennui and a fear of perpetual stasis in the years leading up to 'the Peace'.

The Peace made for conditions in which, in the early years after the Good Friday Agreement, 'culture' became something which was viewed by the governments and the political caucus as a handmaiden of the Peace Process. It could be argued, as Greg McLaughlin and Stephen Baker have done, that this led to 'the impoverishment of the cultural imagination' in Northern Ireland.[3] Perhaps more nuance might be added to this critique by acknowledging that, with the final bedding down of a working Executive in the Northern Assembly, political commentators and the smaller parties in the perpetual coalition have realized that a settlement which everyone agrees on brings a parliament and a culture in which there is no real opposition. While this salves, to a large extent, the turmoil of the Troubles, the cost is an often stifling consensus – one that mirrors the previous domination of Northern Irish culture by the Troubles and sectarianism, and one that allows little space for a language of alternatives. A new consensual claustrophobia replaces an old conflictual claustrophobia. My own suggestion is that the art-documentary tradition which arose during the Troubles had, in various ways, set itself at an angle to agreed ways of understanding the North, and that this meant that, in the time immediately after the Peace, photography had the intellectual resources to consider and identify the new issues which the Peace called into being, and to see the continued existence of old worries which had been left unresolved.

Writing in 2004 about her vision of the future of Northern Ireland, Monica McWilliams, a founder member of the Women's Coalition and (by 2004) a former Assembly member, noted how the term 'normalization' was then much in vogue in political circles. As McWilliams pointed out, normalization was predominantly taken in that context to signify demilitarization. The notion of what was 'normal' was thus subsumed into the terms of the political conflict that had preceded it. For McWilliams normalization also had to include an end to sectarianism, an end to violence against women, and a focus on social issues – the 'peace dividend' had to be genuinely spread, economically, and in such a way that it began to address poverty in the North.[4] This broad sense, that a turn is needed from the politics of negotiation and clashing identities to the politics of the 'social', is one of the impulses behind art-documentary photography in the North both after and indeed before the Peace Process. The interrogation of what lies underneath the skin of politics in the North had become the means by which the 'documentary' mode continued to work within its broad set of photographic practices. The outcome of this was to be that photographers working in the North during the Peace coalesced their projects around the less articulated, sometimes unspoken things which the Peace Process put off or put out of sight. How to commemorate or remember the dead and, more generally, the past, has been the most prominent of these issues, though the ways in which that has been configured have not always been as one might expect.

The putative 'normal' Northern Ireland which was argued over during the post-Agreement politicking period had already been contemplated in documentary work made before the Peace Process had a public

existence. There has long been a socialist tradition in the North which has argued that a concentration on 'national' issues has meant that the economic structures of life in Northern Ireland remained uninterrogated. Robert Wilson (the novelist who writes his fiction under the name Robert McLiam Wilson) and the photographer Donovan Wylie undertook a project, published in 1992, which sought to cut across the sectarian divisions of the North in order to 'assume moral responsibility for the poverty in our society'.[5] At this time Wylie's best known work was *32 Counties*, which was made on a journey around Ireland. *The Dispossessed* also charts a journey, in this case from London to Glasgow to Belfast, chronicling the kinds of deprivation and social exclusion which are found in each city. Wylie's images carefully register dignity and poverty in equal balance, as does Wilson's text. Wilson's take on the confluence of the Troubles with social conditions in Belfast is forthright:

> Belfast's violence involves its citizens in dreadful moral degradation … Simply, the violence makes the poor poorer. It makes the city more hopeless, easier to leave.[6]

This diagnosis is borne out in Wylie's Belfast photographs, which open with his image of Cavehill, a grainy and portentous image later published with the title 'Storm over Belfast'.[7] The texture of the monochrome and the pathetic fallacy of the weather set up the images which follow. Wylie's Belfast in *The Dispossessed* is a landscape of stained brick and closed shutters. There is rubble and there are also, as there are in Patrick Zachmann's 'Belfast. March 1991', discussed in Chapter Two signs of the redevelopment of working-class urban Belfast. Otherwise, Wylie focuses on people, on characterful faces in the midst of deprivation. It is noticeable that Wylie's selection of images in *The Dispossessed* keeps signs of loyalism or republicanism to a minimum (there are several references but many fewer than in, for example, his Belfast images in *Ireland: Singular Images*) and instead portraits and street photography are dominant. The people in this version of working-class Belfast are largely static, waiting for something to happen in a decayed urban environment.

Wilson and Wylie's work makes no precise political link between poverty and conflict and instead allows the comparison between the mainland British cities and Belfast to find its own connections. Wilson describes Wylie's photographs as 'firmly rooted in the pragmatic actuality of what he saw' and he then goes on to argue that what they both encountered were 'appalling conditions' alongside 'the real grandeur of people whose dignity and stature survived their predicament'.[8] Wilson's conviction, which is reflected in Wylie's photography, is that a case must be made for the esteem of those they met, talked to and photographed in *The Dispossessed*. As well as being a moral argument, as Wilson rightly calls it, this is also a political assertion, because when the book gets to Belfast both the text and the images consciously circumnavigate sectarianism in order to get to the social conditions of everyday life. This form of 'normalization' precedes the time of the Peace Process, but makes the same point that McWilliams was making in 2004.

Such 'normalization' can occur on a variety of planes. Photographic documentary projects can have large-scale ambitions, a hope that they can represent entire geographic areas. The outcome of this 'locally' is a re-orientation of place, if not quite a 'normalization' of it. Mark Power, a Magnum photographer,

Chapter Four **Peace: 'present past'**

undertook a series in 2003 entitled *The Shipping Forecast* which had, as it organizing principle, the BBC Radio 4 weather report aimed specifically at seafarers. Power ties his images to the sea areas around the British Isles and his 'Irish Sea' photograph shows a view towards the sea from Bangor, County Down. It is a bleak and bleached view, with a nicely framed equation of the sea beyond the foreground and the puddles of water on the path, which in turn points towards the sea. But this is a photograph which is more important for what it is not. This is a Bangor, in a journalistic photographic project, which has no reference to the Troubles or the politics of Northern Ireland. The animating idea in Power's *The Shipping Forecast* has no need for a more than passingly local sense of the place. Instead the sea is implied in each of his photographs. Such an all-embracing UK or British Isles approach to documentary-photographic projects is similarly evident in John Davis's *Metropoli* (2001). Davis treated Belfast like any other post-industrial city in Britain and so his urban view of 'Church and School' is interested in Belfast's modernist architectural pretensions as an example of a muted utopianism in postwar cities in the United Kingdom. Similarly Davis's view of one of Harland & Wolff's cranes, taken from its partner's gantry, uses the geometrical shapes made by industrial architecture to reflect on the increasing redundancy of such forms of labour and production in the UK economy. Davis's Belfast effectively exists under the same conditions as Birmingham, Liverpool and the other urban centres he visited as part of *Metropoli*. Stuart Franklin's *Sea Fever* (2005) is another project which subsumes Northern Ireland into a UK photographic realm, in this case charting coastal landscapes. All of these projects suggest a more widespread cultural change in how the North is regarded, and not just in photography. The fact that Davis, Power and Franklin treat Northern Ireland as just another stopover (in the UK, or Ireland, or the British Isles) on the route of a longer photographic journey suggests some form of 'normalization', of the North shaking off the photographic conventions which it accumulated during the Troubles. For those whose focus is or has been more fully on the North itself, however, treating the place as 'normal' was never going to be straightforward, or even possible.

Paul Graham's *Troubled Land* had been crucial in the development of a non-journalistic photographic representation of Northern Ireland. Made in the mid-1980s, *Troubled Land*'s ascetic mode of photography, in which single significant markers of 'identity' or the Troubles were etched onto the landscape, provided an influential model for later photographers working in the North. When Graham returned to Northern Ireland in 1994 his series *Ceasefire* was simply made from vistas of the sky, sometimes seemingly brightening, sometimes darker than might be wished. All the photographs are dated 6th April 1994, the day of the announcement of the first 'temporary' ceasefire which the IRA called in that year, preceding the longer-lasting ceasefire which began in August. Graham's response to the event appears whimsical but is deeply intelligent. The ground of Northern Ireland, in Graham's best known work made there, was always marked, written on and contested. His immediate response to the announcement of a ceasefire is to turn away from the ground to the sky. It is, initially, a gesture of hope, a looking up. The sky is, however, full of portents, futures swirling in cloud formations. It is as if Graham has already anticipated the problem which the PR company who put together the cover of the Good Friday Agreement, four years after this, toiled over. Graham's *Ceasefire* photographs show that the 'historic' moment will want to force the symbolic from any image which tries to represent it. Graham preserves his photography from this journalistic momentum by turning away from the materiality of the landscape. In doing so he suggests

**John Davies**
**Harland and Wolff, Belfast**
**2001**
From the *Metropoli* project.
Silver gelatin print.
50cm x 60cm.
© John Davies.
Courtesy of the artist.

that the camera can acknowledge what has happened, but bide its time, wait for the moment to pass, and then turn back to examine what is left behind, after the furore.

Those involved in promoting the Peace Process have liked to think of it as replete with 'historic' events, almost to the point at which history becomes exhausted and falls into parody. Speaking in Belfast in 1997 Tony Blair said that he thought it was time 'to put the past behind us'.[9] Inside the profound oxymoron at work here, Blair knew that the intention of the Agreement was to teach Northern Ireland amnesia. A specific outcome of the contingent desire to forget about the past in order to create the political structures of the Good Friday Agreement was that remembering was, temporarily, officially, forgotten. A series of initiatives (the Bloomfield Report followed by the report of the Consultative Group on the Past) were treated half-heartedly by the governments and the political parties in an attempt to avoid controversy, or to use controversy to political advantage. Meanwhile the 'present past'[10] continued to press on the consciousness of those living in the North, and, as Stefanie Lehner points out, 'the temporality that trauma introduces seems, paradoxically, to remain forever "outside" history'.[11] When trauma is pushed outside 'History', its voice seeks, continually, to find a way back, to be heard. This awful dialectic of suppression leads to what Jacques Derrida described as a 'hauntology', a ghost which stalks that which represses it.[12] It is not too fanciful to see that ghostly presence in Paul Graham's cloud photographs, their immateriality a sign of what has already, at the very moment of the first ceasefire, started to be forgotten.

In the midst of the uncertainty of the Peace Process Moira McIver's 'Memory Memorial' (1995) could be said to anticipate how the legacies of the conflict would continue to nag at the present. McIver's 'memory' is projected backwards to the Second World War, and more widely to the British military story in Northern Ireland, but in doing this her images reverberate with the recent 'memory' of the Enniskillen bombing of 1987, partly because of the prominence of poppies in the work. That doubled awkwardness of the title of the work, 'Memory Memorial', describes well the visual effect in the portraits, in which veterans of the Second World War appear in battledress. Their portraits are framed in such a way that the men's faces rarely appear, and then only partially. Enough is revealed to show their age, their wrinkled skin and their aged postures. The uniforms hark back to their military past, so that the images seem to hold two times together. The implication of McIver's work is that the memories, signalled visually here, do not fade for these men. And the exhibition of these images becomes a challenge for viewers, asking us to assess the legacy of the memory of the Second World War and how, or whether, we recall or comprehend the remnants of the war. As an act of remembrance regarding the global conflict which most shaped the world we inhabit, and which each generation treats with increasing levels of amnesia, McIver's work sits at a point just before Northern Ireland was about to be encouraged to follow, more quickly, a path of forgetfulness.

The consciously over-stressed importance of memory in McIver's work is a doubleness which sets two historical moments side-by-side in order to question the present about its relationship with the history which constitutes it, but which it cannot remember. In the photography which Victor Sloan made around the year 2000, with reference to the ongoing dispute over the Orange Order's march to and from

**Paul Graham**
**Ballymurphy, Belfast, April 1994**
**1994**
From the series *Ceasefire*.
Pigment ink print.
110cm x 141.3cm.
© Paul Graham.
Courtesy of Anthony Reynolds Gallery, London.

**Paul Graham**
**Craigavon, Northern Ireland, April 1994**
**1994**
From the series *Ceasefire*.
Pigment ink print.
110cm x 141.3cm.
© Paul Graham.
Courtesy of Anthony Reynolds Gallery, London.

156

**Paul Graham**
**Shantallow, Northern Ireland, April 1994**
**1994**
From the series *Ceasefire*.
Pigment ink print.
110cm x 141.3cm.
© Paul Graham.
Courtesy of Anthony Reynolds Gallery, London.

Chapter Four **Peace: 'present past'**

**Moira McIver**
**J. Campbell**
**1996**
From the series *Memory Memorial*.
C-type print.
51cm x 61cm.
© Moira McIver.
Courtesy of the artist.

158

**Moira McIver**
**Poppies**
**1996**
From the series *Memory Memorial*.
C-type print.
122cm x183cm.
© Moira McIver.
Courtesy of the artist.

Drumcree church, there is a similar twofold strategy. But in Sloan's case the backward glance is to his own images. The photographs in the *Drumcree* and *Portadown* series are dominated by close-ups of the textures and patterns on surfaces – the walls of houses and the burnt walls of churches, underpasses that are graffitied, and the Perspex on a bus shelter, also graffitied. The latter is the clearest signal in the work that we can understand it as harking back to Sloan's earlier *oeuvre* – Perspex is also, as we have seen, scratched and written on in the *Belfast Zoo* series and the charred walls of the church are scored with white markings which descend the image in the manner of Sloan's own incisions on some his images from the 1980s, in which the Orange Order also appears. 'Bridge, Drumcree' shows that this technique is both self-referential and experiential, in that it records the effects of time on a material substance. 'Bridge, Drumcree' is an image which, like others in this series, could double as an abstract work, a non-representational manifestation of an outpouring of ferocity. Its 'actual' existence as a place, and a set of laboured marks on concrete, connects it back to Sloan's own art (it adopts the coloration of his *Day of Action* sequence, for example), and having done so the piece then raises the possibility that, in 2000, the same forces which created Sloan's first Northern Irish artworks are still at play. Given the circumstances of Drumcree ('"The hatred is hanging off them", said one [police] officer patrolling the town centre'[13]) Sloan's déjà vu is apt. Sloan's images see, intently, that hatred, still in existence after the Good Friday Agreement, and concentrated in the one small geographical area which he has lived and worked in for many years.

In those years immediately after the Good Friday Agreement, Northern Ireland faltered into a new dispensation. Even when it was recognized that the Agreement left some aspects of the Troubles unresolved, it was most often assumed by politicians that issues which directly related to those who might be called 'combatants', such as decommissioning and policing reform, were the dominant, leftover political topics, and so the theatrics of these issues tended to drown out other 'legacies' of the Troubles. One of the most difficult of those neglected aspects of the repercussions of the violence, and one which all participants in the Process knew would have to be addressed, was the fate of the 'Disappeared', those people who were murdered during the Troubles by the IRA (almost exclusively) and buried in unmarked graves. The majority of these burial sites were along the border. David Farrell's *Innocent Landscapes* (published in book form in 2001) shows the places where the Disappeared were searched for.[14] The images in *Innocent Landscapes* are of counties sometimes outside of the range of the North's immediate sightlines (Meath, Louth, Monaghan and Wicklow), but they cast the viewer back to the North, the Troubles and their aftermath. *Innocent Landscapes* is primarily a recognition of the urge for completion and closure, the oft-stated desire of the relatives of murder victims to have the victim's body returned, and for the ritual of a funeral to draw their story to a conclusion. Farrell's photographs perform a social function in this regard – they are reminders to us all of what has been forgotten and they ask us to recall the particular agonies of these victims and their families. They also do much more. In writing about the search for her mother and the campaign to keep the issue of the Disappeared to the forefront of public discourse, Helen McKendry (daughter of Jean McConville, who was murdered by the IRA in 1972), wrote:

> From that first visit to Templetown beach, I felt my mother was close, I enjoyed an
> inner peace for the first time since she had been so cruelly torn from me. Did I really

**Victor Sloan**
**Bridge, Drumcree, Portadown**
**2000**
From the series *Drumcree*.
C-type print.
126.5cm x 160cm.
© Victor Sloan.
Courtesy of the artist.

**David Farrell**
**Innocent Landscapes, Ballynultagh**
**1999**
From the series *Innocent Landscapes*.
© David Farrell.
Courtesy of the artist.

David Farrell
**Innocent Landscapes, Ballynultagh**
**1999**
From the series *Innocent Landscapes*.
© David Farrell.
Courtesy of the artist.

163

David Farrell
**Innocent Landscapes,**
**Templetown**
**1999**
From the series *Innocent Landscapes.*
© David Farrell.
Courtesy of the artist.

want to take her from this beautiful and peaceful beach and place her in Milltown, Belfast, among the very people who had stolen her body in the first place?[15]

At this stage Jean McConville's remains had not been found. Despite official searches of Templetown beach in County Louth, Jean McConville's remains were only discovered accidentally by a member of the public in 2003. Farrell's photographs of the search site at Templetown beach carry with them that same question which Helen McKendry asks. The image here shows the entrance to the site, a car park beside the beach which has been excavated. Just as the land has been disturbed and transformed by the dig, returning the area to sand, so the now solitary barrier for high vehicles, in its redundancy, is transformed into a kind of portal, an ingress into a world which may be inhabited by the ghost of Mrs McConville. Farrell allows the image full sunshine and blue skies, but, by contrast and implication, Belfast in 1972 is 'in' this photograph – and why would anyone want to go 'back' there?

Farrell allows a sublime landscape mode to echo throughout *Innocent Landscapes*, so that some of the more mountainous areas where searches took place appear to be just landscapes, places of de-peopled beauty. But elsewhere the land is gouged by mechanical diggers or marked with less obtrusive signs of the searches which were undertaken for the bodies. *Innocent Landscapes* becomes a tense series of images of evidence-in-waiting, and each hint of a change of texture or colour in the minutiae of the landscape sparks a detective impulse in the viewer, as if something might have been found or uncovered here in the image; as if the photograph was taken as a record of an unearthing. In this sense the images are almost performative – they imitate the act of excavation, its precision and its care. They are also, in the mode of the searches, sensitively attuned to micro-landscapes and to the way in which a landscape registers human presence. Farrell's work at the sites of the Disappeared shows how it is possible to photograph a narrative that is not there. The outcome of this, in a variation of much of the art-documentary work which was undertaken during the Troubles, is that the 'trace', or some sign of the presence of a human being having been 'here', is what his photographs frame or look for.

Farrell continues to revisit the sites of the Disappeared long after the searches are finished, and in the intervals between searches.[16] This persistence and dedication is testimony to his commitment to the cause of remembrance in the case of the Disappeared. It is also a reminder that, in a time when governmental, political and journalistic commentators were 'encouraging pacific attitudes on the ground by "talking up" the peace process', photography was one means by which a sensibility which wished to pause, think and question was able to express itself.[17] Farrell's *Innocent Landscapes*, for example, recalls and keeps current the stories of the Disappeared. The photographs in *Innocent Landscapes* are also there because David Farrell was there. They are records of his presence, an attestation of temporary occupancy of a space. And to get to that space they require a journey, and a thought process which has gone into that journeying. In other words, this work by Farrell, along with the work of many other art-documentary photographers in Northern Ireland during this period, says that we must thoughtfully inhabit somewhere in order to understand it. We must think about the place, see it carefully, view it askance, in order to hope to see it as fully as possible.

The Peace Process was meant to offer a 'dividend' to the province. The terminology, derived from finance and metaphorically turning citizens into shareholders, perhaps gives away what the nature of the 'dividend' was actually to be. As well as being seen as a place of internecine violence, Northern Ireland during the Troubles was a region in which capitalism was said to have been 'held back'. The curing of the conflict meant new economic opportunities, and while the promise was of communal prosperity, the signal to capital and to speculators was that gains and 'dividends' awaited those willing to gamble in this unexploited territory.[18] In common with the rest of the Western world in the early years of the twenty-first century, this 'opportunity' found its expression in the chimera of property, channeled through mortgages and rental incomes. The physical infrastructure of the North, its anachronistic reliance on social housing, its unreformed post-industrial landscapes, all looked liked they needed the same solution which had been offered to similar problems elsewhere in the West. And so a process of redevelopment began, buoyed by its ideological and, as it understood it, logical, connection with the flourishing of the peace.

Like David Farrell, John Duncan is a footslogging photographer, someone who turns the cataloguing of place into mesmeric and dogged repetition. As discussed earlier, in Chapter Two, Duncan's mode of photography has been honed down over his career so that his most recent major projects deploy a confident, face-on, standing position, scrutinizing and cataloguing the changes in Belfast which have been brought about by the Peace Process. Duncan's work has within it an urge for completeness, as if it needs to photograph every Belfast example of the phenomena he becomes fascinated by. This suggests that, in looking at his work, we see something city-wide and historically significant – we are seeing through the lens of a hoarder of the city's secrets. The panorama of objectivity which appears to pervade Duncan's work, in its standing-back from its subjects, its consistent palette and lighting, in fact contains a passion for the place which wants its present to be seen unfolding, its past disappearing and its future uncertain. Duncan's reiterative photographic construction is a sign of how he feels the need to present evidence of what is happening to the city with a tempered urgency.

In his two *Boom Town* series Duncan charts the 'peace dividend' through the ways in which the city of Belfast is materially altered during the Peace. *Boom Town* records promises which were made to the city through the imagery of urban development. It is the ideology of change, as much as the actual architectural and environmental reordering of the city, which Duncan photographs. His sequence of photographs of builders' signs, each one promising a minor utopia rising out of Belfast's miserable past, and propelled by the momentum of the Peace Process, is a case in point. In each of these images the sign rather than the building takes a position just above the centre of the image. In each there is an expanse of tarmac, rubble or gravel in the foreground. These are photographs constituted by a mode of triangulation, so that they seek to stand back far enough to account for the building yet to come. An image of the Crumlin Road Courthouse, and its tasteless sign offering, for gentrification, a building which was the arena for drama and tragedy during the Troubles, is perhaps the most obvious example of how the series works. There is a wonderment at such vulgarity, such brazen erasure of the past. And that becomes more serious and more profound when Duncan looks at the ways in which working-class areas of the city are subsumed by the force of changes which seem to have the authority of the Peace behind them. His image of the sign

John Duncan
**Untitled**
**2002**
From the series *Boom Town*.
C-type print.
20cm x 25cm.
© John Duncan.
Courtesy of the artist.

announcing the building of South Side Studios shows his methodology at its most elucidative. The greys of the sky and the dull colours of Duncan's Belfast street scenes allow the sign in the photograph to become something of an optical illusion, as if it were trying to inhabit a different dimension to the rest of what is in the photograph. Its pledge of future lifestyle paradises hangs, then, where this idyll is going to be, and so the sign seems to be more than a promise. It is a window on a future in which things look as if they will be clearer and brighter. The photograph then frames this window with the world which it will replace, and allows a cramped sense of geography to crowd in. On the right, the last house on the northerly side of Tate's Avenue points the way to the Lisburn Road and thus signals the university area, student life and a set of attitudes which go with that part of the city. To the immediate left of the builder's sign a flagpole with a limp loyalist flag marks the territory of the Village. South Side Studios muscles in on this already tense borderline, and pushes the boundaries of the Village back a little further. The photograph is not just of the sign but of a dividing line, a class demarcation in the city. And the photograph shows that this frontier is about to move, territory is about to be taken over.

In his later work, *Bonfires* (2008), Duncan charts a similar shift in the geographical psychology of Belfast. There is a documentary value in *Bonfires*, in that the work shows events of political symbolism, Eleventh Night bonfires, during their construction. But that is only a part of their impact. *Bonfires* is also prescient about the fate of the phenomenon of the bonfire and what it symbolizes – about whether the bonfires have a future, and whether the kind of bourgeoisification which the Peace Process demands will allow any space (real or metaphorical) for the bonfires. By choosing to photograph the bonfires before, rather than after they are burnt (which would have created the perfect 'aftermath' photograph of contemporary Northern Ireland), and choosing to photograph the bonfires during the time of their construction, Duncan's photographs look forwards, and into the future. The bonfires have an imminence about them. They are waiting to burn, just as *Boom Town* photographs a city about to be built. This sense of futurity is vital to the moment in which the photographs are made. The 'alienation and marginalization'[19] felt by loyalists in the period after the Good Friday Agreement is visible in Duncan's photographs of the bonfires. Alan Jones, writing about attempts to control urban bonfires in Belfast, notes that 'bonfires add risk to bankers' equations'.[20] Bonfires threaten the peace dividend, if that dividend is understood in the strictly financial sense. And so, in Duncan's photographs, bonfires map the tensions at boundary points around Belfast where 'bankers' equations' meet the anachronistic loyalist 'celebration' signified by the bonfire – a specific geographical point where a particular version of history might stop.

The Tate's Avenue bonfire has been built in defiance of the now-completed South Side Studios. However, in the background, Duncan includes another builder's sign, the manifestation of the next step in the process of the redevelopment of the area and so, despite the insignia of loyalism around the bonfire, the forces of capital (flying their own insignia on their billboards) seem confident that they can displace this bonfire and what it represents. The question then becomes what will happen to this bonfire site next year, or the year after? And the same is true for the Sandy Row bonfire, which is surrounded by bland new buildings, including Days Hotel, then relatively newly opened, and heralding, apparently, a nascent tourism market for Belfast. Here too there is a jostling for position between the moving forces of capital and the

**John Duncan**
**Tate's Avenue**
**2008**
From the series *Bonfires*.
C-type print.
100cm x 120cm.
© John Duncan.
Courtesy of the artist.

170

Chapter Four **Peace: 'present past'**

**John Duncan**
**Shore Road**
**2008**
From the series *Bonfires*.
C-type print.
100cm x 120cm.
© John Duncan.
Courtesy of the artist.

172

'disillusionment and falling confidence' of loyalism and unionism.[21] On the Shore Road the geography of redevelopment has pushed the bonfire onto the footpath, as if it had nowhere else to go. On the right-hand side of the image Lidl's signage stands in unknowing mockery of the Union flag on top of the bonfire.

Duncan's *Bonfires* is a work which confronts the impetus of the Peace with the stasis of the bonfires. They stand lonely against the tides of change. They are all about to burn and disappear, and in different ways his images ask whether they will keep reappearing annually and whether the vigorous free market society, with its paradoxically regulated public spaces, will allow the anachronism of the bonfires to persist.

The critical and analytical impulse in Duncan's work is a carefully poised one. It is, as I have suggested earlier, difficulty to be a critic, or even an analyst, of the effects of the Peace Process without being seen as a nay-sayer, and without inviting the assertion that the Peace Process as it stands is the only imaginable alternative to violence. Duncan Morrow, a long-time campaigner for peace and reconciliation, writing in 2003, noted about loyalists, with some regret and sympathy, that 'many are still nostalgic and grieving for a society that they have lost. They cannot see a constructive future for their tradition.'[22] This is, indeed, as true now as it was then. But the overarching assumption here is that being of a 'tradition', and the fate of that tradition (its victory, defeat, acceptance or validation) is the standard measure of how anyone might 'feel' about the Peace. Duncan's work turns towards something more complex – an identity which belongs to the city; a relationship which people have with the place in which they live; a sense of the psychogeography of home being altered by forces beyond one's control or even comprehension. Such alterations in the landscape of people's lives are sometimes intangible, but they take on substance in Duncan's work. And, in this way, his catalogue of change is much more than an inventory of the passing present.

The material changes in the streetscape of Northern Ireland which were brought about by the Peace Process occurred in one very obvious and symbolic manifestation in recent years: the repainting of paramilitary murals. Duncan, Eoghan McTigue and Paul Seawright have all recorded this undoing of the iconography of the Troubles. In *All Over Again* (2004) McTigue pursues the visual blankness of walls which are in the process of being repainted, changed into twee assertions of local pride in sporting heroes or the sentimentalization of labour in days gone by. But, as Aaron Kelly notes, the fact that McTigue photographs these walls at moments at which they are, at least superficially, emptied of meaning, reveals 'that a properly shared and equitable public sphere in the city is yet to be established'.[23] Thus, as with Duncan's *Bonfires*, McTigue's images of the defacing of the 'traditional' murals as they are replaced with a tamer past, are poised at that awkward moment when the choice seems to be one between the horrors of the Troubles and the 'new dawn' of the Peace. Justin Carville notes that in Seawright's, Duncan's and McTigue's documenting of the end of the murals of Belfast, there is a constant 'seepage of the murals' visible traces out through the painted whitewash'.[24] This is exactly the dynamic which exists within these images and this moment in history – are we witnessing an erasure or a covering-up?

At the beginning of the Troubles, Northern Ireland was placed under the scrutiny of many photographic lenses – the press and the military, for example, recorded riots and protests in extraordinary detail. Within

174

art-documentary photography there is an awareness of the power and the ubiquity of the camera. And so it is fitting that an artist such as Victor Sloan should have taken cognizance of a new photographic occurrence in the North – the tourist photograph. In Sloan's *Stop* (2010) series he went on the Troubles tours around the sights of Belfast with an international crew of tourists and photographed both what they saw and them photographing what they saw. Sloan comments, first of all, on the curiosity of Troubles tourism. But there is more to it than this, because it might be argued that these images by Sloan of the new Northern Ireland, which are inherently self-conscious about photography since they include amateur photographers, look back to Sloan's much earlier work. In the *Moving Windows* series from 1985 the connotations of the moving car, from which the images were shot, were sinister, with the aura of the drive-by shooting, the stake-out, the getaway. Here the shots are also taken from inside a vehicle, but now it is an open-top tourist bus, and Sloan's involved, insider eye has been made into a tourist's view of the city of Belfast. There is, then, an estrangement from home in *Stop*, a feeling that the place is not *belonged to* but is a spectacle.

Martin Parr also visited Belfast and found his yen for the surreal in everyday life drawing him to the same, slightly ghoulish, excitement of the Troubles tour bus. There is just a small degree of difference between his image of a woman being transported to Stormont and Sloan's of Carson's statue hectoring a city which is no longer impressed by him. The difference lies in the degree of irony and amusement which the situation provokes. For Parr it is a chance for another examination of the behaviour of tourists, an opportunity to examine what one critic calls Parr's fascination with 'the prescribed ways in which [tourists] interact with sites'.[25] For Sloan, the tourists in his images form a kind of barrier between his camera and the substance of the North. *Stop* as a title for the series seems to suggest that this might be an ending to something – or a plea to stop this new Northern exhibitionism.

The 'new' Northern Ireland waits to be photographed, and to find its new modes of being perceived. The archiving of the past, the alterations in the landscapes and streetscapes, the haunting of the past by the present – all of these have been features of the way in which art-documentary photography has sought to react with care and critical awareness to the often confusingly novel situations which the Process has brought about. Chris Steele-Perkins came back to Belfast in 2008 to revisit people whom he had photographed many years before. His image of Owen Coogan and his family is typical of what he found – as with many of his Troubles images, Steele-Perkins places his subjects in static positions, suggestive of contemplation and entrapment. Black-and-white has become colour, urban degradation has become suburban neatness. What lies behind this, what memories or stories, remains enigmatic in Steele-Perkins's revisit to Northern Ireland, as if he could not quite find an angle into the thoughts behind the inscrutable faces of his subjects.

It will be for a new generation of photographers to shake off the visual legacy which Northern Irish photography now carries with it, to see behind the masks, just as they will have to find ways in which to negotiate with the receding memory of the Troubles. In the final chapter I discuss how some new patterns are, possibly, emerging amongst photographers working in Northern Ireland in ways which are grounded in

**Victor Sloan**
**Stop (Carson)**
**2010**
From the series *Stop*.
Lambda Print.
120cm x 180cm.
© Victor Sloan.
Courtesy of the artist.

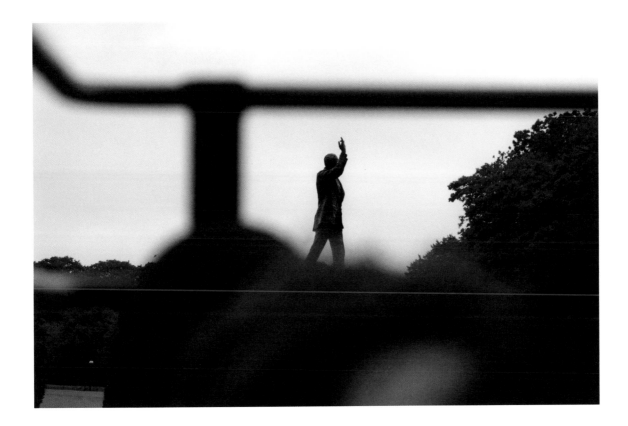

**Martin Parr**
**City Sightseeing Tour**
**2008**
From the series *Guardian Cities Project.*
© Martin Parr/ Magnum Photos.
Courtesy of Magnum Photos.

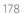

Chapter Four **Peace: 'present past'**

earlier work but which conceptually, visually and geographically are moving beyond the boundaries of Northern Ireland. Meanwhile, there are also signs that photography which very directly addresses the fallout of the Troubles is reaching out towards new ways of seeing the North as it is now.

Adam Patterson's *Men and My Daddy* (ongoing) examines the residues of loyalism in contemporary Northern Ireland, and, as the title of his work suggests, one of the most important factors which Patterson adds to the existing templates within Northern photography is an explicitly personal engagement, an autobiographical strand, which stitches the images into a much more emotive fabric than the pseudo-objectivism which art-documentary modes in the North have often relied on. This is not to say that previous photographers were not personally engaged with the fate of the North, its citizens or its sense of itself. Far from it. But the suppression of any personal narrative or reaction to events was used as a way in which to give a power to the image, as if a confessional mode undermined a wider politics which might emerge from the image. Patterson's aesthetic has clearly come under the influence of (or the same influences as) Seawright and Duncan. Here the tarmacadamed foreground, the barriers and the sense of a symbolically enclosed urban landscape, echo landscape images of Belfast which we have seen already. Patterson also records the over-painting of loyalist murals, and includes archive photographs to explain his back story. But it is the insider informality of images of men waiting to commemorate the dead, with wreaths of poppies, which brings us full circle. At the beginning of the Troubles, press photographers arrived in Belfast, Derry and throughout the North, planting themselves inside groups of men, women and children who were made to represent – in the sense of being typical of – the North. Here Patterson, bequeathed modes of photography from three decades of developing practice, is able to take similar shots to those of the 1970s, but without that aura of drama-about-to-happen, without that anthropologically scrutinizing eye that remains in even the most empathetic of photojournalism. Patterson's work claims 'insider' status without over-declaration. Using the methods of art-documentary photography it promises to tell new stories.

Malcolm Craig Gilbert's *Post-Traumatic Exorcism* (2008– ) is an impatient parody of the dilemma of deferral and constant return of the repressed which has characterized the Peace Process. The men and women of Craig Gilbert's hyper-real Northern Ireland revel in the unreality of the world they inhabit. The heightened colours of the images match the filmic drama of the situations which they dramatize. Tarantino-esque in its wild stories of violence, Craig Gilbert's work brings together a world of digital media (film, television, internet), the alienation of dead capital, and the force of uncanny recurrences unleashed. Discussing the controlling character of McClure in Eoin MacNamee's novel *Resurrection Man* (a book which contemplates amoral excesses of corporeal violence in ways which are similar to Craig Gilbert's work), Aaron Kelly notes that McClure 'appears performative, almost self-effacingly ironic, and gestures towards the historical conditions of late capitalism's reification of place, identity and belonging'.[26] Craig Gilbert's vision is of a society which is trapped in a drift between existence as performance and a damagingly detached irony. His most rural and pastoral scene involves a child playing the role of a gunman – in these staged photographs everyone is enacting a self and is seen to be enacting a self. A father figure looks on, from the shelter of the caravan, with satisfaction and faux self-effacement, so that the generational dynamic is, in the terms which Aaron Kelly uses about McNamee, a perversely reified and violent one. There is irony too in the evangelical sign, because this scene enacts urgent dramas of

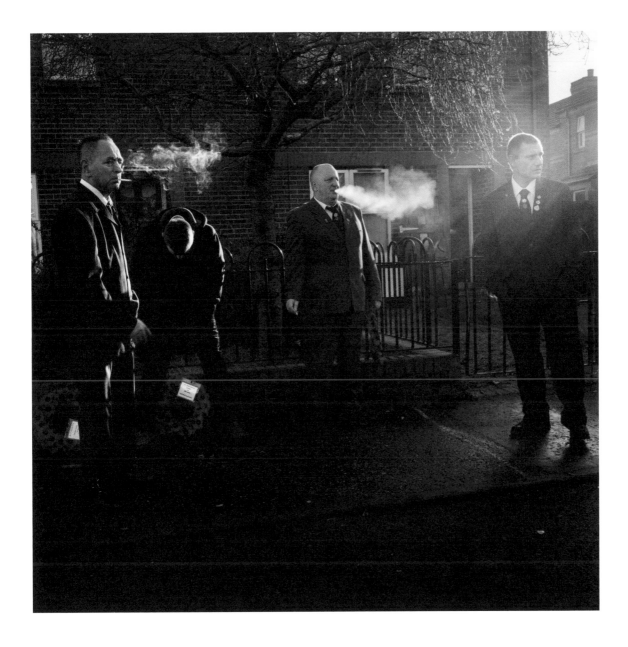

Chapter Four **Peace: 'present past'**

**Adam Patterson**
**Untitled**
**2011**
From the series *Men and My Daddy*.
© Adam Patterson.
Courtesy of the artist.

182

**Malcolm Craig Gilbert**
**A Storm of Betrayal**
**2009**
From the series *Post-Traumatic Exorcism*.
Archival pigment print on cotton rag paper.
53.3cm x 86.3cm.
© Malcolm Craig Gilbert.
Courtesy of the artist.

184

death and rebirth – the child in this image is indeed becoming a 'resurrection man'. And the outcome of Craig Gilbert's work is that the repetition of Troubles-like behaviour occurs in a visual and social demiworld. 'We have moved, then, from an objective reality to a later stage, a kind of ultra-reality that puts an end to both reality and illusion.'[27] This is an unreality which can lead to utter rootlessness, to despair at the incredible, ineffable weight of the past pressing down on the substance-less present. Craig Gilbert's men, in particular, feel the presence of this vacuum. *Post-Traumatic Exorcism* sees and stages the forces which have coalesced and which bubble under the public and political surface of the Peace Process. The hope, if there is one, must be that the work of making and looking at these images, with a critical, questioning view of the North, means that they can begin to be an exorcism.

1   Richard West, 'It's Your Decision?', Source: http://www.source.ie/issues/issues0120/issue15/is15revyoudec.html and also Slavka Sverakova, 'A Cover with a Spin', Source: http://www.source.ie/issues/issues0120/issue15/is15revcovspi.html.

2   Martin Mansergh, 'The Background to the Irish Peace Process' in Michael Cox, Adrian Guelke and Fiona Stephen (eds), *A Farewell to Arms? Beyond the Good Friday Agreement* (Manchester: Manchester University Press, 2006), p. 32.

3   Greg McLaughlin and Stephen Baxter, *The Propaganda of Peace* (Bristol: Intellect, 2010), p. 13.

4   Monica McWilliams, 'Northern Futures', *The Irish Review*, 31 (2004), 84-87.

5   Robert Wilson and Donovan Wylie, *The Dispossessed* (London: Picador, 1992), p. 179.

6   Wilson and Wylie, *The Dispossessed*, p. 173.

7   Donovan Wylie, *Ireland: Singular Images* (London: André Deutsch, 1994), n.p..

8   Wilson and Wylie, *The Dispossessed*, p. 181.

9   Address by Prime Minister Tony Blair at the Royal Agricultural Society Belfast, 16 May 1997: http://cain.ulst.ac.uk/events/peace/docs/tb16597.htm

10  Graham Dawson, *Making Peace with the Past? Memory, Trauma and the Irish Troubles* (Manchester: Manchester University Press, 2007), p. 10.

11  Stefanie Lehner, *Subaltern Ethics in Contemporary Scottish and Irish Literature: Tracing Counter-Histories* (London: Palgrave, 2011), p. 60.

12  See Jacques Derrida, *Specters of Marx* (London: Routledge, 1994).

13  Quoted in Beatrix Campbell, *Agreement! The State, Conflict and Change in Northern Ireland* (London: Lawrence & Wishart, 2008), p. 251.

14  See David Farrell, *Innocent Landscapes* (London: Dewi Lewis, 2001).

15  Helen McKendry, 'Afterword' in Séamus McKendry, *Disappeared: The Search for Jean McConville* (Dublin: Blackwater, 2000), p. 145.

16  See David Farrell's blog at http://source.ie/blog/.

17  G.K. Peatling, *The Failure of the Northern Ireland Peace Process* (Dublin: Irish Academic Press, 2004), p. 6.

18  See Denis O'Hearn, 'Peace Dividend, Foreign Investment, and Economic Regeneration: The Northern Irish Case', *Social Problems*, 47: 2 (2000), 180-200 and Aaron Kelly, 'Geopolitical Eclipse: Culture and the Peace Process in Northern Ireland', *Third Text*, 19: 5 (2005), 545-553.

19  Tony Novosel, *Northern Ireland's Lost Opportunity: The Frustrated Promise of Political Loyalism* (London: Pluto, 2013), p. 218.

20  Alan Jones, 'Just a Little Corner of Belfast to Burn', *Fortnight*, 414 (2003), 12.

21  Graham Spencer, *The State of Loyalism in Northern Ireland* (London: Palgrave, 2008), p. 224.

22  Duncan Morrow, *On the Road of Reconciliation: A Brief Memoir* (Dublin: Columba, 2003), p. 82.

23  Aaron Kelly, 'Walled Communities' in Eoghan McTigue, *All Over Again* (Belfast: Belfast Exposed, 2004), n.p..

24  Justin Carville, *Photography and Ireland* (London: Reaktion, 2011), pp. 157-159.

25  D. Medina Lasansky, 'Introduction' in D. Medina Lasansky and Brian McLaren (eds), *Architecture and Tourism: Perception, Performance and Place* (Oxford: Berg, 2004), p. 2.

26  Aaron Kelly, *The Thriller and Northern Ireland Since 1969: Utterly Resigned Terror* (Aldershot: Ashgate, 2005), p. 105.

27  Jean Baudrillard, *The Intelligence of Evil, or the Lucidity Pact* (Oxford: Berg, 2005), p. 27.

# Chapter Five
# The Archive: 'the sum total'

In its ideal form an archive would like to be 'the sum total of the known and the knowable'.[1] Actual archives, whether in the physical shape of a museum or the more amorphous state of a collection of photographic images, can be modest affairs – dusty, yet layered and structured by organizational obsessions. Shadowing an archive's practical limitations is the impulse to encapsulate everything there is to be known about a particular subject. There has been a wealth of photographic projects and exhibitions in and about Northern Ireland in recent years which have utilized the 'archive' as their organizing principle. These play on the capacity of photography to catalogue and record a truth. They are projects which know that archives imply something total, an unexpurgated completeness, validated by the authenticity of being made from primary materials. Thus there is always a form of irony at work in these Northern Irish, photographic archival projects. They know they are not really, fully archives, but it is through the deployment of the archival impulse that they get their purchase on their subjects. Their urge to archive comes from a conviction that the 'truth', or the 'knowable', is being lost sight of and must be collected before it disappears. In adopting the mode which an authoritative institution would take, these photographic archives express an anxiety about post-Good Friday Agreement Northern Ireland, an anxiety which broadly suggests that there has been a loss, or a contortion, of memory in Northern Irish society. And as with all archives, the way they see the past has implications for the way they imagine the future.

In the post-war, or postmodern, era the archive has been used as an artistic and photographic way of thinking about the aftermath of political and social violence; the archive offers both the chance to gather together stories and overwhelm the viewer with the scale and weight of past events. Artistic versions of the archive sometimes involve (literally) uncovering a hidden history. Mark Dion's *Tate Thames Dig* (1999) collated and catalogued objects dug up from the foreshore of the Thames and included items ranging from clay pipes to contemporary refuse, all of which were exhibited in a specially made wooden cabinet harking back to Victorian naturalist obsessions with the display of species. More often such manifestations of the archive as the meaningful structural principle of an artwork rely on the kind of play of individuality against history which is seen in work such as Gerhard Richter's *Atlas* (1964– ), a vast collection of 'found' images and the artist's own photographs, dominated by portraiture, and dizzying in its capacity to be both personal and historically monumental at the same time. More politically focused examples in recent decades are

Ilan Lieberman's *Niño Perdido* (2006–7), made up of drawn portraits based on photographs of 'disappeared' children from Mexico City, or Felix Gonzales-Torres's *Untitled (Death by Gun)* (1990), which displays the faces of over 400 people who were killed by firearms in the United States in one typical week in 1989.

In earlier, non-Irish historical contexts there was an archival impulse in documentary projects which featured photography as part of their work. Mass Observation in the 1930s used the photography of Humphrey Spender, for example, as part of its extensive record of British society. Much more influential on later global photographic practice was the work of the American photographers who were enlisted to work under the banner of the Farm Security Administration.[2] Within the FSA work, and indeed Mass Observation, was a belief that the revelation of social conditions through the evidence of the photograph would not only catalogue social injustice but also work as a catalyst for change. At the very least there is an insistence within such work on the political importance of recording the facts of individual lives which are lived out in straitened conditions.

As such projects suggest, there is an interest in contemporary art in 'how archival legacies become transformed into aesthetic principles'.[3] And those principles retain a conviction in the capacity of the documentary mode to speak the truth to power, and of the archive to maintain that truth. It is the cumulative power of documentary imagery that gives meaning to the 'aesthetic principles' of much of the work discussed in this chapter.

Photographic archiving is not the preserve of the state, or of national institutions. In a marvellously candid short documentary film about the photographic archive of the *Newtownards Chronicle*, made by *Source* magazine, the unglamorous exigencies of ordering an accumulating store of images on a daily basis are made clear.[4] Similarly the Belfast Exposed archive is an example of an 'unofficial', almost accidental, archive, which is full of the possibility of that it will divulge authentic insights into Belfast's past. In Northern Ireland in recent years there have been several projects which have tried to create accredited archives of Northern Irish life – less all-encompassing in their social ambitions than the large-scale 1930s national-level projects, but nevertheless aware that photographs have an enhanced power when collected together under a single aegis.

Paul Quinn's series *Maguire's Barbers* (1996) becomes 'archival' partly through its repetition of form, with each portrait being taken as if from inside the mirror of the barber's shop. Resonant of the photo-booth, which is in turn resonant of the criminal portrait, or at least the identification document, these images of Belfast men achieve a poised vulnerability. The pause in the tracks of the day which is a visit to the barber's is made equivalent to the photograph itself, and each man looking at himself in the mirror, unable to move away from his own image until the haircut is finished, is not just a replication of the moment at which a portrait photograph is taken but is an extended contemplation of the self. In this way Quinn's series stretches the cataloguing nature of his work. In the act of making his photographs he replicates the process of contemplating his photographs.

190

**Sean McKernan**
**Funeral of Paul McCann**
**1984**
Black-and-white photograph.
© Sean McKernan.
Courtesy of Belfast Exposed.

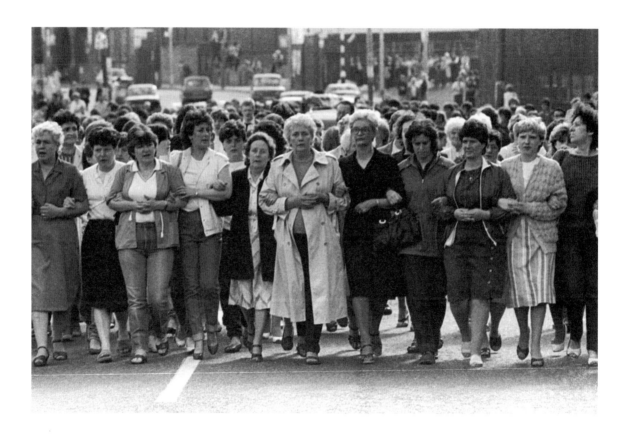

**Sean McKernan**
**Funeral of Paul McCann**
**1984**
Black-and-white photograph.
© Sean McKernan.
Courtesy of Belfast Exposed.

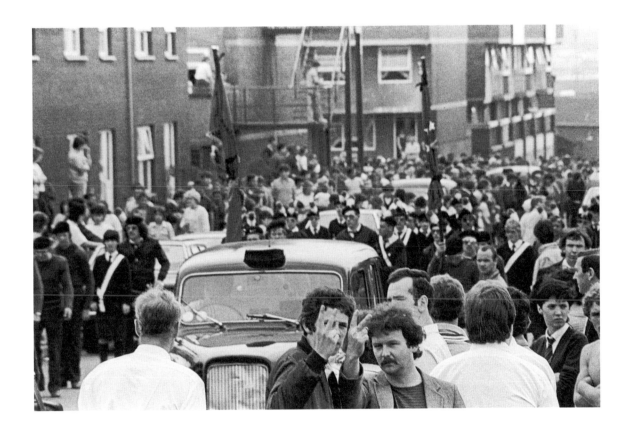

Chapter Five **The Archive:** 'the sum total'

194

Similarly Patrick McCoy's *The People's Taxis* (1998) uses an everyday experience in Belfast, travelling in black taxis, as a chance to reproduce the conditions of portraiture, so that the back of the taxi becomes like a photographer's studio. The camera sees from the point of view of a fellow traveller in the cab and thus what is indexed in *The People's Taxis* is deliberately commonplace. From this basis, the texture of individual personality becomes one of the dominating features of the work. But McCoy's sequencing of the images, in which passengers come and go, uses the circumscribing completeness of the archive of the journey to create narratives which are both workaday and potentially allegorical. The disappearance of a passenger from the sequence, for example, seems to take on massive connotations in the enclosed world which they depict.

The kind of work which Quinn and McCoy undertook is close to the lives of people living, in these cases, in working-class areas of Belfast. Both sets of photographs involve a nuanced sense of the pace and character of life in the city. Quinn and McCoy also very deliberately avoid visual reference to the identity politics of the individuals involved in the portraits. The effect of this is an insistence that life in Northern Ireland exists in more than just the political arena. Putting the day-to-day into an archive form underlines the point: that it is necessary to remember the wholeness of life in Northern Ireland, beyond the shape which is given to existence by the dominance of questions of nationality. McCoy's later work, *Album*, a collection of 'found' photographs, reinforces this notion in cleverly literal ways. As Ciaran Carson wrote about this work:

> … it looks like some of the photographs have been used [as] a dartboard, slashed
> with a knife, splattered with blood. They are punctuated as if by machine-gun fire.
> Who could do such things?[5]

Carson points out that there is a joke here that, consciously or otherwise, takes literally the 'punctum' of Roland Barthes famous theory of photography in *Camera Lucida*.[6] The 'violence' done to these images in their apparent neglect is perhaps a way of representing, and reintroducing, the violence of the society in which they were taken, so that their first existence as family snaps is overlain with, in Carson's phrase, 'blind catastrophe'.[7]

That Quinn and McCoy photographed in this mode in the mid to late 1990s may in future be seen as part of a wider historical moment, one which was formulated by the beginning of the end of the Troubles – and by the time they were working on these projects the tectonic movements towards peace were detectable. The black taxis on the Falls Road, for example, became iconic vehicles of celebration with the announcement of the IRA ceasefire in 1994. As the Good Friday Agreement of 1998 took hold, the sense of what Northern Ireland was to become, and what it had been, started on a process of inexorable and difficult change. This in turn led to new ways of seeing the archive in photographic work made in Northern Ireland. A political necessity in the years following the Good Friday Agreement was that everything not codified within the process of peace had to wait for resolution. Part of that waiting process was to filter out that which did not fit into or attend on the present moment. The difficult and embarrassingly recent

196

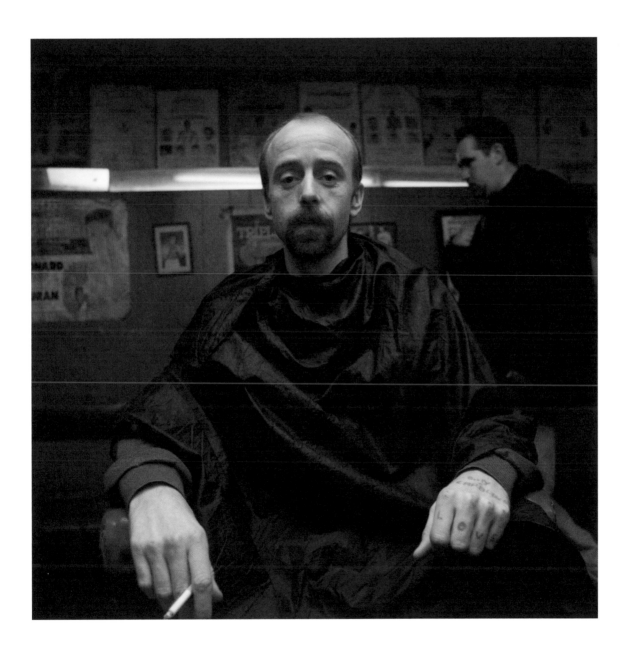

**Patrick McCoy**
**Untitled**
**1998**
From the series *The People's Taxis*.
© Patrick McCoy.
Courtesy of the family of Patrick McCoy.

198

**Patrick McCoy**
**Untitled**
**1998**
From the series *The People's Taxis*.
© Patrick McCoy.
Courtesy of the family of Patrick McCoy.

199

past, and the irritatingly non-conforming present had to be archived, consigned to the past, or left for another day's work. Frankie Quinn's extensive surveys of the Peacelines and interfaces of Belfast, for example, point to the persistence and reinforcement of sectarian boundaries within the city in the post-Agreement period.[8]

Over the years since the Good Friday Agreement, photography in Northern Ireland has reflected on the archival tendency which is now part of the structure of Northern Irish society. Projects by Richard Adam, John Davies, Kai-Olaf Hesse, John Duncan, Claudio Hils, Ursula Burke and Daniel Jewesbury, Donovan Wylie and Broomberg and Chanarin consciously tap photography's archival possibilities and link it to the specific recent history of the North. Each of these projects has a self-consciousness about its own summoning of an archival technique. And, in their singular ways, these photographers draw on those very features of photography which constitute its archival promise (the documentary, the photo-essay, the anthropological study and the photojournalistic commission) as generic backdrops to their interest in Northern Ireland's changing, sometimes disappearing, cultural and social structures.

In the series of archival photographic exhibitions and projects which have been shown in Northern Ireland in the last ten years or so there has been an emphasis on what Paul Ricoeur calls the 'role of being a warrant' which 'constitutes a proof'.[9] At a basic level the photograph in these instances functions, initially at least, as an evidential record; but the nature of the evidence is not straightforward. In presenting themselves as substantiations of reality these photographs insist that a broadly political process of collecting together a 'reality', then collating and reproducing it, is not happening. These archives attest to a social and political lack, a forgetting and skewing of how things are. Simultaneously they function as an archive of an alternative way of seeing. They are not authoritative and institutionally validated. Instead they are critical, with a compassion and social conviction that regrets the need to use serious irony in order to understand and try to see into the empty spaces left behind by a society intent on forgetting. It is the (always disappointed but persistent) promise of full remembrance which makes the archive such a compelling form for recent Northern Irish photographers.

A complex documentary mode is seen in the forms of witnessing which these projects undertake. Kai-Olaf Hesse's *Topography of the Titanic* is specifically honed on the meeting point of old and new Belfasts. The work was made in and around 2003, well before the current *Titanic*-related frenzy in Belfast really took hold, and it has a kind of prescience as a result. Like much urban photography that has come out Belfast in this period, Hesse's landscapes prioritize an absence of texture and life in the city, stripping away detail to search for essence.[10] Hesse's sense of the interpolation of the past into the present raises the city's ghosts, or at least makes a part of the city spectral. This is, sadly, appropriate to a project which, after all, 'commemorates' a human disaster. The landscape of the docks, around which Hesse made his images, seems to offer him shapes and material textures which are imprinted with the memory of the *Titanic*. So a ripped-up strip of reinforced concrete leaves its core iron rods exposed, and they slope back at an angle reminiscent of the funnels on the *Titanic*. The redeveloped area on the city side of Queen's Bridge is seen in all its hopeful banality, and, stared at, it begins to look like an obsessive homage to ship's

202

**Kai-Olaf Hesse**
**Shipbuilding Plans, Old Main Office, Queen's Road**
**2001**
From the series *Topography of the Titanic*.
C-type print.
50cm x 60cm.
© Kai-Olaf Hesse.
Courtesy of the artist.

203

**Kai-Olaf Hesse**
**Donegall Car Park at Queen's Bridge**
**2001**
From the series *Topography of the Titanic*.
C-type print.
50 x 60cm.
© Kai-Olaf Hesse.
Courtesy of the artist.

railings, while elsewhere in the series there are signs of disaster – evacuation directions, or a lifebuoy in an image in which one of the Harland & Wolff cranes is just included. Hesse has a finely tuned sense of how two historical Belfasts are overlain on each other. His photograph of the 'Drawing Room' in the yard is accompanied by an image of the ends of rolled drawings. The history wrapped up and archived here is, as it were, unfolded and printed on the present day city in a photograph which includes another photograph and thus reflects on how the past is officially nostalgized into the present, while also uncannily suggesting that the two might co-exist.

Hesse's *Topography of the Titanic* sees Belfast as a post-industrial locale, haunted by its past in a commercial and economic sense rather than a political one. In that alone *Topography of the Titanic* was a forward-looking project. It also honed in on an area and an idea which were to be transformed into a Belfast tourist industry later in the twenty-first century, and so now, in the few years since it was made, *Topography of the Titanic* provides a record of a moment in time, that interregnum between the Good Friday Agreement and the acceleration of its outworkings in the psychogeography of Belfast. *Topography of the Titanic* could be interpreted as a nostalgic glance at Belfast's past. The conversion of the *Titanic* into a tourist attraction has been one of the most mawkish aspects of Belfast's post-Agreement reinvention of itself, and Hesse's *Topography* could merely have supplemented the cloying sentimentality that has marked the feting of the *Titanic*. However, Hesse is aware of both the degradation of the industrial heritage which the shipyards now represent and the kind of banal visual interplay between past and present which can bleach meaning from the past, neutralizing the life which remains in archived history. *Topography of the Titanic* includes Hesse's own sense of the wasteland architecture of the docks and yards. It encloses within its own images 'archive' photographs in a strict sense. By bringing these texts and textures together it constructs a series of bridges between the two, to reflect on the past-ness of the past and how it can resurface in the present.

One of the primary influences on, and models for, archival photography as it has been manifested in Northern Ireland in recent years is the work of Bernd and Hilla Becher, and in particular the 'inter-relation of topographic observation and photographic coding' in their work.[11] Inherent in the Bechers' 'photographic coding' is a repetition of framing, and with that a suggestion that the architectural structures photographed by the Bechers embody the commodification of culture and the built environment. In this archive of superficial sameness, small variations on an established pattern take on immense significance. John Duncan's *Bonfires* work is the clearest example of the use of a revived version of the 'new objectivity' and its classificatory obsessions. Donovan Wylie's *The Maze* (2004) also makes use of this deliberate archived boredom. The repeated images of disused cells and the gradually overgrowing space between the fences and walls in Wylie's *The Maze* have a hypnotic quality which plays with forgetfulness and remembering. *The Maze* as a project has a particular urgency because the site was being razed as Wylie was making the images, so the Maze was becoming *The Maze*; the real place shown in the photographs was in the process of becoming Wylie's archive. Wylie's *British Watchtowers* (2007) also catalogues architectural legacies of the Troubles as they are about to disappear. These are photographs of space that is about to become emptied space, and which have us cast a glance towards the future without the watchtowers there. They then provoke a question about what Northern Ireland will look like in the coming years. Hesse, Duncan and Wylie have

206

Chapter Five **The Archive:** 'the sum total'

209

Chapter Five **The Archive: 'the sum total'**

Chapter Five **The Archive: 'the sum total'**

Chapter Five **The Archive:** 'the sum total'

produced work which coalesces in different ways around a nagging conviction that forgetting and myopia are at the centre of the new political dispensation in Northern Ireland. The archive, used as an anchoring principle in each project, gives a gravitational centre to their work.

Ursula Burke and Daniel Jewesbury, in their exhibition *Archive: Lisburn Road* (2004), wish to see Belfast in a way which circumvents the 'ideologically-encrusted images on TV and in movies, in art and photojournalism'.[12] *Archive: Lisburn Road* exhibits a practice which is close to a photographic social anthropology. It focuses on the material culture of Belfast's Lisburn Road and the residential areas which cling to it along its east side (an area which has long been the epitome of Belfast's bourgeois culture). Throughout the Troubles (and indeed previously) the specific concentration of respectability in this one area has been a kind of reproach to the rest of the city. Its implication that living a 'non-sectarian' life is a pleasure granted by prosperity, led Maurice Goldring, writing in 1991, to announce the coming death of Belfast's secluded class arbour:

> In Belfast [the] liberal intelligentsia, concentrated in the south of the city, along the Malone and Lisburn Roads, no longer knows what the people think. Protected but weakened by their privileges, they no longer deserve to lead the country.[13]

When Goldring wrote this, the first stirrings of a new Belfast were already apparent. When that transformed Belfast came, after the ceasefires and the Agreement, it left the Lisburn Road trailing in its wake, a faded snapshot in the city's family album.

Burke and Jewesbury consciously deploy the archive form in this project, knowing the problems this may bring:

> The form of the 'archive' is increasingly being used by artists and curators, as a container for a range of critical devices. Often it is employed at an ironic distance, a means by which to 'critique' the practices of anthropology, or ethnography, or colonialism, or museology'.[14]

In denying their work an 'ironic critique', a 'pre-ordained, unvariable formal style', and an 'arbitrarily selected content', Burke and Jewesbury adopt an anti-auteur approach. *Archive: Lisburn Road* maintains a faith in 'the breadth of a genuine archive',[15] and believes that by adding a forgotten part of the city of Belfast to the city's own archive, a broader collective sense of what is possible in representing the city will emerge. In this sense then, *Archive: Lisburn Road* believes that the universal archive of Belfast can be altered, critically, from within.

In *Archive: Lisburn Road*, the singularity the Lisburn Road and its people is on show. And Burke and Jewesbury's photographs reveal that being on show or being hidden are the two modes by which the area binds together its residential and commercial functions. There is an extreme contrast between the

**Ursula Burke and Daniel Jewesbury**
**Untitled**
**2004**
From the series *Archive: Lisburn Road*.
© Ursula Burke and Daniel Jewesbury.
Courtesy of the artists.

216

foreclosure of private space and the scopic nature of the commercial strip which runs along the west side of the road. This yin and yang of home and shopping is made whole through lifestyle, promenading and shopping. Window displays are widening in the images in *Archive: Lisburn Road*, like the eyes looking in on them. Obsessed with looking, the Lisburn Road cries out to be photographed. Jewesbury and Burke close in on the visually claustrophobic world of this paranoid spectacle.

Burke and Jewesbury expand the photographic archive of Belfast by adding images of publicity-shy suburban houses which shield themselves with verdure. Ground-floor interiors are hidden away as places of secret interiority where life remains a mystery. The garden is a kind of *cordon sanitaire*, and the dense, matted hedges refuse to let a gaze pass through them. Amongst the shops on the Lisburn Road there has arisen a new vernacular architecture. Front window frames expand to the size of the original house, and their materials imply that they have shaken off the legacy of red-brick and sash window. In the midst of this denial and reassertion of the Belfast origins of shops selling designer drama, Burke and Jewesbury register signs of the collapse of the style of bourgeois life which holds the two sides of the road together. Burke and Jewesbury's 'archive' has a strong sense of the historical accretion which makes the Lisburn Road, but it also knows that the Lisburn Road is close to being outmoded, becoming an anachronism. It is a quaint version of a future Belfast that was never going to happen.

Having photographed a virtual Northern Ireland in *Red Land Blue Land*, Claudio Hils came to work in Belfast to make *Archive_Belfast* in 2004. *Archive_Belfast* does not make an archive of the city. It photographs the city's archives, from the official to the marginal. Thus there are images of the storerooms and forgotten treasures of organizations such as the Irish Republican Socialist Party, the People's Museum (a museum of the Shankill Road), the Royal Ulster Constabulary George Cross Historical Society, and the Grand Orange Lodge of Ireland. Hils carefully researched and constructed a semi-underground material existence for the leftovers of the Troubles, places where the cultural artefacts of the conflict are squirreled away out of sight of the new Northern Ireland which was emerging out of the 1990s and the first years of the twenty-first century. These are museums or rooms which are either rarely visited or falling into disuse. Yet the fact of their continued existence (and their new status as photographs) means that their significance is not entirely washed away. *Archive_Belfast* asks whether Belfast can be archived, whether its multitudinousness and the depth of its 'troubles' can be classified and contained. The haunting photographs of rooms and X-rays from the Royal Victoria Hospital are reminders of real pain (something which cannot be archived) in a time of peace.

The tradition of museumizing the photograph by taking photographs of museum pieces has a long history that goes back most famously to Roger Fenton's beautiful images of the British Museum in the 1850s. Several of Fenton's photographs, particularly his 1857 'Gallery of Antiquities',[16] are formally echoed in Hils's photographs of the storeroom of the X-ray Department of the Royal Victoria Hospital, the Newspaper Archive at Belfast City Library, and the 'Evidential Video-Tape Archive' at Musgrave Street Police Station (three images which come as a group within the series). Fenton's British Museum photographs were contentious for the very reason that they might allow, as Fox Talbot suggested in *The*

218

**Claudio Hils**
**Police Service of Northern Ireland, Knocknagoney Station Photography Branch,**
**Photostudio backdrop**
**2004**
From the series *Archive_Belfast*.
Ink jet print (mounted on alu-dibond).
100 x 100 cm.
© Claudio Hils
Courtesy of the artist.

220

*Pencil of Nature*, for the dissemination of images of esoteric manuscripts.[17] Even in the earliest days of photography, the photographer in the museum could be seen to have a dangerously democratizing function, turning out to the gaze of the world the museum piece which was only there for the initiated. Looking at *Archive_Belfast* is a similar experience. The contents of the rooms which Hils photographs seem as if they were meant to be hidden away. Once they appear in a photograph a certain mystery and aura is broken, and the secret or unspoken nature of the Troubles becomes public again. This momentary lapse in the containment of the past is overcome, draining it of impact, by having the image slip back into an archive larger than the archive which the photograph is an image of. It is no accident then that the first photograph in the exhibition is the photo studio backdrop at the Photography Branch of the Police Service of Northern Ireland. The irony, pointed to in this meta-photograph, of taking photographs in museums (or secret institutional spaces), as part of an archive, is a reflection on the cultural moment of Northern Ireland at the time, and also an interwoven recognition that the aesthetics which are possible at this moment are those of a culture tending towards the archival – a culture systematizing even its immediate past, an archive which 'defines at the outset the system of its enunciability'.[18] In *Archive_Belfast* such Foucauldian control through definition is echoed in the equally Foucauldian recognition of the role of surveillance. Scattered through the images in *Archive_Belfast* are the mechanisms of CCTV cameras, and reminders that the tapes of such cameras themselves eventually find a home in the perpetually expanding archive of the city. Hils's work implicitly sees the archive as Belfast's new mode of regulating itself. His eye wanders over the records of the powerful, the obscure, the near-defunct, finding in each that the detritus of years of conflict is being stored away. This becomes a way of showing how the city's past is being shepherded into neutralization in a photographic series which questions that archive, and realizes that such an archive can only work by constantly filtering out the dangerous, then cataloguing and shelving it, much as the CCTV footage which watches for crime is then labelled and shelved.

The archival mode deployed in contemporary Northern Irish photography is, like Mass Observation's work in the 1930s, 'an ongoing process of *remembering*'.[19] These photographers use the archive in the face of an official culture which is based on forgetting – the Northern Peace Process, like Paragraph 2 of the Belfast Agreement, can now largely recognize the past only in the process of not recalling it. So the archive has taken on a role akin to the subconscious – a place for storing but not, in the everyday, for retrieval. These photographic projects are drawn to the archive form because of its capacity for memory, and they critique it for its capacity for forgetting. Their archival drive does not come out of a desire to catalogue. They resist that ordering of utterance which the Foucauldian archive authorizes and presupposes. Yet in different ways they all express a suspicion that the forgetfulness of archive fever is conveniently part of the act of 'forgetfulness'[20] in Northern Ireland's current moment, in which the 'museumification' of culture, or more accurately its disappearance into the fire of an archive fever, tries to mark a cultural turning point.

While all photographs eventually become documentary, the images under discussion here are aware that there is an urgent, contorted passing of time around them – the nameless time of the Peace Process, a time in which objects once alive with significance are beginning to have a 'documentary value' in

**Adam Broomberg and Oliver Chanarin**
**Boy on tip toes**
**2011**
From the series *People in Trouble Laughing Pushed to the Ground.*
© Adam Broomberg and Oliver Chanarin.
Courtesy of the artists.

222

**Adam Broomberg and Oliver Chanarin**
**Four men in suits**
**2011**
From the series *People in Trouble Laughing
Pushed to the Ground.*
© Adam Broomberg and Oliver Chanarin.
Courtesy of the artists.

223

**Adam Broomberg and Oliver Chanarin**
**Sofa**
**2011**
From the series *People in Trouble Laughing Pushed to the Ground*.
© Adam Broomberg and Oliver Chanarin.
Courtesy of the artists.

224

**Victor Sloan**
**The Sloan Family Photograph Albums**
**1998**
Lambda print.
100cm x 100cm.
© Victor Sloan.
Courtesy of the artist.

Chapter Five **The Archive: 'the sum total'**

contemporary Northern Ireland, without the help of photography. In responding to Belfast in its post-Agreement existence, these projects re-animate the 'the authenticity of the photograph',[21] not by insisting on its capacity for mimesis, but much more importantly through the way in which they show how it is possible to have an ethical, committed and critical point of view on what is happening in contemporary Northern Ireland, and in particular how the archiving of culture drains away the texture of the present.

It was perhaps this dialectic, in which the archive makes photographs null and void and in which photographs counter this archival bleaching by making their own archives, which underpinned the invited intervention of Broomberg and Chanarin in the Belfast Exposed archive. The resulting exhibition and book, *People in Trouble Laughing Pushed to the Ground*, purports to free the suppressed image from the archive by making images from the hidden, scratched or doctored parts of photographs held within the voluminous Belfast Exposed archives. The neatness of Broomberg and Chanarin's images tells us that the archive (and then the treatment of that archive in the coloured circular stickers put over the parts of the photographs which they reveal and which were, they say, originally put there by users of the archive) conforms to pre-existing ways of seeing, just as Broomberg and Chanarin's round images imitate the camera lens and the rifle-sight.

The Belfast Exposed archive's authenticity, its capacity to hold the truth, its 'community-ness' was treated sceptically in Broomberg and Chanarin's project. Irony, they seem to suggest, is the first necessity when a photographer or a photograph enters the archive. Writing about Chilean photographers, and their use of the archive as a photographic form, Charles Merewether notes the archive's capacity to act as a 'site where memory and forgetfulness can face each other'.[22] This ability of the archive, an apparently static and museumified form, to hold in tension the past and the future, has meant that the archival mode, in all its variations, has been a repeated feature of Northern Irish photography. An exhibition formulated as an archive asks the viewer, initially, to consider the authority of its work. But the eventual outcome is that the 'archontic principle'[23] of the archive, its authoritative gathering together, is made uncertain. The ordered appearance of the archive, shown to be an obsessive impossibility, eventually reveals a lack of order. Through archiving the present, or what has only just become the past, the photographic projects discussed here collapse the safety of nostalgia and ask us to think about what Northern Ireland was a few years ago and what it is becoming. Moreover, collectively these works suggest that the structured world desired by the archive hides an over-laden chaos as Northern Ireland heads towards its unknowable future.

226

1   Thomas Richards, *The Imperial Archive* (London: Verso, 1993), p. 44.

2   See James Guimond, *American Photography and the American Dream* (Chapel Hill: University of North Carolina Press, 1991).

3   Okwui Enwezor, 'Archive Fever: Photography Between History and the Monument' in Okwui Ewezor (ed.), *Archive Fever: Uses of the Document in Contemporary Art* (New York: Steidl, 2008), p. 22.

4   See http://www.source.ie/feature/archive_season.html

5   Ciaran Carson, 'Lost and Found', *Source*, 25 (2000), 18.

6   Roland Barthes, *Camera Lucida* (London: Vintage, 2000 [1980]). For Barthes the 'studium' derives from cultural conventions and intentions as they are expressed in the photograph. The 'punctum' is 'that accident which pricks me' (p. 27), an unexpected, sometimes personal, sometimes subconsciously-driven moment when the photograph reveals a metonymic detail, something which expands in significance from a small point (p. 45).

7   Carson, 'Lost and Found', 18.

8   See http://www.frankiequinn.com/home.html.

9   Paul Ricoeur, 'Archives, Documents, Traces' in Charles Merewether (ed.), *The Archive* (London/Cambridge, MA: Whitechapel/MIT, 2006), p. 67.

10  See John Stathatos, 'The Absence' in Kai-Olaf Hesse, *Topography of the Titanic* (Belfast: Belfast Exposed/ex pose verlag, 2007), pp. 12-15.

11  Liz Wells, *Land Matters: Landscape Photography, Culture and Identity* (London: I.B. Tauris, 2011), p. 269.

12  Ursula Burke and Daniel Jewesbury, *Archive: Lisburn Road* (Belfast: Belfast Exposed Photography, 2004) pp. 15-16.

13  Maurice Goldring, *Belfast: From Loyalty to Rebellion* (London: Lawrence and Wishart, 1991), p. 139.

14  Ursula Burke and Daniel Jewesbury, *Archive: Lisburn Road*, p. 18.

15  Ursula Burke and Daniel Jewesbury, *Archive: Lisburn Road*, p. 19.

16  *Roger Fenton: Photographer of the 1850s* (London: Yale University Press/South Bank Board, 1988), Cat. 21.

17  See Valerie Lloyd, 'Introduction' in *Roger Fenton: Photographer of the 1850s*, p. 12.

18  Michel Foucault, *The Archaeology of Knowledge* (London: Routledge, 2002), p. 146.

19  Don Macpherson, 'Nation, Mandate, Memory' in Jessica Evans (ed.), *The Camerawork Essays: Context and Meaning in Photography* (London: Rivers Oram, 1997), p. 150.

20  See Jacques Derrida, *Archive Fever: A Freudian Impression*, trans. Eric Prenowitz (Chicago and London: University of Chicago Press, 1996), p. 19.

21  Walter Benjamin, 'Little History of Photography' in Walter Benjamin, *Selected Writings: Volume 2, 1927-1934* (Cambridge, Mass.: Belknap, 1999), p. 527.

22  Charles Merewether, 'Archives of the Fallen', in Merewether (ed.), *The Archive*, p. 162.

23  Jacques Derrida, *Archive Fever*, p. 3.

# Chapter Six
# Other Places, Otherwise: 'break up'

Writing about the international dimensions which set the mechanics of the Peace Process whirring, the political scientist Paul Dixon said that 'Northern Ireland could not escape the "irresistible logic of globalization"'.[1] For Dixon this internationalization of the North happened within the 'high' political changes in the world system after the end of the Cold War, when shifting alliances and priorities in the United States highlighted the vulnerability of the UK in the new order of things. It was this, apparently, and the outmoded nature of the Northern conflict, which brought about the Peace Process.

This adjustment in the orientation of the 'Shield of Achilles'[2] certainly had some bearing on the climate within Northern Irish politics in the 1990s. Two of the most iconic sets of photojournalistic images of the 'peace' in recent years have both featured Martin McGuinness and Ian Paisley, and placed them as figures caught up in the unstoppable flow of global money. In December 2007 they are pictured uncomfortably marooned on a sofa at the opening of the Belfast IKEA store, and are visibly sheepish at the resonances of the IKEA tagline, 'Home is the most important place in the world', which dominates the wall behind them. In the same month of the same year McGuinness and Paisley jointly presided over the ringing of the bell to start the day's business at the NASDAQ in New York. Clapping NASDAQers welcome Northern Ireland to the fray; the First and Deputy First Ministers appear as images on the NASDAQ's illuminated signage. 'I am a businessman of God' are Paisley's palliative, subtitled words. The common thread in both photo-opportunities is that the Peace brings a sense of relief, hope and the possibility that the North might join the rest of the world, even if this 'joining' is achieved through the consumerism and profiteering which define contemporary capital. In the phrase which was much used during that year and subsequently, Northern Ireland was 'open for business'.[3]

One critic of globalization as a sociological phenomenon describes it as 'a reduction in the geographical constraints on social arrangements',[4] and what we see in the Paisley/McGuinness public double act is the fostering of a politics that is largely about the 'inflow' of finance and investment. In the years since the establishment of a fully functioning executive in the Assembly this 'inflow' has fostered its sibling, that ultimate manifestation of 'a reduction in … geographical constraints': tourism. The effects of this opening out of the boundaries which had previously been drawn around the North can be lamented for their

dilution of indigenousness or celebrated for their modernization of a region which had been economically stunted by its internal strife. Robert J. Holton notes that globalization in usually understood in its effects on the nation-state through three alternative processes: homogenization (the McDonaldization of society); polarization (the new West/East split in global power); or hybridization (in which an 'original' culture or society syncretizes with 'new' cultural and social influences).[5] Clearly all of these could be said to apply and to be at work in contemporary Northern Ireland.

There is another by-product of this 'irresistible logic' which is particular to the circumstances of the North. Art-documentary photography in Northern Ireland has, for some time, been considering the 'aftermath' of the Troubles. And one of the ways in which this has been achieved has been through a kind of internationalism which undertakes a complex form of comparativism. While Northern Irish politicians were often taken off to other pacified, or about-to-be-solved, conflict zones, to give or get advice, photographers were exploring how the visual politico-aesthetics of the North, something which had developed collectively and individually for a variety of photographers in the 1980s and 1990s, might be stretched or re-imagined outside Northern Ireland. Or at least, outside what Northern Ireland usually was thought to be. In this chapter I will discuss how some of the photographers already featured in this book take photographs outside of Northern Ireland. In such work there is a dialectic of seeing and image-making, in which new places create new images – but those images carry the undertow of 'lessons learnt' in the North. The comparisons made are often tentative, sometimes barely there at all, and as such they are a lesson in not making quick and easy parallels. But there is much to be gained in seeing beyond the confines of the North itself in Northern photography. I have suggested throughout this book that the nature of art-documentary photography in Northern Ireland can only partly be understood as a 'reaction' to press images of the North at the beginning of the Troubles, and that equally, and perhaps more importantly, waves of change in the aesthetics of photography and art practice globally were what really 'made' the kind of photography we have been looking at. It should be no surprise then that Northern Irish photographers have not felt bound by their place of origin when making their work.

Victor Sloan's work in the 1980s, as we have seen, has been crucial to the development of Northern photography. In particular his interrogation of Protestant and unionist manifestations of identity politics, and the space for critique which he was able to introduce into his work, gave a shape to the photography which followed on from his early examples. A revealing corollary to this early work is to be found in the set of images he made about the Vietnamese boat people who arrived in the North of Ireland in the late 1970s, some of whom were 'settled' in the 'new' town of Craigavon.[6] Sloan's images of the Vietnamese refugees are in a variety of modes, as he searches for a way to render their experience. His night-time, colour images stress the comfort and sustenance of the refugees' new lives, though the darkness surrounding them has an ominous quality to it, something potentially engulfing. In his black-and-white photography of the Vietnamese refugees the mode is more photojournalistic, almost to the extent of imitating, in framing and structuring, magazine-feature images of Northern Irish people from the same historical period. And Sloan's interest in the minutiae of individualism in the midst of the experience of displacement, and the way in which arriving in a new culture heightens the awareness of individuals, making them into a representative

**Victor Sloan**
**Vietnamese Boat People, Moyrafferty Community Centre, Craigavon**
**1984**
From the series *Vietnamese Boat People*.
Silver gelatine print.
© Victor Sloan.
Courtesy of the artist.

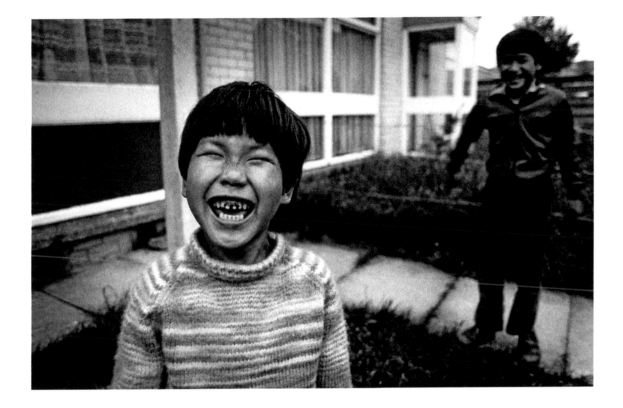

of their 'identity' or ethnicity, is seen in the often casual and close-up portraits he made of some of the younger 'boat people'. Sloan allows the hope of youth and the possibility of a new start a full expression and in doing so asks questions of the society in which these arrivistes now find themselves.

Sloan's photographs of the Vietnamese Boat People reveal that, from the beginning, his own work was broadly interested in the unhinging of identity from any absoluteness which identity might aspire to. And this, in turn, should make us look again at those images of Craigavon, Dungannon, Derry and Portadown from his early canon and think that they are, along with everything else they represent, a consideration of the categorical nature of identity – that notion that identity simply is, now and forever. Sloan's work is made out of a to-and-fro between the poles of the identity politics of his 'place' – an understanding of and a revulsion from the militaristic and uncompromising nature of unionism. His decision to chart the lives of the Vietnamese in Craigavon is an extension of the exploration he had already begun in his other images.

As a contemporary counterpart to Sloan's 1980s work, Adam Patterson's series *Another Lost Child* steps outside Northern Ireland to visualize a cross-racial encounter which takes place between Patterson as photographer and 'Vipoh', a young black man living in London. Patterson's care in making the images of 'Vipoh' – the tenderness and rapport in the work – reflects back on his Northern-based photography and suggests that Patterson's real interest is not so much the delineation of a loyalist story, but an empathetic form of documentary story-telling which unfolds the lives of his subjects with quiet determination.

His film project *Belfast Now*, which is largely made of photographic stills with voiceover, is a case in point. Most directly it is concerned with and confronts the conditions of asylum-seekers living in Belfast. Photographically it also tells a story. Its opening sequence is made up of a quick flicker of black-and-white archive images of Belfast and the Troubles, the last of which is a look down from one of the Harland & Wolff cranes to the ships and containers in the port. The next image, the first of Patterson's, is of Hassan Ali, an asylum-seeker from Somalia, on his crutches, on the banks of one of Belfast's docks. The image effects a switch from archive to documentary, from monochrome to colour, and from then to now. When Hassan, at the end of his testimony, says in the voiceover, 'That's why I came to Belfast. I need peace', he is framed so that one of the yellow H&W cranes is over his left shoulder. The irony is clear, as is the narrative which begins with the first frame. And, as the rest of the film illustrates, the fate of the asylum-seeker in Belfast can be a cruel one. Hassan and his fellow asylum-seekers, each with a different story, are a question to the Belfast which that crane represents – both the Belfast of the past, which the film begins with, and *Belfast Now*. The refugee and asylum-seeker brings an 'identity' which disrupts the well-rehearsed and settled 'two communities' model of Northern Ireland. Sloan saw this in the 1980s, and wondered about the fate of those who had to enter this stark cultural binary with no place in its system. Patterson revisits the same dilemma.

In *Another Lost Child* Patterson implicitly draws a contrast between the North and London, just as Donovan Wylie had done with Robert Wilson in *The Dispossessed*. Here, however, the implication is

233

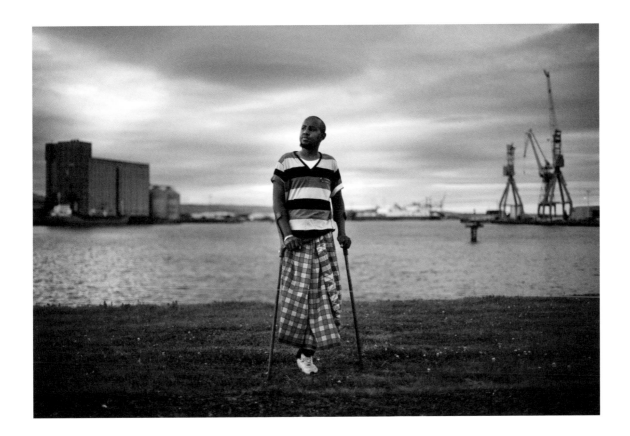

Chapter Six **Other Places, Otherwise: 'break-up'**

234

unemphatic, so that we cannot with any certainty 'see' Northern Ireland in Patterson's London, despite the presence of the white priest in the ceremony that is being undertaken in the bedroom.

Patterson's work as a documentary photographer, necessarily, takes him around the globe and on commissions, and what he produces in the North is simply a part of that wider act of documentation. The boundaries between art photography, documentary photography and photojournalism have, in the past decade or so, once again become blurred. If Sebastião Salgado was an example of a serious documentary photographer who found himself having to move into the art world to show his images (as Julian Stallabrass suggests[7]), then in recent years 'art photographers' have worked on projects which are close to the kinds of commissions given more traditionally to commercial documentary photographers. Patterson's way of photographing is exemplary here, finding an existence between journalistic outlets and gallery spaces.

As we've seen throughout the work discussed in this book, the documentary mode has remained fundamental to photographic art practices in Northern Ireland. Variations on and departures from the documentary still depend on its gravitational pull for their conceptual weight. And the porous boundary between documentary and art photographies, along with the global nature of contemporary photographic practices, has meant that Northern Irish photographers have placed themselves and their work at various junctures across the world.

Paul Seawright's *Invisible Cities* (2007) was made in sub-Saharan Africa and conveys a sense of human isolation amidst increasing urban density. Like some of Seawright's earlier Northern work (such as *Police Force*, 1994–96) *Invisible Cities* sees people trapped and contained by the social institutions which they must inhabit, while the sense of the landscape as a meaningful wasteland which Seawright considers in his African work is discernibly an extension of the more compressed view of a sterile urban landscape which could be seen in, for example, *Fires* (1997). A key project in Seawright's move from Northern-based photography to a photography outside the geographical constraints of the North was *The Missing* (1997), which began as a series of images of the Black Mountain, to the north of Belfast, and which echoed Seawright's *Sectarian Murder* series in that it seemed to intimate a desire to conjure the spirits of the 'Disappeared'. Seawright himself comments on how thinking about the Disappeared 'led to the exploration of similar, more generic themes – identity, territory, our relation to the state, political and social geography, ideology, generational politics, issues of site …'.[8] This abstraction from the specific politics of the Belfast Disappeared towards a consideration of the effects of 'disappearance' per se is a turn towards a more universal photography and at the same time an attempt to find greater clarity about the North by moving the photographic project away from the North. *The Missing* was shot in Rotterdam, centred around a shelter for the homeless, and in its images only glimpses are afforded of the individuality of the subjects of the portrait photographs. Elsewhere, landscapes have faint traces of human habitation. A path worn across a planted urban landscape suggests both escape and disappearance. Seawright is thus able to consider the yearning for return which disappearance leaves behind and to turn that yearning into a non-specific echo of the issue of the Disappeared in Northern Ireland.

In 2002 Seawright was commissioned by the Imperial War Museum to go to Afghanistan. Here Seawright photographed the landscape as a place caught in a kind of historical loop – the 'furrowed mounds and acred cerements', as John Stathatos calls them – which are recurrent tropes of western travel in the region over a long and violent imperial history.[9] Seawright also draws on photographic history to make sense of the 'hidden', the disappeared specificity which the landscape seems to shield from him. 'Valley' consciously echoes Roger Fenton's Crimean War image entitled 'The Valley of the Shadow of Death' (1855), and thus looks back to the very origins of war photography.[10] Fenton's landscape is replete with melancholy patriotism, in the same way that Tennyson's poem 'The Charge of the Light Brigade' is. It is worth noting that Fenton's is an 'aftermath' photograph, taken in the year following the battle (Tennyson's poem was published in late 1854, weeks after the event). Seawright's identification with Fenton is thus not just aesthetic (though he revivifies the effect of barren uncanniness which Fenton achieves). It is also self-contemplative, since it acknowledges that Seawright is not an photojournalist, nor a war reporter, nor an army photographer, but someone who, like Fenton, has arrived to photograph the site in the wake of the action. The gaping hole in the wall in 'Room V' is another sign of the material trail which war leaves behind, its awful breach allowing in rubble which, in colour and substance, looks like it has spilled over from 'Valley'. Recalling Seawright's early work, it is noticeable how, in photographs often taken at a similar focal distance from walls and barriers, such built boundaries in Belfast are solid, flat, unyielding things. Here, in Afghanistan, Seawright is in a landscape which opens itself out along the horizontal plane, but which offers no more definition than he is able to find in the austere verticals of Belfast's social geography. The hole in the wall in 'Room V' is, after all, a window into nothingness, a white oblivion.

Donovan Wylie has also made the trip to Afghanistan. *Outposts* (2011) draws on the work which Wylie did for *The Maze* and then the *British Watchtowers* series in that it furthers his interest in military architecture. In the move from *The Maze* to *Watchtowers* it becomes apparent that it is the 'spectacular' nature of these places – that is, their function as places of the panoptical gaze – that Wylie is drawn to. In his series of images in *The Maze* of the space between sets of prison walls, Wylie visualizes entrapment. In his long, repetitive sequence of photographs of the beds inside cells, Wylie recreates the views of both the entering prisoner and the vigilant warder. That latter function – looking as controlling – is what dominates the *Watchtower* work, and in *Outposts* the landscape's dry desolation seems to reduce the images in such a way that nothing exists within them except the architecture of the military gaze and the metaphysics of looking. The landscape of 'OP 3' is a blasted, denuded, infertile version of that in the *British Watchtowers* photographs.[11] Compared to those, this image is almost apocalyptic, but it also has other links to them – a hostile population to be watched, guerilla tactics to be guarded against. Wylie finds a counterpart to the North which ties the North back into a much larger global narrative of power.

In a similar way, Paul Seawright's more recent work, *Volunteer* (2010), uses a photographic consciousness and conscience to make images of US Army recruiting stations – again Afghanistan is the visual and political backdrop to these images of places where soldiers sign up to be posted there. For this American work Seawright (as he did in Afghanistan with Fenton's iconic photograph) allows photographic history to guide him in his work. So in these images the influences of Robert Frank's *The Americans* (1958) and

237

238

**Donovan Wylie**
**OP 3. Forward Operating Base,**
**Masum Ghar. Kandahar Province,**
**Afghanistan**
**2010**
From the series *Outposts*.
© Donovan Wylie/Magnum Photos
Courtesy of the artist.

New Topographics are visible. Like much of Seawright's work, *Volunteer* is made of landscapes which imply a human presence. They do this not so much through the camera as through the positioning of the camera, which gazes at things which take on immense significance in apparent blandness, as if recording not the photographer's but the volunteer's viewpoint – a would-be recruit pausing at the decisive moment outside the recruiting station, about to become (in a word that, of course, reverberates in a Northern Irish context) a volunteer. Seawright's echoing of Lewis Baltz's industrial landscapes, as ghostly and emptied American dreams, creates a baleful sense of history unfolding. The consistent greys of this work meanwhile, both in the buildings and the skies, parallel the work which Seawright did in Afghanistan, in which the colour of the desert seems to seep into the Afghani atmosphere, and so the US melds, photographically, with the Afghani desert.

This kind of work is cautiously comparative. It does not over-determine the parallels between Northern Ireland and any other place, and, in the cases of Sloan, Seawright and Wylie, that caution is also seen in methodological and photographic self-awareness, so that the work they make in places outside of the North contain intertextual references to photographs from their own *oeuvres*.

Anthony Haughey's *Disputed Territory*, a project discussed previously, overlaps 'Ireland' with Kosovo and Bosnia-Herzegovina and is less cautious in drawing regions together in one scrutinizing documentary format. Haughey's way of photographing all three places means that visually they begin to merge, to close in on each other, and the effects on the landscape of these European civil conflicts is seen to be sadly similar. Haughey's photograph of an ashen landscape in Bosnia, for example, with its thistles suggesting that it has been thus for a year or so, loops back to images of the Irish border as a similarly bleached and disordered terrain, while also generically calling to mind Seawright's *Fires* and the way in which such spoiled and foreshortened panoramas suggest the milieu of post-conflict societies.

Willie Doherty's *Extracts from a File* (2000) is a fine example of how the metaphysical explorations that have always structured his work (an examination of the self-reliance within binary structures, the nature of absence within presence, death within life) do not need a Northern setting for their playing out. Doherty's work has come to imply the North rather than directly addressed it, to the point at which the viewer can only tentatively interpolate Northern contexts into his images. (The same could be said for much of his video work.) Doherty's use of subways, underground car parks and the inhuman scale and film-noir lighting of cities, extends the fraught narratives of his video work, so that his visuals seem to portray Berlin as symptomatic of a world forever on the verge of cruelty, crushing silence or unavoidable, retributive ferocity. In *Retraces* (2002) Doherty returned to Northern Ireland and saw it in the same manner in which he had seen Berlin, with perhaps slightly more light allowed into the photographs, but as a continuation of the desperate attempt to see in the dark, to find the 'traces' of what might have happened in these unforgivingly blank territories.

*Extracts from a File*, as Jane Humphries wrote in a review in 2000, suggests a 'code of untruth and silences'.[12] Doherty's aesthetic never seeks to break that 'code', it simply constructs and observes the aura

243

**Willie Doherty**
**Retraces I**
**2002**
Digital photograph.
114cm x 152cm.
© Willie Doherty.
Courtesy of the artist and Kerlin Gallery, Dublin, Matt's Gallery,
London and Alexander and Bonin, New York.

**Willie Doherty**
**Retraces II**
**2002**
Digital photograph.
114cm x 152cm.
© Willie Doherty.
Courtesy of the artist and Kerlin Gallery, Dublin, Matt's Gallery, London
and Alexander and Bonin, New York.

**Willie Doherty**
**Retraces IV**
**2002**
Digital photograph.
114cm x 152cm.
© Willie Doherty.
Courtesy of the artist and Kerlin Gallery, Dublin, Matt's Gallery, London
and Alexander and Bonin, New York.

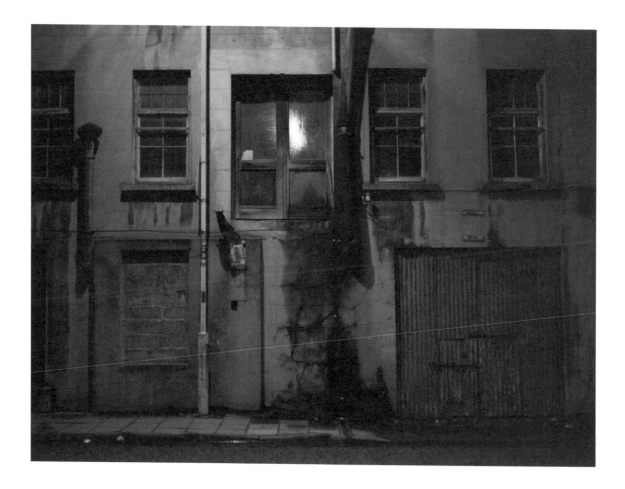

**Willie Doherty**
**Retraces V**
**2002**
Digital photograph.
114cm x 152cm.
© Willie Doherty.
Courtesy of the artist and Kerlin Gallery, Dublin, Matt's Gallery, London
and Alexander and Bonin, New York.

Chapter Six **Other Places, Otherwise: 'break-up'**

of its awful mechanics. When *Extracts from a File* and *Retraces* (which is made of both video work and stills) are seen together then the conclusion must be that Berlin and Derry stand in parallel – darkened and divided cities shadowed by something in their pasts. In Doherty's work, especially at the beginning of his career, Derry's psychogeography was abyssal, founded on a severance which the frame of his photographs (and sometimes his texts) could barely hold together. After the arrival of 'peace' and the fall of the wall, the nature of the fissures in those cities becomes less certain. How do they live on, under pressure to renew themselves as unified municipalities, with the knowledge that they were sites of murderous boundaries? And how does that knowledge haunt their futures? It is the 'silence' which answers these questions which besets and darkens Doherty's photographs of both cities.

Victor Sloan similarly visited Berlin, and made *Luxus* (2006). *Luxus*, Latin for luxury, is also the name of a bar in Berlin. Before the fall of the Berlin wall Luxus was a subcultural refuge in the GDR. After reunification Luxus has remained the same dowdy, unreconstituted remnant of a butcher's shop, while all around it 'luxury' has sprung up in the form of new apartment living.

In some of the images in *Luxus* the markings that were signature elements of Sloan's earlier work are now subtly reflected in the evidence which time leaves on materials: for example, the (digitally enhanced) cracking in the veneer on a wall tile. In exhibition the large size of the images means that their pixilation is visible and grainy, creating a surface to the photograph which is akin to the effects which Sloan previously achieved manually. Sloan's interiors (of the inside of the bar) play on visual reminders of the bar's history as a butcher's shop and create a mystery that is full of a menacing violence. *Luxus*, as with Doherty's Berlin, alludes to something barbarous, to a society which has been deracinated and depraved. The sequence of images, however, has a broader aim, and that is to praise the persistence of *Luxus*, the bar.

The second part of *Luxus*, subtitled 'Luxury', takes the deathliness seen inside the bar outside, into the areas around Luxus. These buildings have been gentrified, yuppified, and rezoned. Luxus remains a stone in the midst of it all, a dowdy remnant of the largely erased past. The bar is celebrated by Sloan, and it (and its owner) represent for him something akin to his own contemporary position in Northern Ireland. *Luxus* does not try to say that Northern Ireland is a post-conflict society in the same way that post-Cold War Berlin is a post-conflict society (though it is worth pointing out that the project which made *Luxus* possible was funded specifically to consider the nature of 'post-conflict' cultures). However, the narrative of regeneration (and the realization that an ex-Stasi building is now an apartment block) pulls both places into a broadly similar trajectory. Luxus, the bar, was *non grata* with the GDR regime under communism because of its apparently Western, liberal ethos. After the fall of the Wall, Luxus exists as an anachronism, a history-laden symbol in a society in which the future is all. Sloan and his photography are, like Luxus, bearing history, and trying to make sense of its newly found teleology of post-conflict utopianism.

The ways in which photographers take with them the work they have previously done can be a stylistic flourish, a mark by which they make the image theirs, a response to a specific set of geographical or temporal circumstances, or, maybe, happenstance. In the case of Doherty, for example, the context of

Victor Sloan
Untitled II (Luxus)
2006
From the series *Luxus*.
Lambdachrome print.
120cm x 180cm.
© Victor Sloan.
Courtesy of the artist.

Berlin (or, say, his later video work in Spain: *Segura* [2010]) allows for something close to a scraping away of the remnants of Irish contexts in order to achieve an abstract manifestation of what interests him. When David Farrell was invited to make work in the Italian town of Lugo he found that the region was known for its intense fogs. The landscape photographs which Farrell made around Lugo find ways to incorporate the fog's refusal to offer up the landscape for his camera. In many of the images Farrell himself appears, holding a camera aloft, searching for an image. The shadowy forms of the trees are as close as we get to definition within these landscapes from *Né Vicino Né Lontano. A Lugo* (2007). It is the appearance of the trees, sometimes a single tree, and Farrell as performing photographer in his own images, together with a quotation from Beckett's *Molloy* in the book version of the work, which, in combination, signify how Farrell responded to the privations of being a landscape photographer who cannot see the landscape he has been commissioned to photograph. While the trees in a visually blank and unadorned landscape, along with the lonely, striving, patient figure of Farrell, may evoke of *Waiting for Godot*, the quotation from *Molloy* reminds us of a hapless, hobbling character, trying to undertake a journey through an indistinct topography. Molloy journeys towards his own death (and the *Trilogy*, of which *Molloy* is part, eventually gets there). This reference, in turn, should send us back to *Innocent Landscapes*, because in that work we look at absolutely and perfectly 'clear' landscapes for signs of pain and death. In Lugo, Farrell photographs the same things which he photographed in Louth or Wicklow, but as inversions of those Irish landscapes. Lugo, for Farrell, produced images which were also about searching the scene for traces of fraught human meaning and death. In Lugo he places those pieces of evidence in the landscape. In *Innocent Landscapes* they are waiting to be uncovered.

Farrell in Lugo is a photographer who is faced with the prospect of not being able to photograph, though he persists and 'fails better'. In a Beckettian way, he appears to be on the verge of losing his 'identity' in Lugo, of disappearing into the fog. It may, in fact, be a feature of (what might be roughly described as) the 'comparative' photography which I have been discussing that the transplantation of the 'Northern Irish' photographer to another country or culture is a kind of liberation from the pressures of identity. Particularly the burden of identity politics. The new politics of Northern Ireland after the Good Friday Agreement constructed an executive which was able to govern through constitutional arrangements tailored to the province. But the source of the Irish 'problem' has not been 'solved'. What caused the Troubles was once described as history, or religion, or even class, but the consensus of recent years attributes the Troubles to 'identity', that undifferentiated conglomeration of all of these factors with added 'culture'.

It is possible to understand what happened in Northern Ireland at the end of the Troubles in a wider British Isles context (as the Good Friday Agreement itself does). The Scottish political theorist Tom Nairn had been predicting and hoping for the 'Break Up of Britain' since the late 1970s, and the devolutions which came about in Northern Ireland, Scotland and Wales seemed like a fulfilment of his prophecies.[13] Michael Rosie and Ross Bond note how Scottish devolution inevitably brought 'into sharper focus the nature of [Scottish] identity'.[14] Devolution in the North has had a similar effect, in that shifting the North's responsibility for itself to a more autonomous political structure, and the ways in which that has been done, have cemented the central importance of a notion of 'identity' to Northern society, without necessarily giving any greater

**David Farrell**
**Untitled**
**2007**
From the series *Né Vicino Né Lontano. A Lugo.*
© David Farrell.
Courtesy of the artist.

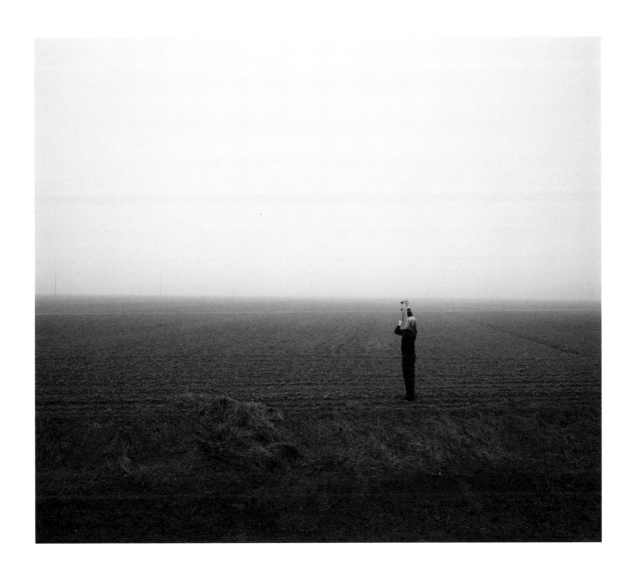

clarity as to what those identities are, and, arguably, meaning that the ultimate fulfilment of the desires of either nationalist or unionist identity are further away then ever. In any case, a heightened self-consciousness about identity was an inevitable outcome of the Peace Process, given its consociational structures.

But how to photograph, not identity, but the 'nature of identity'? In 2010 Belfast Exposed published a book of essays with the title *Where Are the People?*, and the question is a good one. Why, simply put, is so much of the photography produced in Northern Ireland in recent decades devoid of portraiture? There has, of course, been plenty of work done with portraiture in socio-documentary modes (earlier I discussed, for example, the work of Paul Quinn and Patrick McCoy). And, taking the question very literally, there are people in Victor Sloan's work, and in Donovan Wylie's early work, and in Paul Seawright's. There are also 'people' in the apparently depopulated; in John Duncan's photography, or in Daniel Jewesbury and Ursula Burke's *Archive: Lisburn Road*, people are there, implicitly. It is the lives of those who inhabit the spaces of the North that is primary in these photographs. It is just that those 'people' are not in the frame.

If we accept that there is a broad validity to the question, 'Where are the people?', then to begin to answer the question we must turn back to photojournalism. Because this, I would suggest, is where we can find the kernel of truth in the notion that the misrepresentations of the media in Northern Ireland 'caused' art-documentary photography. As I have argued throughout this book, this is only very partially the case. But if it does give momentum to alternative representations it is because photojournalism deploys, in its visual shorthand, an over-determination of 'people' as their identity. People in photojournalism tend to play out a single and absolute role: 'mourner', 'rioter', 'soldier', 'Protestant', 'Catholic'. In a society defined by its identity politics it is difficult to take a portrait without the person who is the subject of the photograph being made to stand, synecdochically, for an identity. The social philosopher Pierre Bourdieu, who generally had a downbeat view of photography's potential, noted that photographs tend to show people in their social roles rather than 'properly speaking, individuals in their capacity as individuals'.[15] In Northern Ireland, by the 1980s, those 'social roles' had calcified in the popular imagination (and its visual media). The tropes of victim, terrorist, policeman, solider were well established, and the terms of engagement, as Protestant or Catholic, unionist or nationalist, called for iconographic portraits to fill the categories. Little wonder then that it was, in the main, landscape traditions which art-documentary photographers were drawn to in order to create images in which lives were signalled, understood and hinted at rather than categorized.

The new climate in the North might have been expected to offer new possibilities and it is the case that, in the period after the Good Friday Agreement, various Northern photographers have taken on 'portraiture' in interestingly angular ways – ways which indicate a desire to circumvent this corralling of the individual into a representation of 'what' they are. Such photography then becomes an attempt to photograph not 'identity' but, exactly, the '*nature* of identity', and in doing so its abstraction of intent becomes part of its aesthetics, a self-consciousness about portraiture which leads to a staging of 'identity' in order to examine it. The work of Malcolm Craig Gilbert, in *Post-Traumatic Exorcism*, is a case in point, a Cindy Sherman-like performance of identity, inflected through mass media.

Gareth McConnell is a photographer working both in and outside Northern Ireland whose interests span the social and the sectarian, the place and the people, and whose body of work roams across landscape and portrait formats. Like John Duncan, Paul Seawright and Eoghan McTigue, he has been drawn to political murals, in McConnell's case taking close-ups of the brushwork of murals to create abstractions from the specificities of the politics of the original murals. But it is the contrast between two sets of portrait-based work that shows how McConnell can look at and then beyond sectarian identity. His *Portraits and Interiors from the Albert Bar* (1999) were made in Carrickfergus and the documentary substructure to these photographs gives them an anthropological air, so that they might be seen as images of revelation and insight – in this case, into working-class loyalism, an 'identity' often regarded as misunderstood and lacking in full articulation. However, McConnell's form of portraiture, and his photographs as a body of work, not just as a collection of individual images, cultivate an aesthetic which pushes what he does beyond simply uncovering what has previously been, socially, unseen. In one image a male customer of the bar shows his tattoos. His shirt is crumpled on the seat in the corner. The scenario for this portrait is its own commentary. It asks us to read the tattoos as the literal overwriting of 'identity' on to the individual. The photographer as capturer of the essence of this identity is enacted in the image by the acknowledgement that the sitter has been persuaded to partially undress. So within the mise en scène here there is a self-awareness that identity is being searched for, that the portraits and interiors will be seen as a cultural disclosure and the people in these portraits will be viewed as symptomatic of their 'identity'. Another portrait shows a young man wearing a T-shirt which has a loyalist insignia on it (possibly that of a marching band), and the over-writing of his clothing matches the inscription on both the tattooed man and the young woman with a tattoo on her arm.[16] It looks, then, as if McConnell's interest is in the labelling and displaying of the self as a staging of cultural identity. His interiors of the bar are like portraits which the subject has vacated, and because they tonally match the portraits they suggest that the customers of the bar and the bar's furniture, its atmospherics, are at one with each other.

There is more to McConnell's work, though, and it can be seen in the concentration in the faces of those he photographs. McConnell coaxes out of his sitters a look into the lens that goes through and past the photographer. It is unsettling at times, partly because it is not defensive. Nor is it necessarily revealing. But it does suggest a desire to see what lies beyond the surface, both on the part of the photographer and the subject. And in McConnell's work, in a very visceral and painfully literal way, the subcutaneous is important. He has taken portraits of Lucky Rich, supposedly the world's most tattooed man, and of the needle-wounds suffered by heroin users. The tattoos on the people in the Albert Bar images are, then, more than insignia – they are scrutinized by McConnell because they may be symptomatic of something which is also under the skin, circulating in the blood. The needles which imprint the tattoos onto the skin, once they are made equivalent, by looking at McConnell's other work, to the users' marks on their legs and arms, suggest an 'identity' which is both bodily and addictively damaging. McConnell's photographs ponder the central premise of cultural identity – that is, that identity is in the human body, that it is the irrefutable essence of who a person is.

This intense scrutiny of the personality, as it is lived out as an identity within our culture, is replicated in

**Gareth McConnell**
**Untitled (Jamesy)**
**1999**
From the series *Portraits & Interiors from the Albert Bar*.
C-type print.
74.7cm x 94.7cm.
© Gareth McConnell.
Courtesy of the artist.

256

**Gareth McConnell**
**Untitled (young mother)**
**1999**
From the series *Portraits & Interiors from the Albert Bar*.
C-type print.
74.7cm x 94.7cm.
© Gareth McConnell.
Courtesy of the artist.

**Gareth McConnell**
**Anna Dhillion**
**2004**
From the series *Ibiza Index (Nothing is Ever the Same as They Said it Was)*.
C-type print.
Dimensions variable.
© Gareth McConnell.
Courtesy of the artist.

258

**Gareth McConnell**
**Mark Craven**
**2003**
From the series *Ibiza Index (Nothing is Ever the Same as They Said it Was).*
C-type print.
Dimensions variable.
© Gareth McConnell.
Courtesy of the artist.

McConnell's *Ibiza Index (Nothing is Ever the Same as They Said it Was)* (2002– ). If the Albert Bar work takes on the publicly-recognized, political identity of loyalism, *Ibiza Index* has more subcultural intents, since it is a series of portraits of young people who go to Ibiza for the purpose, as McConnell wryly puts it, of 'seeking to banish existential isolation by joining a mass congregation for an orgiastic ritual of drug taking and dancing'.[17] The shift here between extremities of individual loneliness and wild abandon in a crowd captures exactly the dilemma of 'identity' in an atomized but identity-obsessed world. While in the North being part of an identity, or being so immersed in it that it is indistinguishable from the self, is often viewed as primarily political, competing forms of 'identity' in a consumerist culture also offer themselves, each with its own promise of absorption and fulfilment. It is as if McConnell is able to catch the look in the eye of his sitters as they wait for their 'identity' (as temporary Ibizans or permanent loyalists) to live up to its promise.

McConnell subsumes himself into the world of those he photographs, and in this way sees how they are consumed by the lives they lead. Anthony Luvera approaches the dilemma of portraiture in a different way, but also with that drive to see 'authentically' how ordinary people comprehend themselves. Luvera's *Residency* was made over a long period leading up to an exhibition in 2008 and involved what Luvera describes as 'assisted self-portraiture'. Luvera worked with homeless people in Belfast and, rather than take portraits of those people he was in contact with, Luvera works with the participants in the project, teaching them how to use a large-format camera. He asks them to choose a place for their final portrait, somewhere that is meaningful to them, and the portrait which they then take of themselves becomes, as Luvera himself describes it, 'the trace of a process that [attempts] to blur distinctions between the participant as "subject" and [Luvera] as the "photographer"'.[18]

As Luvera's methodology implies, portraiture and street photography have within them a strand which tends to denarrativize the photograph's subjects, turning them into ciphers for a commonly experienced city life, and rendering the photographer omnisciently powerful yet transparent. Luvera's *Residency* turns this dynamic around. The photographer here is not the sole source of the power in, nor the only reason for, the existence of these photographs. In *Residency* there is no remnant of a universalizing, modernist bohemian photography which pities the poor, lost city-dweller. Instead there is an undoing of the authoritative self, partly achieved through the deliberate confusion of roles; and while this might seem appropriate to those who are without a stable home place, this is not the point of Luvera's work, but merely its method.

Luvera's is a project driven by a belief that the process of photography is a journey, that it involves not so much the production of images to be interpreted but an organic form of expression-as-self-knowing. In the gallery space the 'Assisted Self-Portraits' are hung above eye level, challenging the viewer to look up to them, and eroding the potential for a simplified empathy as a way to understand them. Just as this asymmetrical viewpoint complicates any comfortable relationship which the viewer might have with the subject, so it also acts as a reminder that the backgrounds for the self-portraits cannot be taken at face value, and that there are complex and unknowable affiliations to place and home being expressed in the

decisions the self-portraitists have made about where they photograph themselves. Luvera's 'relational' methodology makes a very forceful point about the self and how we identify that self within photography, and that is that if a portrait is given an identifying label then the power to be, to speak and to mean independently of that label (in this case 'homeless') is taken away from the subject. Luvera's *Residency* is notable for the fact that it has, and needs, very little acknowledgement of the context of the Troubles or the Peace Process. Luvera is very aware that homelessness and urban displacement were part of the history of the Northern conflict, but the object of his social concern is a phenomenon which crosses those inflections of identity normally seen as central to the ways in which the North is understood. And this fits with new forms of photographic practice which are determined to examine, as suggested above, 'the nature of identity' and are not content to accept 'identity' as it is handed down by social mores and orthodoxies.

Nick Stewart's project, *no-one's not from everywhere* (2007), while mainly using video, provides a strong sense of how artists working in the North are drawn to story and testimony, the local detail and the pull of place, while being very conscious of needing to work outside the complacencies which such personal narratives can bring to an artistic vision. Working as a kind of montage of sentiments, Stewart's project, in the texts and stills in the book which accompanied the exhibition, formulates a dispersed, collaged identity for Northern Irish art, and a sense that 'identity' can be an overweening cultural presence, a stifling context, and an unavoidable gravitational artistic force.

The final declensions of shifts away from the constrictions of the identity politics of the North mean that Northern Ireland, as it is usually understood, is (almost) absent in some photography which might be thought to be 'from' Northern Ireland. Hannah Starkey has become one of the best-known 'Northern Irish' photographers working in the art world today. Her work is generally made outside of Northern Ireland and to think of it as 'Northern Irish' seems particularly reductive. At the very least, her work is impelled by restlessness about the certainties of identity which is what Stewart finds in *no-one's not from everywhere*. Starkey's work, or at least one strand of it, is typified by 'Untitled: June 2007', which shows a young mother with an infant child in front of a wall-map. There is a dignity yet a disengagement (which hovers on falling into disenfranchisement) in the woman's face and in her stare, directed out of the frame and away from the viewer. The map and the framing of the subject hint at, while refusing to fulfil, a photography of social documentary, suggesting antecedents such as Dorothea Lange's images of American migrancy or David Seymour's famous 'Air Raid Over Barcelona, 1938'. But whereas those are images from the political 1930s, here the possibility of mobility is viewed with less pathos, and perhaps even in a way which questions the photographer's capacity for empathy, in order to create an uncertainty as to whether this mother is homeless, migrant, or simply waiting. The image sits between a concerned and engaged socio-documentary mode and a consideration of placelessness as tragedy or opportunity, necessity or choice, and as such it exists at one end of the spectrum of work which Starkey has produced, with a less materially troubled yet interrogated bourgeois cosmopolitanism at the other end.

Starkey's concern with the contemporary female self, its development and the sense of breached wholeness which pervades the artifices of the self, is perhaps most dramatically captured in 'Untitled:

**Anthony Luvera**
**Polaroid from the making of Assisted**
**Self-Portrait of Bryan Horrex**
**2008**
From the series *Residency*.
© Anthony Luvera.
Courtesy of the artist.

**Anthony Luvera**
**Documentation of the making of Assisted**
**Self-Portrait of Bryan Horrex**
**2008**
From the series *Residency*.
© Anthony Luvera.
Courtesy of the artist.

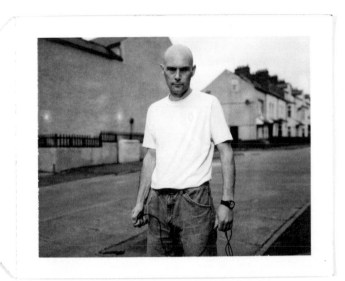

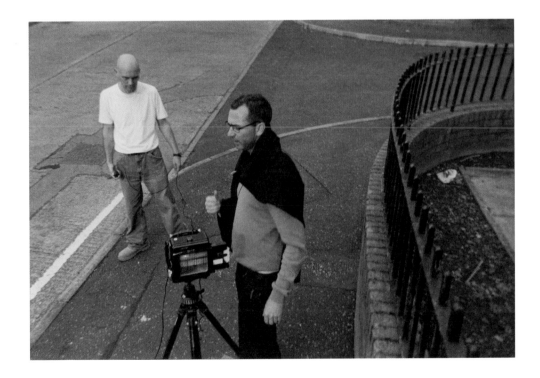

Chapter Six **Other Places, Otherwise: 'break-up'**

**Nick Stewart**
**Rope Bridge**
**2007**
From the series *no-one's not from everywhere.*
Video still.
© Nick Stewart.
Courtesy of the artist.

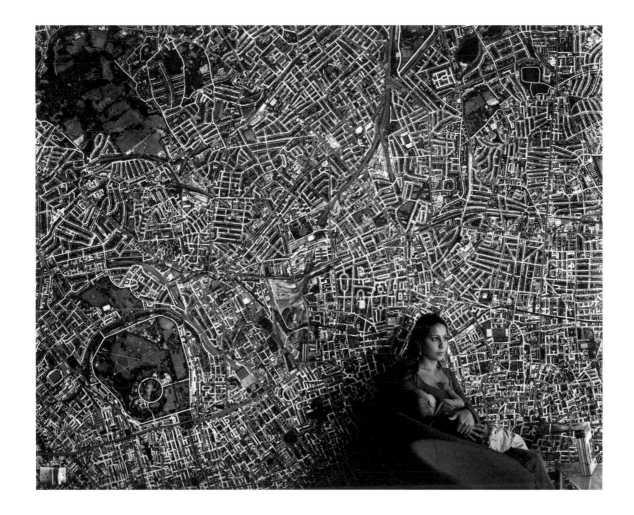

Chapter Six **Other Places, Otherwise: 'break-up'**

May 1997', an image which doubles the self as illusion and implies a purity, maybe even a naïve narcissism, set against the weariness of the older woman who looks on as a younger woman touches her own reflection in the mirror. Such painterly tableaux signal that we should read significance rather than specificity into Starkey's work, and that if her photographs are moments in a narrative, then their stillness is indicative of epiphanies about to come, or in the case of this image, just unfolding. Starkey's art is manifestly set against the spontaneity of the 'decisive moment'. The irony of her work is that it carefully, thoughtfully and artificially stages decision and deliberation by the photographer and inaction in the subject. In this the artist is empowered creator, only for the artist's agency to be undercut by the subject's motionless lack of physical and intellectual agency. The real drama in Starkey's work then is the knowing frustration of female agency as the photographer's artistry engages itself with the unengaged female self.

Starkey's sense of the 'self' is often devoid of the insignia which proclaim an identity. It is the emptiness of non-identity to which her subjects seem to be tending. In 'Untitled: October 1998' there is a rare visual sign of affiliation to the world in the Arsenal badge on the girl's top. Her utter boredom, surrounded and framed by the darkness of an adult world which she is on the verge of stepping into, drains the identification with a group of supporters, and a club, of any potential vibrancy. She waits to enter the world of Starkey's adult women. One of Starkey's best-known works is 'Butterfly Catchers' (1999), and it is rare among her photographs in that it has a discernibly Belfast setting. Like her later work it is a staged image with female subjects. Its mixing of urban realism with a pathetic fantasy prefigures the poles which converge in some of her later, more urbane and cosmopolitan images. The question then becomes whether Starkey's deracination of identity, her sense that 'being' in contemporary Western society has been evacuated of specificity, begins with the sense of Belfast which is registered in 'Butterfly Catchers'. That sardonic title, considered along with the image, suggests an urban landscape which offers few opportunities to those stumbling over it. And in particular Starkey's examination of female experience in an identity-laden society may be what planes away the markers of the exterior self. Whether or not this has its root in the over-determined identities of Northern Irish society is a hard call to make. To assume that it is would be to pull Starkey's work back into the nets of a semantic field which, like a butterfly, it has escaped.

The work of McConnell, Luvera and Starkey, points to how the certainties of political identity by which the North was understood at the beginning of the Troubles are regarded as contestable by contemporary photographers. This is not to say that the political identities of Northern Ireland have become diluted during the past thirty years. The post-Agreement period has, in some ways, seen the attitudes and institutions of sectarian Northern Ireland given a greater sense of permanency. But art-photographic practice has developed ways in which to sever aspects of identity from the unquestionable absoluteness that identity aspires to, until examination of the idea of identity leaves only slivers of the original certitudes intact.

Mary McIntyre's *Elaborate Constructions Engineered on a Massive Scale…* (1996) includes two church interiors which, in their tableau-like framing, show how the architecture of a church constitutes it as a

**Hannah Starkey**
**Untitled: May 1997**
**1997**
Framed C-type print.
122cm x 152cm.
© Hannah Starkey.
Courtesy of Maureen Paley, London.

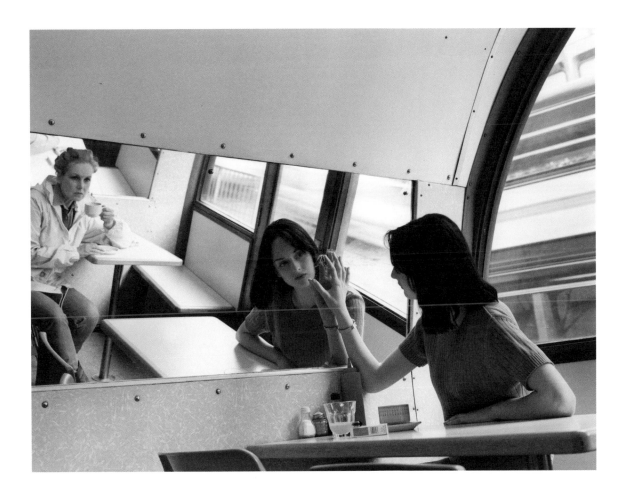

**Hannah Starkey**
**Butterfly Catchers**
**1999**
Framed C-type print.
122cm x 152cm.
© Hannah Starkey.
Courtesy of Maureen Paley, London.

**Mary McIntyre**
**Elaborate Constructions Engineered on a Massive Scale**
**in Order to Create the Proper Images I**
**1997**
Photographic duratran on lightbox.
61cm x 76cm.
© Mary McIntyre.
Courtesy of the artist and the Third Space Gallery.

**Sylvia Grace Borda**
**2012**
From the series *Churches: Coming to the Table*.
Photo-glazed ceramic dinner coupe plate.
10 inches in circumference.
© Sylvia Grace Borda.
Courtesy of the artist.

270

**Mary McIntyre**
**The Lough V**
**2006**
Colour Lightjet photographic print.
80cm x 100cm.
© Mary McIntyre.
Courtesy of the artist and the Third
Space Gallery.

**Mary McIntyre**
**The Mound I**
**2009**
Colour Lightjet photographic print.
80cm x 100cm.
© Mary McIntyre.
Courtesy of the artist.

274

**Victoria J. Dean**
**Wall VI, Whitehead, Co. Antrim**
**2010**
From the series *The Fortified Coastline*.
Lambda print on dibond (framed).
55cm x 55cm.
© Victoria J. Dean.
Courtesy of the artist.

**Victoria J. Dean**
**Telescope, Newcastle, Co. Down**
**2010**
From the series *The Fortified Coastline*.
Lambda print on dibond (framed).
55cm x 55cm.
© Victoria J. Dean.
Courtesy of the artist.

place of meeting, ritual and faith. In this image the 'identity' of the faith is of much less consequence than the photograph's poetics of religious space, and in the context of McIntyre's other photographs from this period it is clear that it is the way in which the interiors of rooms and buildings make and reflect social practice that is her focus. The same might be said of Sylvia Grace Borda's exteriors in *Churches* (2012), which treats those buildings architecturally rather than denominationally.

Mary McIntyre's landscapes were where we began this book, her Caspar David Friedrich 'imitation' being an embodiment of, and statement about, the kind of photography that Northern Irish art photography has become. McIntyre's work, in quiet and concentrated ways, pushes the conceptual edges of what that photography can do with the North. As if aware that the post-Agreement period has brought both the 'development' of the North as a late capitalist enclave and a new, emphatic form of identity politics, and that these create a state of confusion and opacity for future visions of what the North will be, McIntyre's landscapes have shed their specificity, searching for an alternative politics, another way of living, in this landscape. McIntyre's 'Afterwards' (2004) brings together many of the strands which we have seen evolving over the decades since the 1980s. Its de-peopled landscape nevertheless implies human presences, in that some moment has presumably passed (as the title prompts us to imagine). There is little to see here, but much to assume. A story has finished. This is, perhaps, a crime scene. Or a haunted place. Or is it, because we see it photographed and thus give it significance, that we attribute such meanings to this scene? And does this then tells us about our own visual conditioning? In this post-Troubles era, do we yet have the capacity to see Northern Ireland without the intercession of the spectre of the Troubles? We live in this 'afterwards', not knowing what may be behind the everyday. Northern Ireland is a society in which banal places hold extraordinary and often bleak memories. 'Afterwards' asks if those memories are always revenants. It is a prick to our consciences. It may also be a prompt to suggest that we should not assume that the conscience of history, of what came before 'afterwards', lies everywhere, and that there are more, or different, things to be seen in the ordinary than the aftermath of the Troubles. In this, 'Afterwards' is an 'aftermath' image, and is about aftermath images.

And so the Northern photographic landscape, and the landscapes which it photographs, tend to abstraction in McIntyre's work so that we can think about, and then beyond, the particularities of the North. In Victoria Dean's recent work, *The Fortified Coastline* (2012), the Northern Irish landscape retains only the merest traces of the memory of conflict. The 'fortifications', which are at times barely fortified, keep back the sea, that tidal and mythic force which works beyond history. Dean's series includes one image which might represent the future of Northern photography. A lens which looks out over the sea while bolted to the coastline.

1 Paul Dixon, 'Performing the Northern Ireland Peace Process on the World Stage', *Political Science Quarterly*, 121: 1 (2006), 61. Dixon is quoting Michael Cox, '"Cinderella at the Ball": Explaining the End of the War in Northern Ireland', *Millennium*, 27 (1998), 340.

2 The phrase is used by Philip Bobbitt in his US-centric account of global politics, *The Shield of Achilles: War, Peace and the Course of History* (London: Penguin, 2002). Bobbitt takes the phrase from W.H. Auden's 1952 poem 'The Shield of Achilles'.

3 One of the first official usages of the term seems to have been by the then Economy Minister Nigel Dodds speaking at the America-Ireland Fund Gala in Boston in November 2007. See http://www.northernireland.gov.uk/index /media-centre/news-departments/news-deti/news-deti-november-2007/news-deti-161107-northern-ireland-is.htm

4 Malcolm Waters, *Globalization* (London: Routledge, 1995), p. 164.

5 Robert J. Holton, *Globalization and the Nation-State* (London: Macmillan, 1998), pp. 161-185.

6 On the experiences of Vietnamese refugees and their Irish-born children in the Republic see Mark Maguire and A. Jamie Saris, 'Enshrining Vietnamese-Irish Lives', *Anthropology Today*, 23: 2 (2007), 9-12.

7 Julian Stallabrass, 'Sebastião Salgado and Fine Art Photojournalism', *New Left Review*, 223 (1997), 131-161.

8 Paul Seawright, 'The Missing' in *Paul Seawright* (Salamanca: Ediciones Universidad de Salamanca, 2000), pp. 63-65.

9 John Stathatos, 'Hiding in the Open: Paul Seawright's Images of Afghanistan': see http://www.stathatos.net/pages/paul_seawright.html

10 *Roger Fenton: Photographer of the 1850s* (London: South Bank Board, 1988), n.p..

11 Donovan Wylie notes that at the time of making this photograph, which was before troop withdrawals from Afghanistan, he was aware of the sensitive information revealed in it, and that an element of the fort was digitally altered and does not reflect its precise dimensions.

12 Jane Humphries, 'Dublin I (Space: The Final Frontier)', *Circa*, 94 (2000), 48.

13 Tom Nairn, *The Break Up of Britain* (London: Verso, 1981 [1977]). See also Tom Nairn, *After Britain: New Labour and the Return of Scotland* (London: Granta, 2000).

14 Michael Rosie and Ross Bond, 'Routes into Scottishness' in Catherine Bromley, John Curtice, David McCrone and Alison Park (eds), *Has Devolution Delivered?* (Edinburgh: Edinburgh University Press, 2006), pp. 141-142.

15 Pierre Bourdieu, *Photography: A Middlebrow Art* (Cambridge: Polity, 1996), p. 24.

16 This series is described as 'Portraits and Interiors from the Albert Bar' in Gareth McConnell, *Gareth McConnell* (Brighton/Göttingen: Photoworks/Steidl, 2004). A different set of the images appeared under the title 'No Surrender' in *Source*, 28 (2001), 25-32.

17 http://www.garethmcconnell.com/ projects/ibiza-index-nothing-ever-same-they-said-it-was (Project Information).

18 Anthony Luvera, 'Residency' in *Residency* (Belfast: Belfast Exposed, 2011), n.p..

# Bibliography

**A**

Adams, Robert et al., *New Topographics* (Centre for Creative Photography/Eastman House/Steidl: Tuscon/New York/Göttingen, 2010)

Alcobia-Murphy, Shane, *Governing the Tongue in Northern Ireland: The Place of Art/The Art of Place* (Newcastle: Cambridge Scholars Press, 2005)

Allen, Nicholas and Kelly, Aaron (eds), *The Cities of Belfast* (Dublin: Four Courts, 2003)

**B**

Baker, Joe, *Snapshots of Belfast, 1925-1929* (Belfast: Glenrave Local History Project, 2008)

Barthes, Roland, *Camera Lucida* (London: Vintage, 2000 [1981])

Baudrillard, Jean, *America*, translated by Chris Turner (London: Verso, 1999)

Baudrillard, Jean, *The Intelligence of Evil, or the Lucidity Pact* (Oxford: Berg, 2005)

Benjamin, Walter, 'Little History of Photography' in *Walter Benjamin, Selected Writings: Volume 2, 1927-1934* (Cambridge, Mass.: Belknap, 1999), pp. 507-530

Bobbitt, Philip, *The Shield of Achilles: War, Peace and the Course of History* (London: Penguin, 2002)

[Borderlines Team], *Borderlines* (Dublin: Gallery of Photography, 2006)

Bourdieu, Pierre, *Photography: A Middle-brow Art* (Cambridge: Polity, 1996)

Boym, Svetlana, *The Future of Nostalgia* (New York: Basic, 2001)

Broomberg, Adam and Chanarin, Oliver, *People in Trouble Laughing Pushed to the Ground* (London: MACK, 2011)

Brotton, Jerry, *A History of the World in Twelve Maps* (London: Allen Lane, 2012)

Burke, Ursula and Jewesbury, Daniel, *Archive: Lisburn Road* (Belfast: Belfast Exposed, 2004)

Butler, Judith, *Giving an Account of Oneself* (New York: Fordham University Press, 2005)

**C**

Campbell, Beatrice, *Agreement! The State, Conflict and Change in Northern Ireland* (London: Lawrence & Wishart, 2008)

Carr, Garrett, 'Remapping the Irish Border' in Kathleen James-Chakraborty and Sabine Strümper-Krobb (eds), *Crossing Borders: Space Beyond Disciplines* (Oxford/Bern: Peter Lang, 2011), pp. 149-158

Carruthers, Mark, and Douds, Stephen (eds), *Stepping Stones: The Arts in Ulster, 1971-2001* (Belfast: Blackstaff, 2001)

Carson, Ciaran, 'Lost and Found', *Source*, 25 (2000), 17-18.

Carville, Justin, *Photography and Ireland* (London: Reaktion, 2011)

Castels, Robert, *From Manual Workers to Wage Laborers: Transformation of the Social Question* (New Jersey: Transaction, 2003)

Cheng, Wendy, '"New Topographics": Locating Epistemological Concerns in the American Landscape', *American Quarterly*, 63: 1 (2011), 151-162

Corbus Bezner, Lili, *Photography and Politics in America: From the New Deal into the Cold War* (Baltimore & London: Johns Hopkins University Press, 1999)

Cox, Michael, '"Cinderella at the Ball": Explaining the End of the War in Northern Ireland', *Millennium*, 27 (1998), 325-342

Curtis, L.P., Jr., *Apes and Angels: The Irishman in Victorian Caricature* (London and Washington, DC: Smithsonian Institution Press, 1971)

**D**

Dawson, Graham, *Making Peace with the Past? Memory, Trauma and the Irish Troubles* (Manchester: Manchester University Press, 2007)

Derrida, Jacques, *Specters of Marx* (London: Routledge, 1994)

Derrida, Jacques, *Archive Fever: A Freudian Impression*, translated by Eric Prenowitz (Chicago and London: University of Chicago Press, 1996)

Paul Dixon, 'Performing the Northern Ireland Peace Process on the World Stage', *Political Science Quarterly*, 121: 1 (2006), 61-91

Doherty, Willie, *How It Was* (Belfast: Ormeau Baths Gallery, 2001)

Doherty, Willie, *False Memory* (London: Merrell, 2002)

Doherty, Willie, *Disturbance* (Dublin: Dublin City Hugh Lane Gallery, 2011)

Downey, Karen (ed.), *Where Are the People? Contemporary Photographs of Belfast 2002-2010* (Belfast: Belfast Exposed Photography, 2010)

Duncan, John, *Be Prepared* (Edinburgh: Stills, 1998)

Duncan, John, 'Boom Town', *Source*, 31 (2002), 28-36

Duncan, John, *Trees from Germany* (Belfast: Belfast Exposed, 2003)

Duncan, John, *Bonfires* (Brighton/Belfast/Göttingen: Photoworks/Belfast Exposed/Steidl, 2008)

**E**

Enwezor, Okwui, 'Archive Fever: Photography Between History and the Monument' in Okwui Ewezor (ed.), *Archive Fever: Uses of the Document in Contemporary Art* (New York: Steidl, 2008), pp. 11-51

Evans, Jessica (ed.), *The Camerawork Essays: Context and Meaning in Photography* (London: Rivers Oram, 1997)

Ewart, Lavens M., 'Belfast Maps', *Ulster Journal of Archaeology* , 1: 1 (1894), 62-69

**F**

Farrell, David, *Innocent Landscapes* (London: Dewi Lewis, 2001)

Farrell, David, *Né Vicino Né Lontano. A Lugo*, (Rome: Punctum, 2007)

Farrington, Christopher, *Ulster Unionism and the Peace Process in Northern Ireland* (Basingstoke: Palgrave, 2006)

Finn, Jonathan, *Capturing the Criminal Image: From Mug Shot to Surveillance Society* (Minneapolis: University of Minnesota Press, 2009)

Flusser, Vilém, *Writings* (Minneapolis/London: University of Minnesota, 2002)

Foucault, Michel, *The Archaeology of Knowledge* (London: Routledge, 2002)

Fox, David and Stevens, Sylvia (dirs), *Picturing Derry* (Faction Films, 1984)

**G**

Gaffikin, Frank and Morrissey, Mike, 'The Role of Culture in the Regeneration of a Divided City: The Case of Belfast' in Frank Gaffikin and Mike Morrissey (eds), *City Visions: Imagining Place, Enfranchising People* (London: Pluto, 1999), pp. 164-179

[Gallery of Photography, Dublin], *Lie of the Land* (Dublin: Gallery of Photography, 1995)

Goldring, Maurice, *Belfast: From Loyalty to Rebellion* (London: Lawrence and Wishart, 1991)

Govedarica, Natasa, 'I am what I see?' in Anthony Haughey, *Disputed Territory* (Dublin: DIT/Gallery of Photography, 2006), pp. 122-125

Griffiths, Stuart, 'Northern Ireland Archive', *Photoworks*, 16 (2011), 24-33

Guimond, James, *American Photography and the American Dream* (Chapel Hill: University of North Carolina Press, 1991)

**H**

Haines, Keith, *East Belfast (Images of Ireland)* (Stroud: History Press, 2007)

[Half Moon Photography Workshop], *Camerawork*, 14 (1979)

Haughey, Anthony, *Disputed Territory* (Dublin: Gallery of Photography, 2006)

Herron, Tom and Lynch, John, *After Bloody Sunday: Representation, Ethics, Justice* (Cork: Cork University Press, 2007)

Hesse, Kai-Olaf, *Topography of the Titanic* (Belfast: Belfast Exposed/ex pose verlag, 2007)

Hillen, Seán, *Irelantis* (Dublin: Irelantis, 1999)

Hillen, Seán, *Photomontages, 1983-1993* (Dublin/Paris: Gallery of Photography/Centre Culturel Irlandais, 2004)

Hillen, Seán, *What's Wrong? With The Consolation of Genius* (Dublin: Oliver Sears, 2011)

Hils, Claudio, *Red Land Blue Land* (Ostfildern-Ruit: Hatje Cantz Verlag, 2000)

Hils, Claudio, *Archive_Belfast* (Belfast/Ostfildern-Ruit: Belfast Exposed/Hatje Cantz, 2004)

Holton, Robert J., *Globalization and the Nation-State* (London: Macmillan, 1998)

Humphries, Jane, 'Dublin I (Space: The Final Frontier)', *Circa*, 94 (2000), 46-48

**J**

Jacquette, Dale, 'Untitled', *Philosophy and Literature*, 19: 1 (1995), 102-105

Jeffrey, Ian, *Photography: A Concise History* (London: Thames & Hudson, 2006)

Jones, Alan, 'Just a Little Corner of Belfast to Burn', *Fortnight*, 414 (2003), 12-13

Judt, Tony, *Postwar: A History of Europe Since 1945* (London: Pimlico, 2007)

**K**

Kelly, Aaron, 'Walled Communities' in Eoghan McTigue, *All Over Again* (Belfast: Belfast Exposed, 2004), n.p.

Kelly, Aaron, *The Thriller and Northern Ireland Since 1969: Utterly Resigned Terror* (Aldershot: Ashgate, 2005)

Kelly, Aaron, 'Geopolitical Eclipse: Culture and the Peace Process in Northern Ireland', *Third Text*, 19: 5 (2005), 545-553

Kelly, Liam, *Thinking Long: Contemporary Art in the North of Ireland* (Kinsale: Gandon, 1996)

Brian Kennedy, 'Borderline Case', *Circa*, 94 (2000), 30-31

Kirk, Bill, *The Klondyke Bar* (Belfast: Blackstaff, 1975)

Kirkland, Richard, *Identity Parades: Northern Irish Culture and Dissident Subjects* (Liverpool: Liverpool University Press, 2002)

**L**

Lambkin, Brian, Fitzgerald, Patrick and Devlin Trew, Johanne, 'Migration in Belfast History: Trajectories, Letters, Voices' in Olwen Purdue (ed.), *Belfast: The Emerging City, 1850-1914* (Dublin: Irish Academic Press, 2013), pp. 235-269

Lehner, Stefanie, *Subaltern Ethics in Contemporary Scottish and Irish Literature: Tracing Counter-Histories* (London: Palgrave, 2011)

Lethen, Helmut, *The Culture of Distance in Weimar Germany* (Ewing, NJ: University of California Press, 2001)

Levinas, Emmanuel, 'The Trace of the Other' in William McNeill and Karen S. Feldman (eds), *Continental Philosophy: An Anthology* (Oxford: Blackwell, 1998), pp. 176-185

Lloyd, Valerie, 'Introduction' in *Roger Fenton: Photographer of the 1850s* (London: Yale University Press/South Bank Board, 1988)

Loftus, Belinda, 'Photography, Art and Politics: How the English Make Pictures of Northern Ireland's Troubles', *Circa*, 13 (1983), 10-14

Long, Richard, *Heaven and Earth* (London: Tate, 2009)

Luvera, Anthony, *Residency* (Belfast: Belfast Exposed, 2011)

Luxenberg, Alisa, 'Creating Désastres: Andrieu's Photographs of Urban Ruins in the Paris of 1871', *Art Bulletin*, 80: 1 (1998), 113-137

**M**

Macpherson, Don, 'Nation, Mandate, Memory' in Jessica Evans (ed.), *The Camerawork Essays* (London: Rivers Oram, 1997), pp. 145-152

Maguire, Mark and Saris, A. Jamie, 'Enshrining Vietnamese-Irish Lives', *Anthropology Today*, 23: 2 (2007), 9-12

Mansergh, Martin, 'The Background to the Irish Peace Process' in Michael Cox, Adrian Guelke and Fiona Stephen (eds), *A Farewell to Arms? Beyond the Good Friday Agreement* (Manchester: Manchester University Press, 2006), pp. 24-40

McAvera, Brian, *Marking the North: The Work of Victor Sloan* (Dublin: Open Air, 1990)

McBrinn, Joseph, *Northern Rhythm: The Art of John Luke (1906-1975)* (Belfast: National Museums Northern Ireland, 2012)

McConnell, Gareth, 'No Surrender', *Source*, 28 (2001), 25-32

McConnell, Gareth, *Gareth McConnell* (Brighton/Göttingen: Photoworks/Steidl, 2004)

McKendry, Helen, 'Afterword' in Séamus McKendry, *Disappeared: The Search for Jean McConville* (Dublin: Blackwater, 2000), pp. 145-146

McLaughlin, Greg and Baxter, Stephen, *The Propaganda of Peace* (Bristol: Intellect, 2010)

McMonagle, Barney, *No Go: A Photographic Record of Free Derry* (Derry: Guildhall, 1997)

McNamee, Eoin, *The Ultras* (London: Faber, 2004)

McTigue, Eoghan, *All Over Again* (Belfast: Belfast Exposed Photography, 2004)

McWilliams, Monica, 'Northern Futures', *The Irish Review*, 31 (2004), 84-87

Medina Lasansky, D., 'Introduction' in D. Medina Lasansky and Brian McLaren (eds), *Architecture and Tourism: Perception, Performance and Place* (Oxford: Berg, 2004), pp. 1-12

Merewether, Charles, 'Archives of the Fallen', in Charles Merewether (ed.), *The Archive* (London/Cambridge, MA: Whitechapel/MIT, 2006), pp. 121-138

Miller, David, *Don't Mention the War: Northern Ireland, Propaganda and the Media* (London: Pluto, 1994)

Mitchell, W.J.T., *Picture Theory* (Chicago and London: Chicago University Press, 1994)

Morrow, Duncan, *On the Road of Reconciliation: A Brief Memoir* (Dublin: Columba, 2003)

Murphy, Brendan, *Eyewitness: Four Decades of Northern Life* (Dublin: O'Brien, 2003)

Murphy, Brendan, *Portfolio* (Belfast: Brehon, 2008)

**N**

Nairn, Tom, *The Break Up of Britain* (London: Verso, 1981 [1977])

Nairn, Tom, *After Britain: New Labour and the Return of Scotland* (London: Granta, 2000)

Novosel, Tony, *Northern Ireland's Lost Opportunity: The Frustrated Promise of Political Loyalism* (London: Pluto, 2013)

**O**

O'Brien, Paul, 'Willie Doherty: Language, Imagery and the Real', *Circa*, 104 (2003), 51-54

O'Hearn, Denis, 'Peace Dividend, Foreign Investment, and Economic Regeneration: The Northern Irish Case', *Social Problems*, 47: 2 (2000), 180-200

Olley, Jonathan, *Castles of Ulster* (Belfast: Factotum, 2007)

Orvell, Miles, 'Weegee's Voyeurism and the Mastery of Urban Disorder', *American Art*, 6: 1 (1992), 18-41

**P**

Peatling, G.K., *The Failure of the Northern Ireland Peace Process* (Dublin: Irish Academic Press, 2004)

Petruck, Peninah R. (ed.), *The Camera Viewed: Writings on Photography, Vol. II* (London: Dutton, 1979)

Pollock, Vivienne and Parkhill, Trevor, *Belfast (Britain in Old Photographs)* (Stroud: History Press, 1997)

Price, Mary, *The Photograph: A Strange, Confined Space* (Stanford: Stanford University Press, 1994)

Prus, Timothy and Wylie, Donovan, *Scrapbook* (Göttingen: Steidl, 2009)

**Q**

Quick, Andrew, 'The Space Between: Photography and the Time of Forgetting in the Work of Willie Doherty' in Annette Kuhn and Kirsten Emiko McAllister (eds), *Locating Memory: Photographic Acts* (New York/Oxford: Berghahn, 2006), pp. 155-172

**R**

Raban, Jonathan, *Soft City* (London: Fontana, 1975)

*Report of the Bloody Sunday Inquiry* [Saville Report] (London: TSO, 2010)

Richards, Thomas, *The Imperial Archive* (London: Verso, 1993)

Ricoeur, Paul, 'Archives, Documents, Traces' in Charles Merewether (ed.), *The Archive* (London/Cambridge, MA: Whitechapel/MIT, 2006), pp. 66-69

Roberts, John, 'Photography after the Photograph: Event, Archive, and the Non-Symbolic', *Oxford Art Journal*, 32: 2 (2009), 281-298

Rolston, Bill and Miller, David (eds), *War and Words: The Northern Ireland Media Reader* (Belfast: Beyond the Pale, 1996)

Ronen, Ruth, *Aesthetics of Anxiety* (New York: SUNY, 2009)

Rosie, Michael and Bond, Ross, 'Routes into Scottishness' in Catherine Bromley, John Curtice, David McCrone and Alison Park (eds), *Has Devolution Delivered?* (Edinburgh: Edinburgh University Press, 2007), pp. 141-158

**S**

Salvesen, Britt, 'New Topographics' in Adams, Robert et al., *New Topographics* (Centre for Creative Photography/Eastman House/Steidl: Tuscon/New York/Göttingen, 2010), pp. 11-67

Seawright, Paul, *Paul Seawright* (Salamanca: Centre for Photography of the University of Salamanca, 2000)

Simpson, Kirk, *Truth Recovery in Northern Ireland* (Manchester: Manchester University Press, 2009)

Sloan, Victor, *Victor Sloan, Selected Works, 1980-2000* (Belfast: Ormeau Baths Gallery/Orchard Gallery, 2001)

Soja, Edward W., 'Six Discourses on the Postmetropolis' in Sallie Westwood and John Williams (eds), *Imagining Cities: Scripts, Signs, Memory* (London: Routledge, 1997), pp. 19-30

Sontag, Susan, *On Photography* (London: Penguin, 1979)

Sontag, Susan, 'War and Photography' in Nicholas Owen (ed.), *Human Rights, Human Wrongs* (Oxford: Oxford University Press, 2003), pp. 251-273

[South Bank Board], *Roger Fenton: Photographer of the 1850s* (London: Yale University Press/South Bank Board, 1988)

Spencer, Graham, *The State of Loyalism in Northern Ireland* (London: Palgrave, 2008)

Stallabrass, Julian, 'Sebastião Salgado and Fine Art Photojournalism', *New Left Review*, 223 (1997), 131-161

Stathatos, John, 'The Absence' in Kai-Olaf Hesse, *Topography of the Titanic* (Belfast: Belfst Exposed/ex pose verlag, 2007), pp. 12-15

Steele-Perkins, Chris, 'Catholic West Belfast', *Camerawork*, 14 (1979), 4-7

Steiner, George, 'The City Under Attack', *Salmagundi*, 24 (1973), 3-18

Stewart, Nick, *no-one's not from everywhere* (Portadown: Millenium Court, 2007)

Szarkowski, John, *The Photographer's Eye* (New York: Museum of Modern Art, 2007 [1966])

**T**
Tagg, John, 'The Currency of the Photograph' in Victor Burgin (ed.), *Thinking Photography* (London: Macmillan, 1982), pp. 110-141

Tuan, Yi-Fu, *Space and Place: The Perspective of Experience* (Minneapolis: University of Minnesota Press, 2001 [1977])

**W**
Walker, Brian and Dixon, Hugh, *No Mean City: Belfast 1880-1914 in the Photographs of Robert French* (Belfast: Friar's Bush, 1984)

Waters, Malcolm, *Globalization* (London: Routledge, 1995)

Weegee, *Naked City* (Boston: Da Capo, 2002)

Weir, Peggy, *North Belfast (Images of Ireland)* (Stroud: History Press, 2007)

Wells, Liz, *Land Matters: Landscape Photography, Culture and Identity* (London: I.B. Tauris, 2011)

Whelan, Yvonne and Harte, Liam, 'Placing Geography in Irish Studies: Symbolic Landscapes of Spectacle and Memory' in Liam Harte and Yvonne Whelan (eds), *Ireland Beyond Boundaries: Mapping Irish Studies in the Twenty-first Century* (London: Pluto, 2007), pp. 175-197

Whyte, John, *Interpreting Northern Ireland* (Oxford: Clarendon, 1990)

Wilson, Robert and Wylie, Donovan, *The Dispossessed* (London: Picador, 1992)

Winchester, Simon, 'The Aftermath Project' in Jim Goldberg et al. (eds), *War is Only Half the Story* (New York: Mets & Schilt/Aperture/The Aftermath Project, 2008), pp. 4-7

Wylie, Donovan, *Ireland: Singular Images* (London: André Deutsch, 1994)

Wylie, Donovan, *The Maze* (London: Granta, 2004)

Wylie, Donovan, *British Watchtowers* (Göttingen: Steidl, 2007)

**Z**
Ziff, Trisha (ed.), *Still War: Photographs from the North of Ireland* (New Amsterdam: New York, 1990)

# Acknowledgements

Richard West rekindled my interest in photography by asking me to write for *Source*. I am very grateful to him and to Pauline Hadaway, and all at Belfast Exposed, for giving me the grounding in Northern Irish photography which led to this book. Tanya Kiang and Trish Lambe at the Gallery of Photography in Dublin have also been generous and encouraging.

My colleagues in the School of English, Media and Theatre Studies at NUI Maynooth facilitated research leave to finish this book and I thank them for their collegiality and goodwill.

I have benefitted greatly from my conversations with Ursula Burke, Garrett Carr, John Duncan, David Farrell, Seán Hillen, Daniel Jewesbury, Anthony Luvera and Paul Seawright. I have also learned much from other photographers whose work I have got to know well, including Noel Bowler, Michael Durand, Peter Evers and Patrick Hogan.

My thanks to Siobhán Garrigan, Eamonn Hughes, Stefanie Lehner and Gail McConnell, for their encouragement and wisdom. My gratitude to Selina, Jo, Kim and Ivor for their love, company and care.

Simon Coury provided sage and precise advice on the manuscript. I am indebted to Karen Downey, who has been the guiding spirit of this project, for her determination and continual support.

# Biographies

About the Author

Colin Graham is the author of *Ideologies of Epic* and *Deconstructing Ireland*. He is co-editor of *The Irish Review*, and of three collections of essays, and has published articles in many journals, including *Cultural Studies*, *Third Text*, *Journal of Visual Culture*, *Irish Studies Review*, *The Dublin Review*, and *Edinburgh Review*. He also writes for *Source* and *The Vacuum*. He is curator of the Illuminations exhibition space at NUI Maynooth, where he lectures in English.

About the Curator

Karen Downey is Senior Curator at Belfast Exposed. She has developed and directed Belfast Exposed's exhibition and book publishing programmes since 2000. Karen also works as an independent curator. In 2009 she curated Northern Ireland's presentation at the 53rd Venice Biennale with a solo exhibition by Susan MacWilliam, and in 2011 she curated *Versions and Diversions* at Temple Bar Gallery + Studios, Dublin. In 2012 she was Lead Curator and Editor for *Into the Light: The Arts Council – 60 Years of Supporting the Arts*.

# Image Credits

The author and the publisher wish to express their thanks to the following sources of visual material and/or permission to reproduce it:

© Abbas/Magnum Photos. Courtesy of Magnum Photos.

© Craig Ames. Courtesy of the artist.

© BPK, Berlin/Hamburger Kunsthalle/Caspar David Friedrich, *The Wanderer above the Sea of Fog*. Courtesy of BPK.

© BPK, Berlin/Museum der bildenden Künste, Leipzig/Caspar David Friedrich, *The Stages of Life*. Courtesy of BPK.

© Adam Broomberg and Oliver Chanarin. Courtesy of the artists.

© John Byrne. Courtesy of the artist.

© Garrett Carr. Courtesy of the artist.

© Gerry Casey. Courtesy of Belfast Exposed.

© Malcolm Craig Gilbert. Courtesy of the artist.

© John Davies. Courtesy of the artist.

© Victoria J. Dean. Courtesy of the artist.

© Willie Doherty. Courtesy of the artist and Kerlin Gallery. Dublin, Matt's Gallery, London and Alexander and Bonin. New York.

© John Duncan. Courtesy of the artist.

© David Farrell. Courtesy of the artist.

© Sylvia Grace Borda. Courtesy of the artist.

© Paul Graham. Courtesy of Anthony Reynolds Gallery, London and Wolverhampton Art Gallery.

© Stuart Griffiths. Courtesy of the artist.

© Anthony Haughey. Courtesy of the artist.

© Kai-Olaf Hesse. Courtesy of the artist.

© Seán Hillen. Courtesy of the artist and Maeve Hall and Oliver Sears.

© Claudio Hils. Courtesy of the artist.

© Daniel Jewesbury and Ursula Burke. Courtesy of the artists.

© Philip Jones Griffiths/Magnum Photos. Courtesy of Magnum Photos.

© Bill Kirk. Courtesy of the artist.

© Les Levine. Courtesy of Irish Museum of Modern Art.

© Anthony Luvera. Courtesy of the artist.

© Peter Marlow/Magnum Photos. Courtesy of Magnum Photos.

© Gareth McConnell. Courtesy of the artist.

© Patrick McCoy. Courtesy of John Duncan and the McCoy family.

© Mary McIntyre. Courtesy of the artist and the Third Space Gallery.

© Moira McIver. Courtesy of the artist.

© Sean McKernan. Courtesy of Belfast Exposed Photography.

© Eoghan McTigue. Courtesy of the artist.

© Brendan Murphy. Courtesy of the artist.

© Northern Ireland Office/Good Friday Agreement cover. Courtesy of CAIN, (cain.ulster.ac.uk).

© Jonathan Olley. Courtesy of the artist.

© Martin Parr/Magnum Photos, Courtesy of Magnum Photos.

© Adam Patterson. Courtesy of the artist.

© Mark Power/Magnum Photos. Courtesy of Magnum Photos.

© Paul Quinn. Courtesy of the artist.

© Paul Seawright. Courtesy of the artist. 'Gate' (1997) courtesy of the artist and Irish Museum of Modern Art.

© Victor Sloan. Courtesy of the artist.

© Hannah Starkey. Courtesy of Maureen Paley, London.

© Chris Steele-Perkins/Magnum Photos. Coutesy of Magnum Photos.

© Nick Stewart. Courtesy of the artist.

© Donovan Wylie/Magnum Photos. Courtesy of the artist.

© Patrick Zachmann/Magnum Photos. Courtesy of Magnum Photos.

# Index

Numbers in bold refer to images